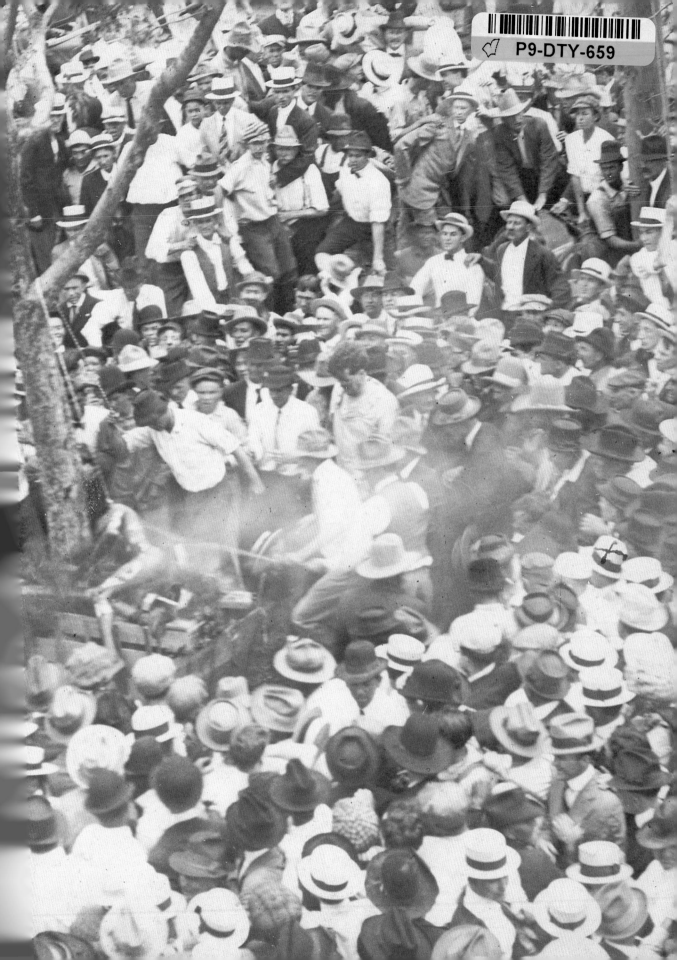

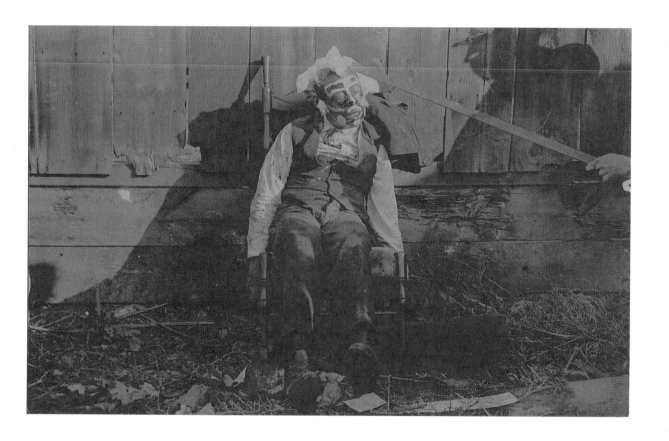

WITHOUT SANCTUARY

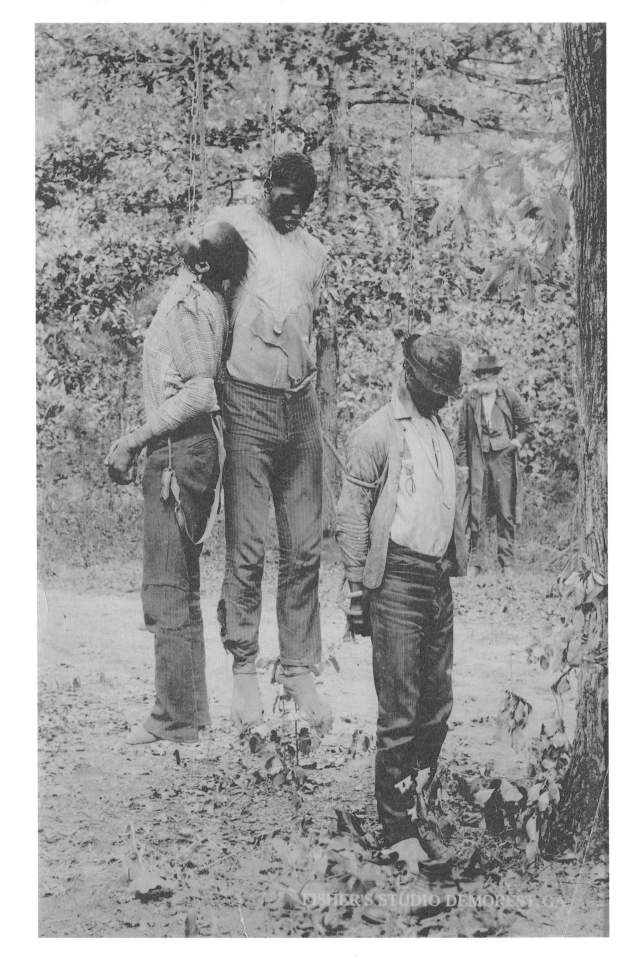

WITHOUT

LYNCHING PHOTOGRAPHY IN AMERICA

SANCTUARY

James Allen

Hilton Als

Congressman John Lewis

Leon F. Litwack

TWIN PALMS PUBLISHERS

2005

CONTENTS

FOREWORD
Congressman John Lewis

Without Sanctuary brings to life one of the darkest and sickest periods in American history. As a young child, growing up very poor in rural Alabama, I heard stories about lynchings and about the nightriders coming through, intimidating and harassing black people. At the time it all seemed nightmarish, unreal—even unbelievable. The photographs in this book make real the hideous crimes that were committed against humanity.

Many people today, despite the evidence, will not believe—don't want to believe—that such atrocities happened in America not so very long ago. These photographs bear witness to the hangings, burnings, castrations, and torture of an American holocaust. Despite all I witnessed during the height of the civil rights movement, and all I experienced of bigotry and hate during my lifetime, these photographs shocked me.

What is it in the human psyche that would drive a person to commit such acts of violence against their fellow citizens? This book cannot answer my question, but it does fill me with deep sadness and an even stronger determination to keep such atrocities from happening again. It is my hope that *Without Sanctuary* will inspire us, the living, and as yet unborn generations, to be more compassionate, loving, and caring. We must prevent anything like this from ever happening again.

HELLHOUNDS

by Leon F. Litwack

From the Mississippi Delta in the early twentieth century, Robert Johnson, a black bluesman, articulated a lonely and terrifying sense of personal betrayal and anguish that transcended both time and region. With his songs and guitar licks, his chilling and relentless matter-of-factness, he suggested a society impossible to change or overcome and a new generation of interior exiles like himself, exiles in their own land, empty of belief or hope, vulnerable, without sanctuary.

> *I got to keep moving, I got to keep moving*
> *blues falling down like hail*
> *blues falling down like hail*
> *Uumh, blues falling down like hail*
> *blues falling down like hail*
> *and the days keeps on worryin' me*
> *there's a hellhound on my trail,*
> *hellhound on my trail,*
> *hellhound on my trail.*

On a Sunday afternoon, April 23, 1899, more than two thousand white Georgians, some of them arriving from Atlanta on a special excursion train, assembled near the town of Newman to witness the execution of Sam Hose, a black Georgian. The event assumed a familiar format. Like so many lynchings, this one became a public spectacle. As in most lynchings, the guilt of the victim had

not been proven in a court of law. As in most lynchings, no member of the crowd wore a mask, nor did anyone attempt to conceal the names of the perpetrators; indeed, newspaper reporters noted the active participation of some of the region's most prominent citizens. And as in most lynchings, the white press and public expressed its solidarity in the name of white supremacy and ignored any information that contradicted the people's verdict.

Sam Hose worked for a planter, Alfred Cranford. He asked his employer for an advance in pay (some reported he had tried to collect wages already owed him) and for permission to visit his ill mother. The planter refused, precipitating a harsh exchange of words. On the following day, while Hose chopped wood, Cranford resumed the argument, this time drawing his pistol and threatening to kill Hose. In self-defense, Hose flung his ax, striking Cranford in the head and killing him instantly. Within two days, newspapers reported an altogether different version. Cranford had been eating dinner when Hose —*"a monster in human form"*— sneaked up on him, buried an ax in his skull, and after pillaging the house, dragged Mrs. Cranford into the room where her husband lay dying and raped her.

If versions of Cranford's death varied, the story of Sam Hose's fate did not. After stripping Hose of his clothes and chaining him to a tree, the self-appointed executioners stacked kerosene-soaked wood high around him. Before saturating Hose with oil and applying the torch, they cut off his ears, fingers, and genitals, and skinned his face. While some in the crowd plunged knives into the victim's flesh, others watched *"with unfeigning satisfaction"* (as one reporter noted) the contortions of Sam Hose's body as the flames rose, distorting his features, causing his eyes to bulge out of their sockets, and rupturing his veins. The only sounds that came from the victim's lips, even as his blood sizzled in the fire, were, *"Oh, my God! Oh, Jesus."* Before Hose's body had even cooled, his heart and liver were removed and cut into several pieces and his bones were crushed into small particles. The crowd fought over these souvenirs. Shortly after the lynching, one of the participants reportedly left for the state capitol, hoping to deliver a slice of Sam Hose's heart to the governor of Georgia, who would call Sam Hose's deeds *"the most diabolical in the annals of crime."*

The next morning, smoldering ashes and a blackened stake were all that remained. On

the trunk of a tree near the scene, a placard read, "*We Must Protect Our Southern Women,*" and one prominent Georgia woman, Rebecca Felton, gave voice to that sentiment: "*The premeditated outrage on Mrs. Cranford was infinitely more intolerable than the murder of her husband.*" As for Hose, Felton claimed any "*true-hearted husband or father*" would have happily dispatched the "*beast,*" with no more concern than if he were shooting down a mad dog; indeed, "*The dog is more worthy of sympathy.*"

The leading newspaper in Atlanta urged its readers to "*keep the facts in mind*" when they judged the actions of the lynchers. "*The people of Georgia are orderly and conservative, the descendants of ancestors who have been trained in America for 150 years. They are a people intensely religious, homeloving and just. There is among them no foreign or lawless element.*" The newspaper then provided the "facts" of Hose's alleged offenses, rendering his fate that much more explicable. "*When the picture is printed of the ravisher in flames, go back and view that darker picture of Mrs. Cranford outraged in the blood of her murdered husband.*"

In a subsequent investigation, conducted by a white detective, Cranford's wife revealed that Hose had come to the house to pick up his wages and the two men had quarreled.

When her husband went for his revolver, Hose, in self-defense, picked up and hurled the ax, which killed Cranford instantly. Hose then fled the scene. He never entered the house, she told the detective, nor did he assault her. Still another investigation, conducted by Ida B. Wells, a black journalist who had been driven from Memphis in 1892 for her "*incendiary*" editorials on lynching, reached the same conclusions. The results of neither investigation were of any apparent interest to the white press or presumably to the white public. [1]

Thousands of black men and women met the same fate. Varying only in degrees of torture and brutality, these execution rituals were acted out in every part of the South. Sometimes in small groups, sometimes in massive numbers, whites combined the roles of judge, jury, and executioner. Newspaper reporters dutifully reported the events under such lurid headlines as "COLORED MAN ROASTED ALIVE," describing in graphic detail the slow and methodical agony and death of the victim and devising a vocabulary that would befit the occasion. The public burning of a Negro would soon be known as a "*Negro Barbecue,*" reinforcing the perception of blacks as less than human.

The use of the camera to memorialize

lynchings testified to their openness and to the self-righteousness that animated the participants. Not only did photographers capture the execution itself, but also the carnival-like atmosphere and the expectant mood of the crowd, as in the lynching of Thomas Brooks in Fayette County, Tennessee, in 1915:

Hundreds of kodaks clicked all morning at the scene of the lynching. People in automobiles and carriages came from miles around to view the corpse dangling from the end of a rope. . . . Picture card photographers installed a portable printing plant at the bridge and reaped a harvest in selling postcards showing a photograph of the lynched Negro. Women and children were there by the score. At a number of country schools the day's routine was delayed until boy and girl pupils could get back from viewing the lynched man.[2]

During a lynching at Durant, Oklahoma, in 1911, the exuberant and proud lynchers bound their victim to some planks and posed around him while photographers recorded the scene. A black-owned newspaper in Topeka, Kansas, in printing the photograph, wanted every black newspaper to do likewise, so that *"the world may see and know what semi-barbarous America is doing."* Many photographs of lynchings and burnings (such as the burning of Sam Hose)

would reappear as popular picture postcards and trade cards to commemorate the event. A Unitarian minister in New York, John H. Holmes, opened his mail one day to find a postcard depicting a crowd in Alabama posing for a photographer next to the body of a black man dangling by a rope. Responding to the minister's recent condemnation of lynching, the person who sent the card wrote, *"This is the way we do them down here. The last lynching has not been put on card yet. Will put you on our regular mailing list. Expect one a month on the average."*[3]

Some thirty years after emancipation, between 1890 and 1920, in response to perceptions of a New Negro born in freedom, undisciplined by slavery, and unschooled in proper racial etiquette, and in response to growing doubts that this new generation could be trusted to stay in its place without legal and extra-legal force, the white South denied blacks a political voice, imposed rigid patterns of racial segregation (Jim Crow), sustained an economic system—sharecropping and tenantry—that left little room for ambition or hope, refused blacks equal educational resources, and disseminated racial caricatures and pseudo-scientific theories that reinforced and comforted whites in their racist beliefs and practices.

The criminal justice system (the law, the courts, the legal profession) operated with ruthless efficiency in upholding the absolute power of whites to command the subordination and labor of blacks.

But even this overwhelming display of superiority did not afford white southerners the internal security they sought or relieve their fears of *"uppity," "troublesome,"* ambitious, and independent-minded black men and women who had not yet learned the rituals of deference and submission. The quality of the racial violence that gripped the South made it distinctive in this nation's history. In the late nineteenth and early twentieth century, two or three black southerners were hanged, burned at the stake, or quietly murdered every week. In the 1890s, lynchings claimed an average of 139 lives each year, 75 percent of them black. The numbers declined in the following decades, but the percentage of black victims rose to 90 percent. Between 1882 and 1968, an estimated 4,742 blacks met their deaths at the hands of lynch mobs. As many if not more blacks were victims of legal lynchings (speedy trials and executions), private white violence, and *"nigger hunts,"* murdered by a variety of means in isolated rural sections and dumped into rivers and creeks.

Even an accurate body count of black lynching victims could not possibly reveal how hate and fear transformed ordinary white men and women into mindless murderers and sadistic torturers, or the savagery that, with increasing regularity, characterized assaults on black men and women in the name of restraining their savagery and depravity. Nothing so dramatically or forcefully underscored the cheapness of black life in the South. The way one black Mississippian recalled white violence in the 1930s applied as accurately and even more pervasively to the late nineteenth and early twentieth centuries. *"Back in those days, to kill a Negro wasn't nothing. It was like killing a chicken or killing a snake. The whites would say, 'Niggers jest supposed to die, ain't no damn good anyway—so jest go on an' kill 'em.'"* Whatever their value as laborers, black people were clearly expendable and replaceable. "In those days it was *'Kill a mule, buy another. Kill a nigger, hire another,'"* a black southerner remembered. *"They had to have a license to kill anything but a nigger. We was always in season."* [4]

The cheapness of black life reflected in turn the degree to which so many whites by the early twentieth century had come to think of black men and women as inherently and permanently inferior, as less than human, as

little more than animals. "*We Southern people don't care to equal ourselves with animals*," a white Floridian told a northern critic. "*The people of the South don't think any more of killing the black fellows than you would think of killing a flea . . . and if I was to live 1,000 years that would be my opinion and every other Southern man.*" A former governor of Georgia, William J. Northen, after canvassing his state in the interest of law and order, found the same disregard for black life. "*I was amazed to find scores and hundreds of men who believed the Negro to be a brute, without responsibility to God, and his slaughter nothing more than the killing of a dog.*"[5]

Lynching was hardly a new phenomenon. For many decades, it had served as a means of extra-legal justice in the Far West and Midwest, and most of the victims had been white, along with numbers of American Indians, Mexicans, Asians, and blacks. But in the 1890s, lynching and sadistic torture rapidly became exclusive public rituals of the South, with black men and women as the principal victims. During slavery, blacks had been exposed to violence on the plantations and farms where they worked and from the patrollers if they ventured off those plantations. The financial investment each slave represented had operated to some degree as a protective shield for blacks accused of crimes, but in the event of an insurrection—real or imagined—whites had used murder, decapitation, burning, and lynching to punish suspected rebels and impress upon all blacks the dangers of resistance.

The violence meted out to blacks after emancipation and during Reconstruction, including mob executions designed to underscore the limits of black freedom, anticipated to a considerable degree the wave of murder and terrorism that would sweep across the South two decades later and become one of its unmistakable trademarks. What was strikingly new and different in the late nineteenth and early twentieth century was the sadism and exhibitionism that characterized white violence. The ordinary modes of execution and punishment no longer satisfied the emotional appetite of the crowd. To kill the victim was not enough; the execution became public theater, a participatory ritual of torture and death, a voyeuristic spectacle prolonged as long as possible (once for seven hours) for the benefit of the crowd. Newspapers on a number of occasions announced in advance the time and place of a lynching, special "excursion" trains transported spectators to the scene, employers sometimes released

their workers to attend, parents sent notes to school asking teachers to excuse their children for the event, and entire families attended, the children hoisted on their parents' shoulders to miss none of the action and accompanying festivities. Returning from one such occasion, a nine-year-old white youth remained unsatisfied. *"I have seen a man hanged,"* he told his mother; *"now I wish I could see one burned."* [6]

The story of a lynching, then, is more than the simple fact of a black man or woman hanged by the neck. It is the story of slow, methodical, sadistic, often highly inventive forms of torture and mutilation. If executed by fire, it is the red-hot poker applied to the eyes and genitals and the stench of burning flesh, as the body slowly roasts over the flames and the blood sizzles in the heat. If executed by hanging, it is the convulsive movement of the limbs. Whether by fire or rope, it is the dismemberment and distribution of severed bodily parts as favors and souvenirs to participants and the crowd: teeth, ears, toes, fingers, nails, kneecaps, bits of charred skin and bones. Such human trophies might reappear as watch fobs or be displayed conspicuously for public viewing. The severed knuckles of Sam Hose, for example, would be prominently displayed in the window of a grocery store in Atlanta. [7]

The brutalities meted out in these years often exceeded the most vivid of imaginations. After learning of the lynching of her husband, Mary Turner—in her eighth month of pregnancy—vowed to find those responsible, swear out warrants against them, and have them punished in the courts. For making such a threat, a mob of several hundred men and women determined to *"teach her a lesson."* After tying her ankles together, they hung her from a tree, head downward. Dousing her clothes with gasoline, they burned them from her body. While she was still alive, someone used a knife ordinarily reserved for splitting hogs to cut open the woman's abdomen. The infant fell from her womb to the ground and cried briefly, whereupon a member of this Valdosta, Georgia, mob crushed the baby's head beneath his heel. Hundreds of bullets were then fired into Mary Turner's body, completing the work of the mob. The Associated Press, in its notice of the affair, observed that Mary Turner had made *"unwise remarks"* about the execution of her husband, *"and the people, in their indignant mood, took exceptions to her remarks, as well as her attitude."* [8]

Apprehended for allegedly killing his white employer, Luther Holbert and his wife found themselves subjected to mob justice in Doddsville, Mississippi, in 1904. Some one thousand people stood and watched as the self-appointed executioners went about their business, engaging in the increasingly familiar ritual of torture, mutilation, and murder. A reporter for the *Vicksburg Evening Post* described the execution of the Holberts.

When the two Negroes were captured, they were tied to trees and while the funeral pyres were being prepared they were forced to suffer the most fiendish tortures. The blacks were forced to hold out their hands while one finger at a time was chopped off. The fingers were distributed as souvenirs. The ears of the murderers were cut off. Holbert was beaten severely, his skull was fractured and one of his eyes, knocked out with a stick, hung by a shred from the socket. . . . The most excruciating form of punishment consisted in the use of a large corkscrew in the hands of some of the mob. This instrument was bored into the flesh of the man and woman, in the arms, legs and body, and then pulled out, the spirals tearing out big pieces of raw, quivering flesh every time it was withdrawn.

Holbert and his employer had quarreled before the murder, but there was no evidence to implicate Holbert's wife. Two blacks, mistaken for Luther Holbert, had already been slain by a posse.[9]

When a mob meted out lynch justice in Fort White, Florida, in 1893, they did so with a ferocity that was becoming all too typical. Trains brought in additional participants and spectators from surrounding cities. After a mock trial, the prolonged execution began. *"Every one knew what the crowd meant,"* a resident noted afterwards, *"but no one expected such horrible butchery."* They sawed at his throat, cut off both his ears, cut out one eye, and stuffed handkerchiefs in the victim's mouth to stifle his *"awful screams."* Stabbing him repeatedly, the lynchers came close to cutting out his backbone. He was then dragged two blocks before the crowd emptied their guns into his body. One year earlier, near Memphis, the same kind of violence had been inflicted on Lee Walker, removed from the county jail and hanged from a telegraph pole after his skin had been cut to ribbons by the mob. As Walker swung on the pole, blood streaming down his body from the knife wounds, the crowd hurled expletives at him. *"The Negro died hard,"* one observer wrote. *"The neck was not broken, . . . and death came by strangulation. For fully ten*

minutes after he was strung up the chest heaved occasionally and there were convulsive movements of the limbs." But the crowd had not finished. Throwing the body into a fire, they watched with "astonishing coolness and nonchalance" as it burned. Finally, the relic hunters moved in to retrieve portions of the rope and what was left of the charred body.[10]

Once having settled on lynch justice, mobs were not overly scrupulous about determining the guilt of the black victim. The idea, after all, as one black observer noted, was to make an example, "knowing full well that one Negro swinging from a tree will serve as well as another to terrorize the community." After a barn burning near Columbus, Mississippi, suspicion fell on the son of Cordelia Stevenson. Unable to locate him, a mob of whites settled on his mother, seized and tortured her, and left her naked body hanging from the limb of a tree for public viewing. A jury rendered the usual judgment in such cases, deciding she had come to her death at the hands of persons unknown.[11]

Neither women nor entire families escaped the savagery of white mobs. Bessie McCroy, along with her son and daughter, were removed from a jail in Carroll County, Mississippi, and taken to the edge of town, where a crowd of five hundred men hanged them and riddled their bodies with bullets. Members of a mob in Okemah, Oklahoma, entered the local jail to seize Laura Nelson, accused of murdering a sheriff, then raped the black woman before hanging her along with her teenage son. When a white farmer in Gray, Georgia, was found dead in his home, suspicion fell on Will Green and his seventeen-year-old son. Despite their pleas of innocence, a mob lynched both of them and riddled their bodies with bullets. Authorities subsequently determined that neither the father nor the son had anything to do with the farmer's death.[12]

The way whites in Monticello, Georgia, dealt with a black family in 1915 was no doubt meant as a warning to all blacks who dared to challenge white authority. When the local police chief came to the home of Daniel Barber to arrest him on a bootlegging charge, Barber and his family forcibly resisted the officer. After police subdued and arrested the Barbers, some two hundred enraged whites stormed the jail and dragged Barber, his son, and his two married daughters to a tree in the very center of the black district. The mob chose to hang the entire family, one by one. Daniel Barber had to watch each of his children die before the noose was tightened around his neck.[13]

When permitted to speak before being lynched, some of the victims professed their guilt and asked for forgiveness, while others protested their innocence. Many simply tried to make peace with their God. Before his burning, Henry Noles of Winchester, Tennessee, confessed his crime and asked his friends to *"meet him in glory."* He mounted the stump *"stolidly"* and laughed as he told the mob, *"Tell all my sisters and brothers to meet me in glory. I am going to make that my home. Tell my mother to meet me where parting will be no more."* Taken from the stump, he was then chained to a tree and his body saturated with oil. Soon *"the quivering body was enveloped in flames."* A lynch mob in Cuthbert, Georgia, agreed to the victim's request that they take his picture and send it to his sister. She collapsed upon receiving the photo showing him hanging on a tree. Jesse Washington, a black youth, pleaded his innocence with the lynch mob (he had been retried after a judge had expressed doubt over a guilty verdict), but to no avail. The crowd, made up of *"the supposed best citizens of the South,"* looked on with approval as the flames enveloped the squirming youth. Souvenir hunters then proceeded to hack his body with penknives, carrying away their human loot. One white spectator failed to share the carnival mood of the crowd. *"I am a white man, but today is one day that I am certainly sorry that I am one,"* he wrote afterward. *"I am disgusted with my country."* [14]

The degree to which whites came to accept lynching as justifiable homicide was best revealed in how they learned to differentiate between *"good"* lynchings and *"bad"* lynchings. A newspaper reported the execution of Elmo Curl, at Mastadon, Mississippi, as *"a most orderly affair, conducted by the bankers, lawyers, farmers, and merchants of that county. The best people of the county, as good as there are anywhere, simply met there and hanged Curl without a sign of rowdyism. There was no drinking, no shooting, no yelling, and not even any loud talking."* What characterized a *"good"* lynching appeared to be the quick dispatch of the victim *"in a most orderly manner"* without prolonging his or her agony for the crowd's benefit. When a mob made up of *"prominent citizens,"* including a member of the South Carolina state legislature, lynched a black man near Charleston, the local newspaper thought it had been done in the *"most approved and up-to-date fashion."* [15]

No doubt the mob in Howard, Texas, thought itself orderly, even democratic in its ritualistic execution of a black man. Farmers in the surrounding neighborhood were notified to attend, and some two thou-

sand spectators responded. The victim was given two hours for prayers, and the mob heeded his request to see his brother and sister before the execution. The question of how he should be executed was submitted to the crowd, and a majority voted for death by burning. Neither the orderliness of the proceedings nor the democratic proclivities of the mob in any way alleviated the agony of the victim. *"The negro's moans were pitiful,"* a reporter noted. *"He struggled, his great muscles swelling and throbbing in an effort to break the chains which bound him."* Five minutes after the mob applied the match, the victim was dead, and at least one newspaper found the *"hellish deed"* unjustifiable. *"The deliberately-planned and calmly-executed spectacle was over. The crowd dispersed."* But the legacy of this lynching, the editor insisted, would linger. *"That five minutes of a return to primal savagery cannot be wiped out within the course of one brief life time. Five thousand Texans are irremediably debased."* [16]

Even some ordinarily unsympathetic white Mississippians thought the lynching of Lloyd Clay in Vicksburg in 1919 might have been misguided. A twenty-two-year-old day laborer from a respected family, Clay was accused of rape, even though the victim denied he had been her assailant. Overly zealous to remove Clay from the jail, the mob accidentally shot two whites. Still, they carried off the execution, clumsily trying to hang him and finally burning him alive near the center of town. Newspapers called it *"hideous"* and *"horrible,"* *"one of the worst lynchings in history,"* and at least one newspaper thought Clay was *"probably an innocent man, and one wholly out of the classes of the 'bad negro.'"* Another newspaper labeled the lynchers rank amateurs who lacked the necessary skills to dispatch their victim. The more than one thousand spectators reportedly remained passive during the execution, though some thought the executioners had been clumsy and inflicted *"needless suffering"* on Clay. The lynching incurred further criticism for having taken place in a white neighborhood. At least six white women fainted, and others reported that their *"sensibilities"* had been *"shocked."* [17]

Some executions were more spectacular than others, but none of them were particularly exceptional. If Sam Hose's execution appeared prominently in the southern press, hundreds of lynchings were accorded only a brief mention, particularly as they became routine affairs by the end of the century, requiring no more notice or comment in some newspapers than the daily weather.

"*Now-a-days*," a bishop of the Southern Methodist Church noted, "*it seems the killing of Negroes is not so extraordinary an occurrence as to need explanation; it has become so common that it no longer surprises. We read of such things as we read of fires that burn a cabin or a town.*" Few members of a lynch mob were, in fact, ever apprehended, and only rarely did the leaders or the participants seek to conceal their identity. The confident manner in which they went about their business was matched only by the complacency, the matter-of-factness, and often the good humor with which it was viewed. Occasionally, editorialists and political leaders voiced concern and condemned lynchings, but the public tended to praise the lynchers for fulfilling their responsibilities as white males. The Memphis newspaper chose to judge each lynching according to its merits, basing any verdict on the nature of the victim's crime. It had no problem with lynching a Negro rapist but thought it wrong to lynch a Negro who refused to be vaccinated. [18]

It became convenient for some whites and portions of the press to blame lynching on lower-class whites. Although the "*best people,*" like other whites, took for granted the inferiority of blacks, they were said to be more paternalistic and less likely to carry their views to a violent conclusion. "*Ravening mobs are not composed of gentlemen,*" affirmed Atlanta's leading newspaper. But the evidence suggested otherwise. Perhaps "*rednecks,*" "*crackers,*" and "*peckerwoods*" played a more public role in lynchings, but they often did so with the tacit approval and at times the active and zealous participation of upper- and middle-class whites. Exceptions existed among all classes, but invariably "*gentlemen*" and "*ladies,*" especially the newer generation of whites who had grown up after the Civil War, were no more sympathetic to black people and their aspirations than lower-class whites. If they sometimes displayed a greater sympathy, they felt less of a threat to their exalted position in southern society.

Drawn from all classes in southern white society, from the "*rednecks*" to the "*best people,*" lynchers came together in an impressive show of racial and community solidarity. Neither crazed fiends nor the dregs of white society, the bulk of the lynchers tended to be ordinary and respectable people, few of whom had any difficulty justifying their atrocities in the name of maintaining the social and racial order and the purity of the Anglo-Saxon race. The mobs who meted out "*summary justice*" [19] were pronounced by one Georgian as "*composed of our best citizens,*"

who are foremost in all works of public and private good." In the same spirit, a Meridian, Mississippi, newspaper concluded, *"The men who do the lynchings . . . are not men who flout law but men who sincerely believe they have the best interest of their fellow men and women at heart."* [20]

Although some whites found lynchings unacceptable and barbaric, few of the perpetrators were ever brought to trial. Townspeople closed ranks to protect their own kind, thereby becoming partners in the crimes committed. Eyewitnesses refused to testify, and grand juries refused to bring indictments against easily identifiable mob participants. Even if they had, juries would have refused to convict, whatever the evidence. In the vast majority of reported lynchings, the courts, coroners' juries, or other official bodies chosen to investigate the murders concluded routinely that black victims had met their deaths *"at the hands of unknown parties," "at the hands of persons unknown,"* or *"by persons unknown to the jury."* In an Alabama community, 110 whites examined for a jury that would judge members of a lynch mob were asked, *"If you were satisfied from the evidence beyond a reasonable doubt that the defendant took part with or abetted the mob in murdering a Negro, would you favour his con-*

viction?" Seventy-six answered no, and the remaining thirty-four would certainly have weighed very carefully the consequences of rendering a guilty verdict. [21]

Not only did distinguished public officials at all levels of government hesitate to condemn lynching, but some also chose to participate in lynch mobs. *"I led the mob which lynched Nelse Patton, and I am proud of it,"* a former U. S. senator from Mississippi, William Van Amberg Sullivan, boasted in 1908. *"I directed every movement of the mob and I did everything I could to see that he was lynched."* In the public burning of John Hartfield in Jones County, Mississippi, the district attorney, who would later be elected to Congress, not only witnessed the burning but used the occasion for some electioneering and refused to bring charges against the mob leaders. The mob that carried out the grisly dismemberment of Willis Jackson in Honea Path, South Carolina, in 1911 was led by Joshua W. Ashleigh, who represented the district in the state legislature. His son, editor of the local newspaper, also participated in the lynching; indeed, he proudly told his readers that he *"went out to see the fun without the least objection to being a party to help lynch the brute."* When some shocked South Carolinians

demanded a state investigation, Governor Cole Blease demurred. Rather than use his power of office to deter whites from *"punishing that nigger brute,"* he vowed that if necessary he would gladly have resigned as governor *"and come to Honea Path and led the mob."* The newspaper in Spartanburg warned that any attempt to indict the murderers *"would make heroes of the lynchers and eminently qualify them for public office."* [22]

If political leaders failed to act, judges, sheriffs, jailers, and local police often stood by helplessly during a lynching or, on occasion, actively participated in the ritual. It was not uncommon for members of a lynch mob to pose for news photographers with the sheriff and the intended victim. Even if a conscientious law enforcement official chose to remain committed to his oath of office, he was likely to encounter insurmountable obstacles, such as the will of the community, which was usually more than sufficient to prompt him to submit to the seemingly inevitable. *"I went into that cell block with every intention of fulfilling my oath and protecting that man,"* an officer reported, *"but when the mob opened the door, the first half-a-dozen men standing there were leading citizens—businessmen, leaders of their churches and the community—I just couldn't do it."* [23]

Before lynching two men in Morganton, North Carolina, in 1889, the mob held prayer services. That spoke quite eloquently to the degree to which lynchings took place in some of the most churchified communities of the South. If white churches showed a relative indifference to lynching violence, there were some compelling reasons. The lynch mobs often included their parishioners. *"The only ways to keep the pro-lynching element in the church,"* a white Mississippian acknowledged some years later, *"is to say nothing which would tend to make them uncomfortable as church members."* Some clergymen, however, denounced lynchings, and a few took action. In Bulloch County, Georgia, the Rev. Whitely Langston expelled parishioners who had participated in a lynch mob—a most unpopular action that resulted in the loss of twenty-five members of the congregation. It was left to Ida B. Wells, a black editor and anti-lynching activist, to question the relative silence of white churches: *"Our American Christians are too busy saving the souls of white Christians from burning in hellfire to save the lives of black ones from present burning in fires kindled by white Christians."* [24]

When whites condemned lynching, they seemed less concerned over the black victims than over the very real possibility that

white civilization itself was on trial. Even as whites could readily agree on the inferiority of blacks and the need to maintain white supremacy, some also perceived and expressed alarm over the destabilization of the social order and the descent of their region into anarchy and barbarism. *"The greater peril at this hour where outbreak and lawlessness are at the surface,"* a southern minister declared, *"is not that the negro will lose his skin, but that the Anglo-Saxon will lose his soul."* The mayor of Statesboro, Georgia, like some of the more conscientious public officials, expressed alarm over the breakdown of law and order, even as he confessed his helplessness in preventing lynchings. *"If our grand jury won't indict these lynchers, if our petit juries won't convict, and if our soldiers won't shoot, what are we coming to?"* [25]

But even those who deplored lynching did so within limits, acknowledging that a higher law might sometimes have to prevail. The *"better sort"* of whites who paid lip service to law and order all too often found themselves mixing their outrage over a lynching with a more compelling sense of justice and retribution. Speaking to an audience at the University of Chicago, John Temple Graves, the influential Atlanta newspaper publisher, was swept up in a wave of emotion as he sought to communicate the imminent peril facing every white female in the South. Under the circumstances, he likened the lynch mob to an *"engine of vengeance, monstrous, lawless, deplorable,"* but, nonetheless, *"the fiery terror of the criminal and the chief defense of woman."* [26] Of course, if Graves's characterization of the imperiled white female had any merit, the epidemic of lynchings he condoned had obviously done nothing to enhance the woman's security. Nor would the eminent publisher have even contemplated the same mob justice being meted out to whites belonging to his own social class who were guilty of ravishing black women.

It took little time before a *"folk pornography"* emerged in the South, playing on themes from the past and adding some new dimensions. [27] To endorse lynching was to dwell on the sexual depravity of the black man, to raise the specter of the black beast seized by uncontrollable, savage, sexual passions that were inherent in the race. That is, the inhumanity, depravity, bestiality, and savagery practiced by white participants in lynchings would be justified in the name of humanity, morality, justice, civilization, and Christianity. And there was little reason to question the deep convictions on which whites acted; they came, in fact, to believe in their own

rhetoric, much as the defenders of slavery had. The Negro as beast became a fundamental part of the white South's racial imagery, taking its place alongside the venerated and faithful Sambo retainer, and whites were perfectly capable of drawing on both to sustain their self-image. Blacks, after all, possessed a dual nature: they were docile and amiable when enslaved or severely repressed, but savage, lustful, and capable of murder and mayhem when free and uncontrolled—like those blacks who had grown up since the Civil War. This generation, a Memphis newspaper insisted, had "*lost in large measure the traditional and wholesome awe of the white race which kept the Negroes in subjection. . . . There is no longer a restraint upon the brute passion of the Negro.*"[28]

Whites seemed incapable of grasping the fundamental hypocrisy that condemned black rape of white women and condoned or ignored white rape of black women. For a black man, sexual advances to a white woman, or what might be perceived as sexual advances, were a certain invitation to a tortured death. For a white man, the exploitation of a black woman for his sexual initiation or pleasure enjoyed community toleration. The most expedient way to dispose of the issue was to deny the existence of the white rapist, as black women were said to give themselves willingly, even wantonly, to white men. Not all whites actually believed this argument, however, even if they routinely invoked it for public consumption. While condemning black rape in no uncertain terms, some whites suggested that blacks had been provoked not by white women but by white men taking liberties with black women and thereby inviting retaliation. When T. W. Walker, a Georgia black man, was sentenced to death for killing a wealthy white planter, the first news dispatches could find no reason for the attack; a black editor, however, charged that the planter had brutally assaulted Walker's wife. Before Walker could be removed from the courtroom, he was shot by the planter's brother; severely wounded, he was then hanged. The planter's brother escaped prosecution, but not the black editor, who was immediately arrested for libel.[29]

White fears were based on the assumption that most lynchings stemmed from sexual assault. But in many cases, reports of sexual assault proved entirely baseless or upon closer examination revealed only that a black male had broken the rules of racial etiquette, had behaved in a manner construed as a racial insult, or had violated the

bar on consensual interracial sex. What Walter White would call "*the Southern white woman's proneness to hysteria where Negroes are concerned*," based on his investigation of scores of lynchings, created situations of imagined rather than actual sexual assaults in which both innocent white and black lives were lost in the name of preserving the sanctity of white womanhood.[30]

As long as blacks cast their "*lustful eyes on white women*," a Little Rock newspaper declared, and "*as long as any of them seek to break down the barrier that has been between the Negro and white man for a thousand years*," whites would not be "slow or timid" in the methods they employed to mete out an appropriate punishment."*This may be 'Southern brutality' as far as the Boston Negro can see, but in polite circles, we call it Southern chivalry, a Southern virtue that will never die.*"[31] But chivalry in defense of imperiled white womanhood was only a rationalization, not an explanation of the epidemic of mob murder that consumed the South. Rape and sexual indiscretion, in actuality, proved to be a relatively minor cause of mob violence. Of the nearly three thousand blacks known to have been lynched between 1889 and 1918, for example, only 19 percent were accused of rape. But in many cases what the public

thought had occurred became much more important than what did happen. The public's perception of lynching, fed by the media and improved means of communication, was invariably that a sexual crime by black men had precipitated it. "*Having created the Frankenstein monster (and it is no less terrifying because it is largely illusory)*," Walter White concluded, "*the lyncher lives in constant fear of his own creation.*"[32]

The offenses which precipitated mob violence related less to sex-related crimes (as sensationalized in the press) than to questions of physical assault and murder (the most common charge), theft, arson, violations of the racial code, economic competition, and disputes over crop settlements. Many of the transgressions by blacks would have been regarded as relatively trivial if committed by whites and were not grounds anywhere else for capital punishment: using disrespectful, insulting, slanderous, boastful, threatening, or "*incendiary*" language; insubordination, impertinence, or improper demeanor (a sarcastic grin, laughing at the wrong time, a prolonged silence); refusing to take off one's hat to a white person or to give the right-of-way (to step aside) when encountering a white on the sidewalk; resisting assault by whites; "*being troublesome*

24

generally"; disorderly conduct, petty theft, or drunkenness; writing an improper ("*insulting*") letter to a white person; paying undue or improper attention to a white female; accusing a white man of writing love letters to a black woman; or living or keeping company with a white woman; turning or refusing to turn state's evidence; testifying or bringing suit against a white person; being related to a person accused of a crime and already lynched; political activities; union organizing; conjuring; discussing a lynching; gambling; operating a "*house of ill fame*"; a personal debt; refusing to accept an employment offer, "*jumping*" a labor contract; vagrancy; refusing to give up one's farm; conspicuously displaying one's wealth or property; and (in the eyes of whites) trying to act like a white man.[33]

Victims of lynch mobs, more often than not, had challenged or unintentionally violated the prevailing norms of white supremacy, and these offenses ranged from the serious (in the eyes of whites) to the trivial. Charles Jones, a youth from Grovetown, Georgia, was lynched by 150 whites for stealing a pair of shoes and "*talking big.*" Henry Sykes was lynched in Okolona, Mississippi, for calling up white girls on the telephone and annoying them. A Texas youth was jailed for writing an insulting letter to a young white woman; a mob broke into the jail and shot him to death. Jeff Brown accidentally brushed against a white girl as he was running to catch a train; a mob hanged him for "*attempted rape.*" For their "*utter worthlessness,*" John Shaw and George Call, two eighteen-year-old youths from Lynchburg, Virginia, were shot to death after the mob's attempt to hang them failed.[34] A South Carolina editor acknowledged in 1917 that some three-fourths of lynchings were for "*trivial offenses,*" and sometimes entirely innocent men were "*butchered.*"[35]

All too often, black southerners, innocent of any crime or offense, were victims of lynchings or burnings because they were black and in the wrong place at the wrong time. The only evidence against Jim Black, Thomas Ryor, and James Ford, implicated in the murder of the wife of a white farmer of Hendersonville, South Carolina, was that they had been spotted in the neighborhood; the three black youths were quickly lynched. The white farmer later confessed to murdering his wife and concealing her body. Fred and Jane Sullivan were accused of burning a barn; a mob lynched the couple, ignoring their four-year-old child. After emptying their guns into Bob Kennedy for assaulting a

white man, a mob discovered he was not the man wanted for the crime and immediately continued their chase for "*the guilty one.*" [36]

Men lynch most readily, a southern critic observed, when the black victim has "*offended that intangible something called 'racial superiority.'*" That offense, in fact, with no suggestion of sexual impropriety, precipitated scores of brutal lynchings. "*When a nigger gets ideas,*" a federal official in Wilkinson County, Mississippi, declared, "*the best thing to do is to get him under ground as quick as possible.*" Rufus Moncrief made one such mistake when on his way home from work he encountered a group of white men: he did not display the expected humble demeanor and seemed reluctant to pull off his hat to them when they spoke to him. The men beat him badly, and soon other whites joined in the attack, some of them severing Moncrief's limbs with a saw. They dragged what remained of him to a nearby tree and strung him up as they continued to mutilate his body. For good measure, they hung Moncrief's dog next to him and then informed Moncrief's wife that she would find two black puppies hanging to a tree and ordered her to remove them quickly or the farm would be burned to the ground. The eighty-year-old woman cut the bodies down and placed them in a large oats bag for burial. The coroner's inquest decided Moncrief had come to his death at the hands of parties unknown to the jury. [37]

Investigators frequently found no easily ascertainable reason for a lynching, except perhaps white emotional and recreational starvation. For some, "*nigger killing*" had simply become a sport, like any other amusement or diversion, and its popularity prompted a black newspaper in 1911 to call it "*The National Pastime.*" [38] Like any other amusement or recreational diversion, Walter White said of lynching, it provided whites with a welcome escape from "*the endless routine of drab working-hours and more drab home life.*" In Augusta, Georgia, in 1890, a black man was found one morning in the street, his body riddled with bullets. Suspecting a certain group of men may have been responsible, a white resident asked one of them, "*Pat, who killed that nigger?*" "*Oh, some of the boys,*" he responded, with a grin. "*What did they do it for?*" the resident asked. "*Oh, because he was a nigger,*" Pat replied, as if that were more than sufficient explanation. "*And,*" Pat added, "*he was the best nigger in town. Why, he would even take off his hat to me.*" [39]

Although seldom cited as the reason for mob violence, the assumption persisted that

an occasional lynching, for whatever reason, served a useful purpose, that periodically it became necessary to remind a new generation of blacks of their place in southern society. "*You don't understand how we feel down here,*" a young white southerner explained to a northern visitor; "*when there is a row, we feel like killing a nigger whether he has done anything or not.*" It was imperative that blacks understand their limits. "*A white man ain't a-goin' to be able to live in this country if we let niggers start gettin biggity,*" a white Mississippian said of a black being held for trial. "*I wish they'd lemme have him. I'd cut out his black balls and th'ow 'em to the hawgs.*" Some years later, when the number of lynchings subsided, a white resident of Oxford, Mississippi, told a visitor that lynching still had a reaffirming and cathartic quality that benefited the entire community. "*It is about time to have another lynching,*" he thought. "*When the niggers get so that they are not afraid of being lynched, it is time to put the fear in them.*" [40]

Some lynchings took place for no other apparent reason than to bring down a black person who had managed to achieve a measure of economic success. Anthony Crawford, born of slave parents in 1865, had become a substantial landowner and farmer in Abbeville, South Carolina. He had twelve sons and four daughters, most of them living nearby. As secretary of the local African Methodist Episcopal Church, he was a pivotal figure in the black community. Few blacks—or whites—had done more to embrace the gospel of self-help. "*Anthony Crawford's life and character,*" one observer noted, "*embodied everything that Booker T. Washington held to be virtuous in a Negro.*" On October 21, 1916, Crawford came to town to sell his cotton. He exchanged harsh words with a local white businessman over the offering price. When a store clerk wielding an ax handle went after Crawford, he backed away only to be arrested and placed in jail, securing him initially from a white mob angry over his reported insolence. "*When a nigger gets impudent we stretch him out and paddle him a bit,*" the store manager boasted. The president of the National Bank of Abbeville concurred, "*Crawford was insolent to a white man and he deserved a thrashing.*"

Released on bail, Crawford headed toward the gin, where his cotton was waiting. The white mob quickly regrouped and attacked him. Crawford resisted, injuring one of the whites, but the men finally overpowered him and kicked him until he had lost consciousness. The sheriff persuaded the mob to permit him to regain custody of Crawford.

From his cell, Crawford was heard to say, while spitting blood where they had kicked out his teeth, *"I thought I was a good citizen."* By not displaying *"the humility becoming a 'nigger,'"* however, he had become vulnerable. When a false rumor circulated that Crawford might be moved to another jail, the mob mobilized again and easily entered the jail. After shoving Crawford's broken body down three flights of stairs, they mutilated him, dug their heels into his upturned, quivering face, tied a rope around his neck, and dragged him through the streets of the Negro quarter as a warning. Finally, they hung him to a pine tree and emptied their guns into his body. Dutifully, the coroner convened a jury, which quickly reached the verdict that Anthony P. Crawford had come to his death at the hands of parties unknown to the jury. A subsequent citizens' meeting ordered the remainder of the Crawford family to leave town within three weeks.

A leading South Carolina newspaper had little difficulty in ascertaining the principal reason for Crawford's murder. *"Crawford was worth around $20,000 and that's more than most white farmers are worth down here. Property ownership always makes the Negro more assertive, more independent, and the cracker can't stand it."*

The citizens of Abbeville, regardless of class, demonstrated by their action—and inaction—not only extraordinary cowardice but also their own complicity in the crime. Pointing to the tree where Crawford was hanged, a resident remarked, *"I reckon the crowd wouldn't have been so bloodthirsty, only its been three years since they had any fun with the niggers, and it seems though they jest have to have a lynching every so often."* [41]

If lynchings were calculated to send a forceful message to the black community and underscore its vulnerability, whites succeeded. But at the same time, it exposed black men and women—in ways they would never forget—to the moral character of the white community. The impression conveyed was not so much the racial superiority of whites as their enormous capacity for savagery and cowardice, the way they inflicted their terror as crowds and mobs, rarely as individuals. *"The lynch mob came,"* a Mississippi woman remembered. *"I ain't never heard of no one white man going to get a Negro. They're the most cowardly people I ever heard of."* [42]

> They got the judges
> They got the lawyers
> They got the jury-rolls
> They got the law
> They don't come by ones

They got the sheriffs
They got the deputies
They don't come by twos
They got the shotguns
They got the rope
We git the justice
In the end
And they come by tens. [43]

It said much of the desperation many blacks felt that they might choose to find in the intensity of white violence and repression a sign of hope and progress. From his extensive investigations, Walter White concluded that *"lynching is much more an expression of Southern fear of Negro progress than of Negro crime."* Lynching, in this view, did not necessarily succeed in reinforcing racial repression; on the contrary, it suggested the refusal of black men and women to submit with equanimity to that repression. None other than Frederick Douglass suggested in 1892 that the racial violence and lynchings may actually be *"a favorable symptom."*

It is proof that the Negro is not standing still. He is not dead, but alive and active. He is not drifting with the current, but manfully resisting it and fighting his way to better conditions than those of the past, and better than those which popular opinion prescribes for him. He is not contented with his surroundings. . . .

A ship rotting at anchor meets with no resistance, but when she sets sail on the sea, she has to buffet opposing billows. The enemies of the Negro see that he is making progress and they naturally wish to stop him and keep him in just what they consider his proper place. They who aspire to higher grades than those fixed for them by society are scouted and scorned as upstarts for their presumptions.

The extraordinary amount of attention and energy expended upon black southerners, Henry M. Turner argued in 1904, refuted most compellingly the charge of inferiority. *"More laws have been enacted by the different legislatures of the country, and more judicial decisions have been delivered and proclaimed against this piece of inferiority called negro than have been issued against any people since time began."* Based on the attempts to suppress the race, Turner concluded, *"it would appear that the negro is the greatest man on earth."* [44]

It was bold talk in the face of harsh realities. How many who underwent the ordeal of fire lived to tell about it? Who can know now what those blacks who lived at the time were prepared to suffer in the name of race regeneration and redemption? The obstacles black people faced were exceptional, unlike those faced by any group of immigrants, shaped profoundly by the slave experience

and the ways in which white people perceived and acted upon racial differences. While maintaining that blacks were incapable of becoming their social, political, or economic equals, the dominant society betrayed the fear that they might. What had alarmed the white South during Reconstruction was not evidence of black failure but evidence of black success, evidence of black assertion, independence, and advancement, evidence of black men learning the uses of political power. The closer the black man got to the ballot box, one observer noted, the more he looked like a rapist.

That suggests the magnitude of the problem. Even as whites scorned black incompetence, they feared evidence of black competence and independence. Even as whites derided blacks for their ignorance, they resented educated, literate, ambitious, and successful blacks. The Negro as a buffoon, a menial, a servant, was acceptable; that kind of Negro threatened no one. The violence inflicted on black people was often selective, aimed at educated and successful blacks, those in positions of leadership, those determined to improve themselves, those who owned farms and stores, those suspected of having saved their earnings, those who had just made a crop—that is, black men and women perceived by whites as having stepped out of their place, *"trying to be white."*

The contradictions mounted, and few blacks could find ways to reconcile them. How could they be frugal if they found it impossible (even dangerous) to accumulate any savings? How could they maintain a clean appearance and clean homes if denied decent housing and the basic city services whites were accorded, and if whites greeted with derision black efforts to upgrade their appearance and homes? How could they be hardworking and diligent if denied the rewards of their labor? How could they be expected to respect the law if the law and its enforcement agencies refused to accord them minimal respect and protection?

The terrorism meted out by whites rested on the racism of genteel society. If mobs lynched blacks with calculated sadistic cruelty, historians and the academic sciences were no less resourceful in providing the intellectual underpinnings of racist thought and behavior, validating theories of black degeneracy and cultural and intellectual inferiority, helping to justify on *"scientific"* and historical grounds a complex of laws, practices, and beliefs. Popular literature, newspaper caricatures, minstrel shows, and vaudeville depicted blacks as a race of buf-

foons and half-wits. And with *Birth of a Nation* in 1915, the cinema did more than any historian to explain the *"Negro problem"* to the American people—the dangers (vividly depicted on the screen) posed by a race freed from the restraints of slavery. Beneath the grinning exterior of the black man, this film warned, there lurks a mindless savagery that demands white vigilance—and, if necessary, vigilantism.

Any people who could endure so much brutalization and endure, Ralph Ellison once suggested, *"is obviously more than the sum of its brutalization."* In the face of relentless white hostility, blacks drew inward, constructing in their communities a separate world, a replica of the society from which they had been excluded, with their own schools, churches, businesses, fraternal orders, cultural practices, and forms of activism and expression. Within rigidly prescribed boundaries, black men and women also improvised strategies for dealing with whites. The choices were never easy; the risks were always great. To survive was to make what a Louisiana black man called a *"pragmatic resignation"* to reality, to watch every word and action in the presence of whites, to veil their inner feelings, to wear the mask.

Neither black accommodation nor resignation translated into contentment or respect for the white world. Blacks did not expect in their dealings with whites any demonstration of fairness or a sense of justice. *"It's stamped in me, in my mind, the way I been treated,"* Ned Cobb said of his life as a tenant farmer and sharecropper in Alabama, *"the way I have seed other colored people treated—couldn't never go by what you think or say, had to come up to the white man's orders. . . . Well, that's disrecognizin me. Just disrecognized, discounted in every walk of life. . . . That's the way they worked it, and there's niggers in this country believed that shit. . . . I've studied and studied these white men close."* Ned Cobb accommodated; he never submitted. To *"get along"* and to obtain what he wanted from white people, he acquired the necessary demeanor and verbal skills. He learned *"to humble down and play shut-mouthed."* He knew to play dumb when the situation demanded it. And although he *"got tired of it,"* he learned *"to fall back,"* to take *"every kind of insult."* But there were limits, and these assumed a growing importance in his life. He refused to submit passively to the whims of every white man. He refused to demean himself, to become one of the *"white men's niggers."* *"In my years past, I'd accommodate anybody; but I didn't believe in this way of bowin to my knees and doin what any white man said do. . . . I just ain't goin to go*

nobody's way against my own self. First thing of all — I care for myself and respect myself." That determination to maintain his self-respect, to draw a line between himself and whites, ultimately cost him twelve years in a state prison, where he could contemplate the difference between the life of a black convict and the life of a black sharecropper. *"Outside, they raised figures against me in place of wire."* [45]

Through the first three decades of the twentieth century, the mechanisms regulating the place of black men and women remained mostly in place. The number of lynchings decreased significantly after 1930 but did not cease. Nor did the quality of the brutality meted out to black southerners diminish. The more spectacular lynching murders — Claude Neal in Marianna, Florida, in 1934; Cleo Wright in Sikeston, Missouri, in 1942; George W. Dorsey and Roger Malcolm and their wives in Monroe, Georgia, in 1946; Willie Earle in Pickens, North Carolina, in 1947; Emmet Till in Money, Mississippi, in 1955; Mack Charles Parker in Poplarville, Mississippi, in 1959 — anticipated a new wave of terrorist killings that would erupt when whites used every means at their disposal to maintain their supremacy in the face of an emboldened

and enlarged civil rights movement. Between 1961 and 1965, for example, twenty-one civil rights murders were recorded in the Deep South, and not one white man was convicted of murder in any of the crimes.

Early in the twentieth century, black activists had sought to arouse public opinion about the lynching epidemic in the South. Black activist and journalist Ida B. Wells mobilized public opinion early in the century, as did the newly organized National Association for the Advancement of Colored People (NAACP). Within the South, some whites stepped forward to challenge lynchings, most notably the Association of Southern Women for the Prevention of Lynching, established by Jessie Daniel Ames in 1930. Both black and white activists worked in the 1930s for federal anti-lynching legislation, but not even a liberal president, Franklin Delano Roosevelt, was willing to endanger his southern white support by endorsing such legislation. Concerned that perceptions of a violent South discouraged investments and impeded economic development, white businessmen began to press for changes, and law enforcement agencies made some progress in bringing accused blacks to trial. But the carefully constructed apparatus of white

supremacy demonstrated extraordinary staying power, and in all too many instances, rapid trials and unequal justice translated into legal lynchings. *"Dere ain' no use,"* a South Carolina black man reflected in the 1920s, *"De courts er dis land is not for niggers. . . . It seems to me when it come to trouble, de law an' a nigger is de white man's sport, an' justice is a stranger in them precincts, an' mercy is unknown."* [46]

Nearly a century after the Civil War, on new battlefields—Montgomery, Selma, Birmingham, Little Rock, Boston, Chicago, Los Angeles—another struggle would be fought over the meaning of freedom and justice in America, by a new generation of African Americans, in a rapidly changing world, and in a new climate of political necessity. The enlarged role of the United States in the world community as the leader of the *"free world,"* along with the outbreak of a Cold War in which the Soviet Union exploited the sorry record of Americans as protectors of their own oppressed, dictated a reappraisal of the role of inferiority that had been traditionally assigned to African Americans. Every racial episode and outbreak of racist violence in the United States was now instantly reported around the world, affecting adversely the American image.

More than a million black Americans fought in World War II to make the world safe for democracy. After the war, even larger numbers developed new strategies and tactics to make the United States safe for themselves. The conviction grew that the way it used to be did not have to be any longer, and black men and women would give voice to that feeling in ways white America could no longer ignore.

The need for this grisly photographic display may be disputed for catering to voyeuristic appetites and for perpetuating images of black victimization. This is not an easy history to assimilate. It is a necessarily painful and ugly story, as it includes some of the bleakest examples of violence and dehumanization in the history of humankind. The intention is not to depict blacks only as victims or whites only as victimizers, but the extent and quality of the violence unleashed on black men and women in the name of enforcing black deference and subordination cannot be avoided or minimized. Obviously, it is easier to choose the path of collective amnesia, to erase such memories, to sanitize our past. It is far easier to view what is depicted on these pages as so depraved and barbaric as to be beyond the realm of reason. That

enables us to dismiss what we see as an aberration, as the work of crazed fiends and psychopaths. But such a dismissal would rest on dubious and dangerous assumptions.

The photographs stretch our credulity, even numb our minds and senses to the full extent of the horror, but they must be examined if we are to understand how normal men and women could live with, participate in, and defend such atrocities, even reinterpret them so they would not see themselves or be perceived as less than civilized. The men and women who tortured, dismembered, and murdered in this fashion understood perfectly well what they were doing and thought of themselves as perfectly normal human beings. Few had any ethical qualms about their actions. This was not the outburst of crazed men or uncontrolled barbarians but the triumph of a belief system that defined one people as less human than another. For the men and women who comprised these mobs, as for those who remained silent and indifferent or who provided the scholarly and scientific explanations, this was the highest idealism in the service of their race, in the preservation of their heritage. One has only to view the self-satisfied expressions on their faces as they posed beneath black peo-

ple hanging from a rope or next to the charred remains of a Negro who had been burned to death.

What is most disturbing about these scenes is the discovery that the perpetrators of the crimes were ordinary people, not so different from ourselves—merchants, farmers, laborers, machine operators, teachers, lawyers, doctors, policemen, students; they were family men and women, good, decent churchgoing folk who came to believe that keeping black people in their place was nothing less than pest control, a way of combatting an epidemic or virus that if not checked would be detrimental to the health and security of the community. *"We whites,"* a Memphis merchant explained to an English visitor in 1909, *"have learnt to protect ourselves against the negro, just as we do against the yellow fever and the malaria—the work of noxious insects."*[47]

Even as these scenes recede into the past, they should continue to tax our sense of who we are and who we have been. *Without Sanctuary* is a grim reminder that a part of the American past we would prefer for various reasons to forget we need very much to remember. It is part of our history, part of our heritage. The lynchings and terrorism carried out in the name of racial supremacy

cannot be put to rest, if only because the issues they raise about the fragility of freedom and the pervasiveness of racism in American society are still very much with us.

1. The account of the Hose lynching is based on the *Richmond Planet*, Oct. 14, 1899, which reprinted the extensive investigation conducted by a detective sent by Ida B. Wells, and on the *Savannah Tribune*, April 29, May 6, 13, 1899; *Atlanta Constitution*, April 14-25, 1899; *Atlanta Journal*, April 24, 1899; *New York Tribune*, April 24, 1899, *New York Times*, April 24, 25, 1899; *Boston Evening Transcript*, April 24, 1899; *Kissimmee Valley* (Florida) *Gazette*, April 28, 1899; *Springfield* (Massachusetts) *Weekly Republican*, April 28, 1899, in Ralph Ginzburg, *100 Years of Lynchings* (Baltimore, 1961, 1988), 10-21; Thomas D. Clark, *Southern Country Editor* (Indianapolis, 1948), 229-31; W. Fitzhugh Brundage, *Lynching in the New South: Georgia and Virginia, 1880-1930* (Urbana, 1993), 82-84; Donald L. Grant, *The Way It Was in the South: The Black Experience in Georgia* (New York, 1993), 162-64. Much of the press referred to him as Sam Holt. Only the *New York Times* (April 25, 1899) published the story of a lyncher procuring a slice of Hose's heart for the governor. Rebecca Felton's observation may be found in "How Should the Women and Girls in Country Districts Be Protected: A Symposium Secured by Mrs. Loulie M. Gordon," Rebecca Felton Papers, University of Georgia Library.

2. *Crisis* 10 (June 1915), 71.

3. *Topeka Plaindealer*, quoted in *Crisis*, Dec. 1911, 60; postcard in NAACP, Administrative File, Lynching, etc., 1885-1916, NAACP Papers, C371, Library of Congress; *Crisis*, Jan. 1912, 110.

4. Charles Evers, *Evers* (New York, 1971), 23; Neil R. McMillen, *Dark Journey: Black Mississippians in the Age of Jim Crow* (Urbana, Ill., 1989), 224.

5. *Crisis* 2 (May 1911), 32; *Crisis* 3 (Jan. 1912), 108.

6. Booker T. Washington to editor of *New Orleans Times-Democrat*, June 19, 1899, *Southern Workman*, 28 (Oct. 1899), 375.

7. For the reference to the Atlanta butcher shop, see W. E. B. DuBois, "My Evolving Program for Negro Freedom," in Rayford W. Logan, *What the Negro Wants* (Chapel Hill, 1944), 53.

8. *Savannah Tribune*, May 25, 1918; Walter F. White, "The Work of a Mob," *Crisis* 16 (Sept. 1918), 221-22.

9. *Vicksburg Evening Post*, Feb. 13, 1904, quoted in Walter White, *Rope and Faggot: A Biography of Judge Lynch* (New York, 1929), 35-36.

10. Emily K...., Fort White, Florida, to M. DuBois, Nov. 30, 1893, Egbert DuBois Papers, Duke University Library; *Memphis Commercial*, July 23, 1892 [?], quoted in Ida B. Wells, "Lynch Law," in *The Reason Why The Colored American Is Not in the World's Columbian Exposition* (Chicago, 1893), 30-33.

11. Kelly Miller, "Possible Remedies for Lynching," *Southern Workman* 28 (Nov. 1899), 419; *Chicago Defender*, Dec. 18, 1915.

12. Thomas D. Clark, *Southern Country Editor*, 239; *Crisis* 2 (July 1911), 99-100; *Chicago Defender*, July 10, 1915.

13. *Crisis* 9 (March 1915), 225-28; John Dittmer, *Black Georgia in the Progressive Era, 1900-1920* (Urbana, 1977), 139. The same issue of *Crisis* reprints editorial opinion from around the country. In the South, the savage lynching elicited some negative reactions. The *Atlanta Journal* pronounced it "savage lawlessness," and a meeting of some two hundred Monticello residents, with the mayor presiding, voiced its disapproval.

14. *Baltimore Afro-American Ledger*, Aug. 31, 1901; Bessie Jones, *For the Ancestors: Autobiographical Memories* (Urbana, 1983), 42; *Chicago Defender*, May 20, 1916.

15. J. Nelson Fraser, *America, Old and New: Impressions of Six Months in the States* (London, 1912), 277 N.

16. *The State* (Columbia, S.C.), Sept. 10,1905, NAACP Files, C343, Manuscript Division, Library of Congress.

17. McMillen, *Dark Journey*, 241.

18. T. Thomas Stanford, *The Tragedy of the Negro in America* (North Cambridge, Mass., 1897),198; *Memphis Commercial Appeal*, Jan. 22, 1900, quoted in Thomas H. Baker, *The Memphis Commercial Appeal: The History of a Southern Newspaper* (Baton Rouge, 1971), 206.

19. Belle Kearney, *A Slaveholder's Daughter*, 5th ed. (New York, 1900), 95.

20. Savannah *Morning News*, quoted in Edward L. Ayers, *Vengeance and Justice: Crime and Punishment in the 19th Century American South* (New York, 1984), 244-45; McMillen, *Dark Journey*, 239.

21. Ray Stannard Baker, *Following the Colour Line* (New York, 1908), 198.

22. McMillen, *Dark Journey*, 224, 244-45, 247; *Crisis* 3 (Dec. 1911, 56-57, 61); Bertram Wyatt-Brown, *Southern Honor: Ethics and Behavior in the Old South* (New York, 1982), 439.

23. Jacquelyn Dowd Hall, *Revolt against Chivalry: Jessie Daniel Ames and the Women's Campaign against Lynching* (New York, 1979), 140.

24. Clark, *Southern Country Editor*, 243; McMillen, *Dark Journey*, 246; Baker, *Following the Colour Line*, 189; Ida B. Wells, *Crusade for Justice: The Autobiography of Ida B. Wells*, ed. Alfreda M. Duster (Chicago, 1970), 154-55.

25. Reverend John E. White, "The Need of a Southern Program on the Negro," *South Atlantic Quarterly* 6 (1907), 184-85; Baker, *Following the Colour Line*, 190.

26. *The Possibilities of the Negro in Symposium* (Atlanta, 1904), 15.

27. Hall, *Revolt against Chivalry*, 150-51. The term "folk pornography" was used by Hall in her insightful chapter on lynching and rape.

28. *Memphis Daily Commercial*, May 17, 1892 quoted in Ida B. Wells, *Southern Horrors* (New York, 1892)

29. *Crisis* 3 (Jan. 1912), 101.

30. White, *Rope and Faggot*, 57-58; *Crisis* 3 (Nov. 1911), 11. For instances in which both whites and blacks suffered from the hysteria over sexual assaults, see, for example, Ayers, *Vengeance and Justice*, 241-42.

31. *Little Rock Daily News*, quoted in *Crisis* 15 (April 1918), 288-89.

32. NAACP, *Thirty Years of Lynching in the United States, 1889-1918* (New York, 1919), 36; White, *Rope and Faggot*, 56-7. See also Monroe N. Work (ed.), *Negro Year Book: An Annual Encyclopedia of the Negro, 1937-1938* (Tuskegee, Ala., 1937), 156-58.

33. NAACP, *An Analysis of 3,216 Lynchings in Thirteen States for the Period 1889 to March, 1935*; NAACP, *Thirty Years of Lynching*; *Lynch List as Published in the Richmond Planet* (Richmond, 1889?); W. Laird Clowes, *Black America: A Study of the Ex-Slave and His Late Master* (London, 1891), 95; *Arkansas Weekly Mansion* (Little Rock), June 23, 1883; Harry Johnston, *The Negro in the New World* (London, 1910), 466; *Chicago Defender*, Jan. 10, 1910; Robert T. Kerlin, *The Voice of the Negro 1919* (New York, 1920), 100-101; McMillen, *Dark Journey*, 236. "It is said the negro gets justice in the State courts, and yet to be 'impolite,' 'indolent,' or 'impertinent' are capital offenses in the South, for which the negro is mercilessly shot down, and in all the Court Records since the war not a single white

man has been hung for wantonly killing a colored man, much less for murdering an 'indolent' or 'impertinent''nigger.'" From speech of W. A. Pledger of Georgia, *Official Compilation of Proceedings of the Afro-American League National Convention Held at Chicago, January 15, 16, 17, 1890* (Chicago, 1890), 23.

34. Articles from a variety of newspapers and periodicals, in Group 1 Administrative File Subject File (C371), NAACP Papers, Manuscript Division, Library of Congress.

35. W. W. Ball, editor *The State*, Columbia, S.C., to Frederick Calvin Norton, Dec. 1, 1917, W. W. Ball Papers, Duke University Library.

36. *New York Tribune*, March 3, 1904, Dec. 2, 1905, in Group 1, Administrative File Subject File (C371), NAACP Files, Division of Manuscripts, Library of Congress.

37. Hall, *Revolt against Chivalry*, 141-2; Allison Davis, *Leadership, Love and Aggression* (New York, 1983), 160; *Chicago Defender*, Sept. 22, 1917. Of the 4,715 blacks known to have been lynched between 1882 and 1946, some 26 percent were accused of a minor infraction or of no crime at all.

38. *Crisis* 1 (Jan. 1911), 18-19. The term appeared above a two-page cartoon depicting a lynching, and the caption read, "Seventy-five percent of the Negroes lynched have not even been accused of rape."

39. White, *Rope and Faggot*, 9; *Pittsburgh Dispatch*, Jan. 11, 1890, quoted in Clowes, *Black America*, 94-95. On "nigger killing" as a recreational diversion, see also Johnston, *Negro in the New World*, 463.

40. Albert Bushnell Hart, "The Outcome of the Southern Race Question," *North American Review* 188 (July 1908), 56; David L. Cohn, *Where I Was Born and Raised* (Boston, 1948), 74; McMillen, *Dark Journey*, 236-37.

41. [Roy Nash], "The Lynching of Anthony Crawford" 1916; W. T. Andrews, attorney-at-law, Sumter, S.C., to W. E. B. DuBois, Oct. 26, 1916; *Scimitar* (Abbeville, S.C.), February 1, 15, 1917; New York *Evening Post*, Nov. 23, 1916, NAACP Papers (C343, C364), Manuscript Division, Library of Congress.

42. Fanny Lou Hamer, "To Praise Our Bridges," in Dorothy Abbott (ed.), *Mississippi Writers: Reflections of Childhood and Youth* 5 vols. (Jackson, Miss., 1985-91), vol. 2, 323.

43. Sterling A. Brown, "Old Lem," *The Collected Poems of Sterling A. Brown* (New York, 1980), 170-71.

44. White, *Rope and Faggot*, 11; introduction to *The Reason Why the Colored American Is Not in the World's Columbian Exposition*, in Philip S. Foner (ed.), *The Life and Writings of Frederick Douglass* 4 vols. (New York, 1950-55), vol. 4, 476; Henry M. Turner, "Races Must Separate," in *The Possibilities of the Negro in Symposium*, 94.

45. Theodore Rosengarten, *All God's Dangers: The Life of Nate Shaw* (1974), 109-10, 413, 432-33, 390, 545.

46. E. C. L. Adams, *Nigger to Nigger* (New York, 1928), 108-9.

47. William Archer, *Through Afro-America* (London, 1910), 60.

This essay was drawn in part from Leon F. Litwack's *Trouble in Mind: Black Southerners in the Age of Jim Crow* (Alfred A. Knopf Inc., 1998)

GWTW

by Hilton Als

So what can I tell you about a bunch of unfortunate niggers stupid enough to get caught and hanged in America, or am I supposed to say lynched? I'm assuming this aggressive tone to establish a little distance from these images of the despised and dead, the better to determine the usefulness of this project, which escapes me, but doesn't preclude my writing about it. Too often we refuse information, refuse to look or even think about something, simply because it's unpleasant, or poses a problem, or raises "issues"—emotional and intellectual friction that rubs our heavily therapeuticized selves the wrong way. I didn't like looking at these pictures, but once I looked, the events documented in them occurred in my mind over and over again, as did the realization that these pictures are documents of America's obsession with niggers, both black and white. I looked at these pictures, and what I saw in them, in addition to the obvious, was the way in which I'm regarded, by any number of people: as a nigger. And it is as one that I felt my neck snap and my heart break, while looking at these pictures.

In any case, America's interest in niggers — and people more than willing to treat other people as niggers—is of passing interest since America's propensity to define race

and the underclass through hateful language, and hateful acts is well-known, and discussed. What isn't talked about is what interest the largely white editors (who constitute what we call Publishing), have in hiring a colored person to describe a nigger's life. For them, a black writer is someone who can simplify what is endemic to him or her as a human being—race—and blow it up to cartoon proportions, thereby making the coon situation "clear" to a white audience. To be fair, no such offensive non-ideas were put to me when this present collaboration was suggested, but would my inclusion in this book, as the nearly ahistorical, "lyrical" voice have been suggested if I were not a Negro? Or am I "lyrical" and ahistorical because I am a Negro? I am not going to adopt a mea culpa tone here, since I agreed to supply what I have always thought of as a soundtrack to these pictures, which, viewed together, make up America's first disaster movie.

But before I can talk about these pictures, such as the picture of the beautiful black guy with the incredibly relaxed shoulders who has been whipped—front and back—and who does not reveal anything to us (certainly not with his eyes) except his obvious pain: his flesh-eating scars, and the many pictures of people with their necks snapped, bowels loosened, feet no longer arched—before I can talk about any of the "feelings" they engender in me, I want to get back to the first question I posed: What is the relationship of the white people in these pictures to the white people who ask me, and sometimes pay me, to be Negro on the page?

Of course, one big difference between the people documented in these pictures and me is that I am not dead, have not been lynched or scalded or burned or whipped or stoned. But I have been looked at, watched, and it's the experience of being watched, and seeing the harm in people's eyes—that is the prelude to becoming a dead nigger, like those seen here, that has made me understand, finally, what the word "nigger" means, and why people have used it, and the way I use it here, now: as a metaphorical lynching before the real one. "Nigger" is a slow death. And that's the slow death I feel all the time now, as a colored man.

And according to these pictures, I shouldn't be talking to you right now: I'm a little on the nigger side, meant to be seen and not heard, my tongue hanged and with it, my mind. But before that happens, let me tell you what I see in these photographs: I see a

lot of crazy-looking white people, as crazy and empty-looking in the face as the white people who stare at me. Who wants to look at these pictures? Who are they all? When they look at these pictures, who do they identify with? The maimed, the tortured, the dead, or the white people who maybe told some dumb nigger before they hanged him, You are all wrong, niggerish, outrageous, violent, disruptive, uncooperative, lazy, stinking, loud, difficult, obnoxious, stupid, angry, prejudiced, unreasonable, shiftless, no good, a liar, fucked up—the very words and criticism a colored writer is apt to come up against if he doesn't do that woe-is-me Negro crap and has the temerity to ask not only why collect these pictures, but why does a colored point of view authenticate them, no matter what that colored person has to say?

In writing this, I have become a cliché, another colored person writing about a nigger's life. So doing, I'm feeding, somewhat, into what the essayist George W. S. Trow, has called "white euphoria," which is defined by white people exercising their largesse in my face as they say, Tell me about yourself, meaning, Tell me how you've suffered. Isn't that what you people do? Suffer nobly, poetically sometimes even? Doesn't suffering define you? I hate seeing this, and yet it is what I am meant to write, since I accepted the assignment, am "of the good," and want to know why these pictures, let alone events, have caused me pain. I don't know many people who wouldn't feel like a nigger looking at these pictures, all fucked up and hurt, killed by eyes and hands that can't stand yours. I want to bow out of this nigger feeling. I resent these pictures for making me feel anything at all. For a long time, I avoided being the black guy, that is, being black-identified. Back then, I felt that adopting black nationalism limited my world, my world view. Now I know from experience that the world has been limited for me by people who see me as a nigger, very much in the way the dead eyes and flashbulb smiles in these photographs say: See what we do to the niggers! They are the fear and hatred in ourselves, murdered! Killed! All of this is painful and American. Language makes it trite, somehow. I will never write from this niggerish point of view again. This is my farewell. I mean to be courtly and grand. No gold watch is necessary, as I bow out of the nigger business.

In my life as a city dweller, I have crossed dark nighttime streets so as not to make the white woman walking in front of me feel

fear. I have deliberately not come up behind a neighbor opening the door to our apartment building, so as not to make him feel what colored people make him feel: robbed, violated, somehow. I have been arrested on my way to school, accused of truancy. Once, when I was coming out of a restaurant with a friend, four or five cops pinned me to a wall, pointing guns at my head, I looked just like someone else. This is not to be confused with the time I sat with the same friend in his car, chatting, me in the back seat leaning over my friend's shoulder, and suddenly the car was flooded with white lights, police lights, and the lights on the hoods of their cars were turned on, and five or six cops, guns out of their holsters and pointed at me, were ordering me to get out of the car. We thought you were a carjacker, they said, as I stood in that white light which always reminds me of movie premiere lights, you know, where people look like all dressed-up shadows as those lights hit them, getting out of their cars?

This is what makes me feel nigger-ish, I'm afraid: being watched. I go to parties with white people. Invariably, one of them will make a comment about my size. They say, We'd know you anywhere, you're so big! I mean, you're so distinctive!, when they mean something else altogether, perhaps this: we have been watching you become what our collective imagination says you are: big and black—niggerish—and so therefore what? Whatever. As long as it can be lynched, eventually.

Once or twice I thought I might actually get killed in my New York of cops and very little safety—a nigger casualty, not unlike the brilliant Negro short story writer and poet, Henry Dumas, who was shot and killed in a subway station in Harlem, another case of "mistaken identity" in a colored village? He was thirty-three years old when he was killed in 1968, and had written at least one short story that I consider a masterpiece, "Ark of Bones," a story made distinct by the number of lynchings that fill the air without being explicitly referred to. All those colored tragedies, even before you've had a chance to grow up, Dumas seems to say in this tale of two boys who are ignorant of their history, and then not. That is their rite of colored male passage: having to drag all those lynchings around with them, around their necks: those are their ancestors. Too bad when violent deaths define who you are. Here's a little of the narrator, Fish, and his voice, which is all he has: "Headeye, he was followin' me," Fish begins. "I knowed he

was followin' me. But I just kept goin', like I wasn't payin' him no mind." What Headeye and Fish eventually see, walking through a wood where maybe a cousin was lynched, maybe not, is an ark floating on a river. The ark is filled with the bones of their black ancestors. The ark carrying those bruised bones is "consecrated" ground, but it is divine ground that can never settle, since its home is a stream. Those bones keep moving, like the dead niggers on these pages. Every time you turn a page, they move.

But back to the idea of being watched by (primarily) white editors and being lynched by eyes. What I mean is that so much care, so much care is taken not to scare white people simply with my existence, and it's as if they don't want to deal with the care, too: it makes their seeing me as a nigger even more complicated. I know many, many colored people who exercise a similar sensitivity where white people are concerned, anything to avoid being lynched by their tongues or eyes. Certain colored people want to lynch you, too. They are competitive, usually, and stupid people who believe that if they work hard and sell out they can be just like most white people and hate niggers even more than they do since they "know" them. Those colored people are, in some ways, worse than white people, since they imagine that they are the sometimes-lynched class, as opposed to the always-lynched. Fact is, if you are even half-way colored and male in America, the dead heads hanging from the trees in these pictures, and the dead eyes or grins surrounding them, it's not too hard to imagine how this is your life too, as it were. You can feel it every time you cross the street to avoid worrying a white woman to death or false accusations of rape, or every time your car breaks down anywhere in America, and you see signs about Jesus, and white people everywhere and your heart begins to race, and your skin becomes clammy, and the perspiration sticks to your flesh, just like Brock Peters in the film version of *To Kill a Mockingbird*, where he's on trial for maybe "interfering" with a white woman; it's her word against his but her word has weight, like the dead weight of a dead lynched body.

Once you're strung up, as they say in *The Ox-Bow Incident*, or maybe the Maureen O'Hara version of *The Hunchback of Notre Dame*, or maybe in *In Cold Blood*, or once they've fixed a pain in the neck for you, as they say in *His Girl Friday* (all these movies have lynchings in them, or make reference

to lynchings), once that's happened, what happens to your body? Did the families in these pictures stand at the periphery and wait for it all to be over, when someone, maybe the youngest among them, could climb the tree and cut Cousin or Mother or Father down? It's hard to see if any of the lynched have anything but rope and eyes staring at them in these pictures. When they were lynched their humanity was taken from them so why not their families? They have no names in these pictures—maybe addresses, I don't know, since I couldn't look past the pictures, really. What difference would it have made to get the facts of any of these lives, white or colored, right? Don't we want this story to go away?

I'm ashamed that I couldn't get into the history of these people. I saw these pictures through a strange light that my mind put up to obscure what I saw when I looked at all these dead niggers, their bodies reshaped by tragedy. I think the white light I saw was the white light those cops put on me. If you look at any number of old newsreel pictures taken at the big Hollywood premieres held at the Pantages, or Grauman's Chinese, in the nineteen thirties, forties, or fifties, some of the guests walking past the movie lights— klieg lights—look like shadowy half people trying to fill their suits or dresses. People as penumbrae. That's the light I saw when I looked at these pictures; it made the people in the pictures look less real. When I thought of that white light, I thought of my introduction to the South, where many of these niggers were killed: it was sitting in a darkened movie theatre with my mother and little brother, watching a revival of *Gone With the Wind*, which some people called *GWTW*. We ignored the pitiful colored people in the film because we wanted to enjoy ourselves, and in Margaret Mitchell's revisionist tale of the South, Vivien Leigh was so pretty. We couldn't think of those dumb niggers hanging from the trees in some field or another in Atlanta, or outside of it, even though we knew about that by then, I'm sure we did, though I don't think I'd heard Billie Holiday sing "Strange Fruit," about all those black bodies swinging in the Southern trees. At any rate, I didn't like Billie Holiday for a long time: her voice didn't make sense to me, nor did those black bodies, nothing so terrible was ever going to happen to me in Brooklyn, where I was considered cute and knew I would live forever. The world was going to love me forever. Whites and blacks. I could make them love me, just as Vivien

Leigh made so many men fall in love with her before the fall of Atlanta, in a movie that came out around the time Billie Holiday was singing "Strange Fruit," and perhaps that's an interesting thing to try now, watching *GWTW* to the sound of Billie Holiday singing "Strange Fruit." See her black bodies and weariness smeared all over Vivien Leigh's beautiful face, and Hattie McDaniel's (at times) ridiculous one.

Sitting in the movie theatre, watching *GWTW* for the first time, I was in love with Vivien Leigh and not all those niggers, the most hateful among them being a brown-faced, oily-skinned carpetbagger who looks at our Vivien Leigh with some kind of lust and disgust. I hated him then because he intruded on the beautiful pink world. Leigh's girlishness could have smothered me; I would have made her forget that I was colored and that she could lynch me if she wanted to because I knew I could make her love me. But how do you get people to ignore their history? I never thought of those things when I had love on my mind.

In the middle of the movie, Vivien Leigh as Scarlett suffers, and says she will never suffer again, and I loved her so much I didn't want her to suffer. As I grew up, I retained that feeling toward women who looked like my first movie star love: I didn't want them to suffer, even though they, like Vivien Leigh as Scarlett, could lynch a nigger to pay for all their hardship: God didn't make people of her class and wealth and race to suffer. For sure, Scarlett, in real life, might have lynched a nigger in order to make that person pay for all the inexplicable pain she had gone through and eventually come out the other side of, a much better person. After that, her world might have looked completely different.

Killer of Jack Daw

Aug. 3, 1935

Vengence in Siskiyou County

1. *The lynching of Clyde Johnson. August 3, 1935, Yreka, California.*

2. *Lynching. Circa 1905, location unknown.*

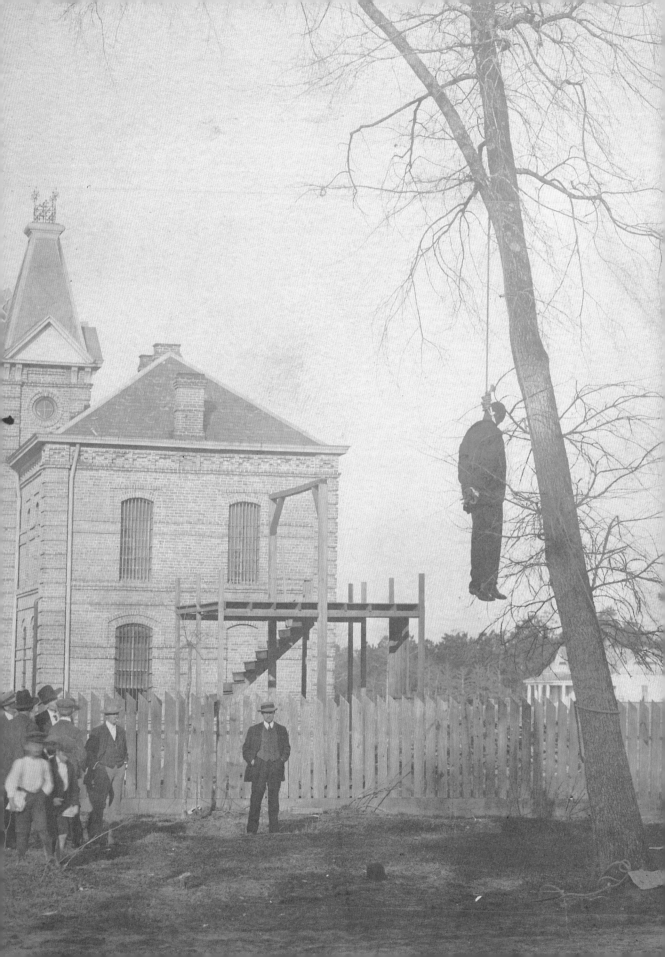

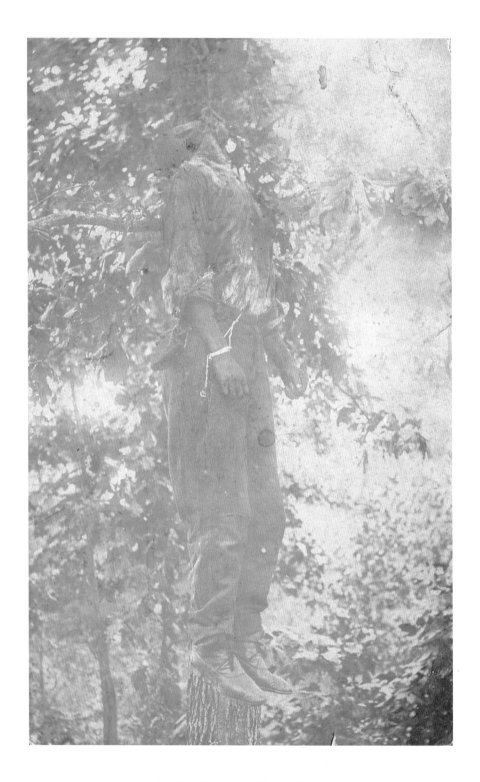

3. *Lynching. Circa 1905, Trenton, Georgia.*

4. Right, *The lynching of Bennie Simmons. June 13, 1913, Anadarko, Oklahoma.*

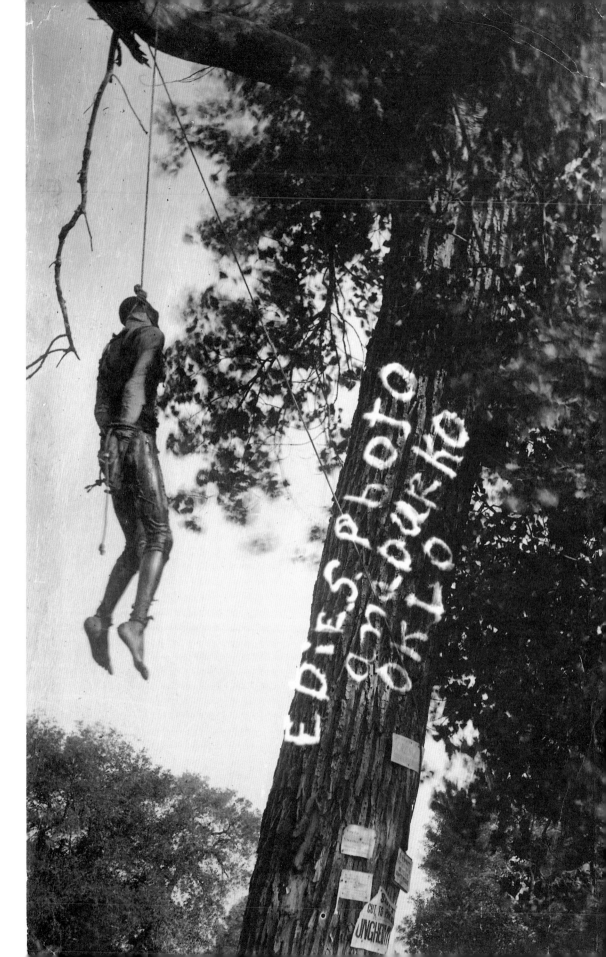

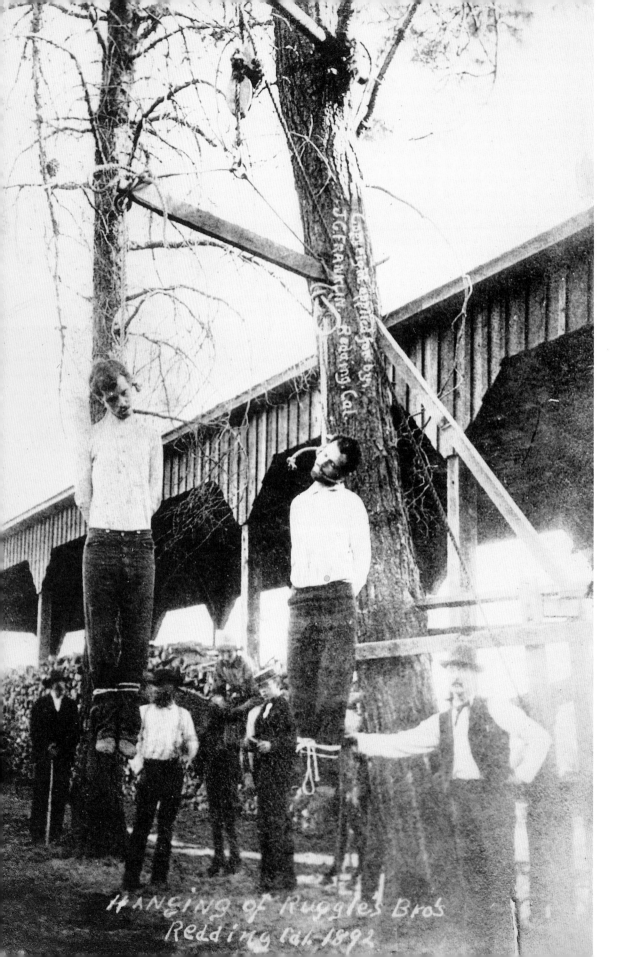

Copyright applied for by J.C. FRANKLIN Redding, Cal.

HANGING of Ruggles Bros
Redding Cal 1892

5. *The lynching of John D. and Charles Ruggles. July 24, 1892, Redding, California.*

6. Following pages, *Lynching. Circa 1910, location unknown.*

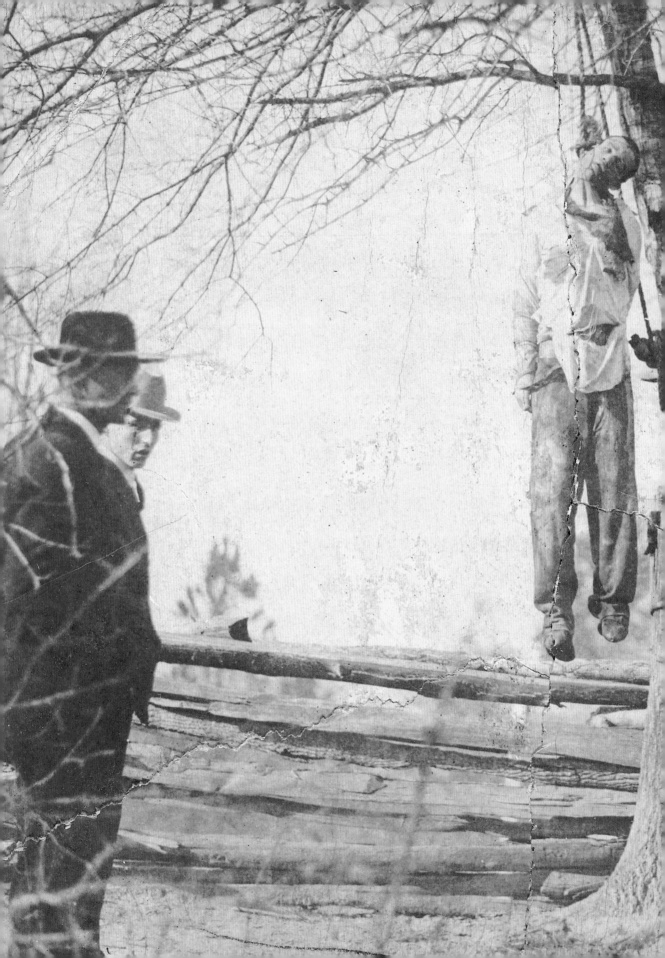

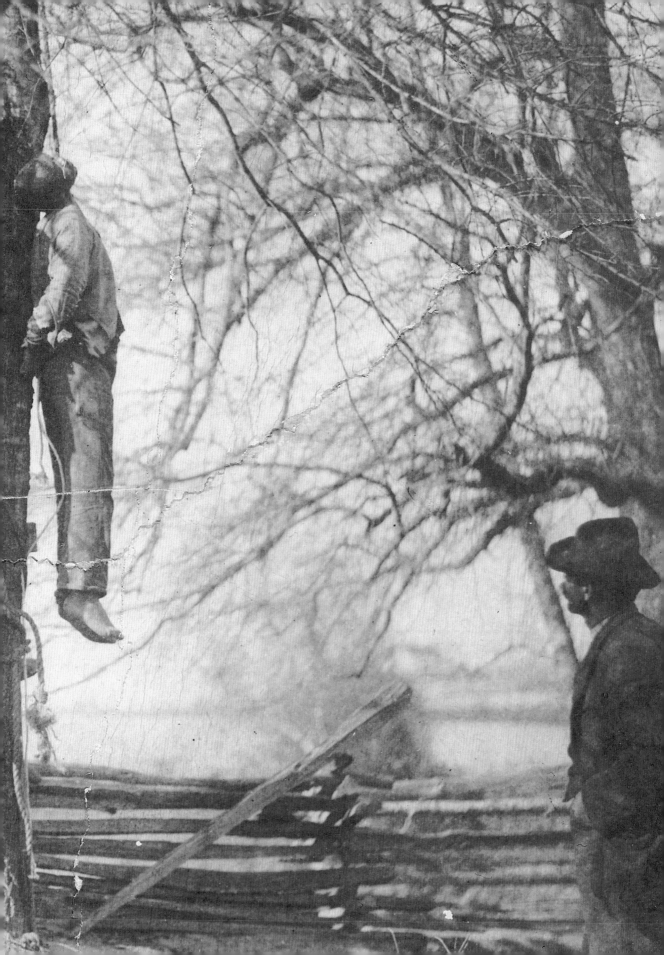

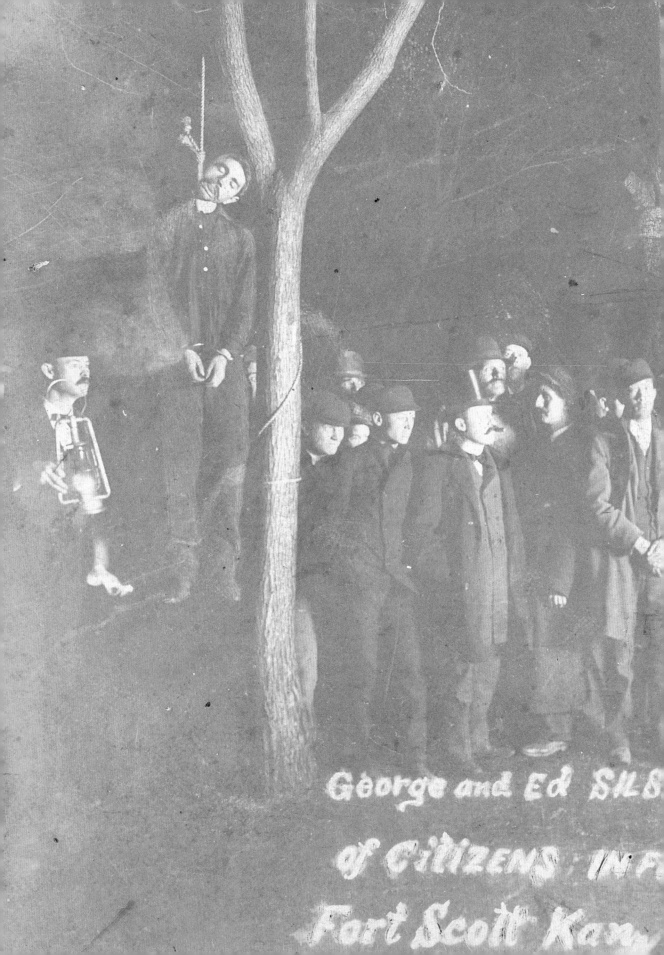

George and Ed SILS

of CITIZENS IN F

Fort Scott Kan.

HANGED BY A MOB

NT OF JAIL ... 20 1900

Fast Light By Dukes

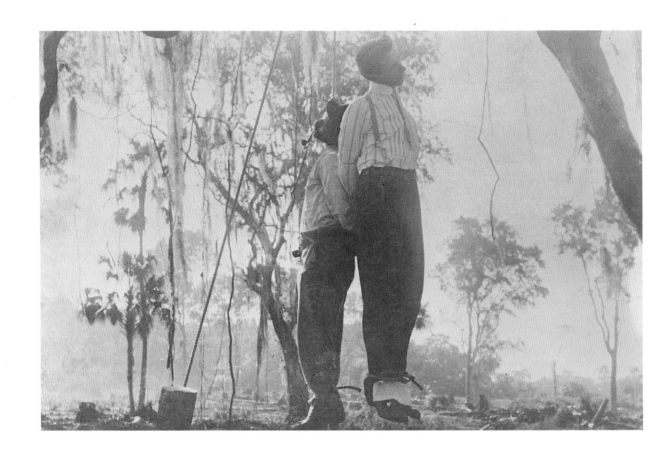

7. Preceding pages, *The lynching of George and Ed Silsbee.*
January 20, 1900, Fort Scott, Kansas.

8. and 9. *The lynching of Castenego Ficcarotta and Angelo Albano.*
September 20, 1910, Florida.

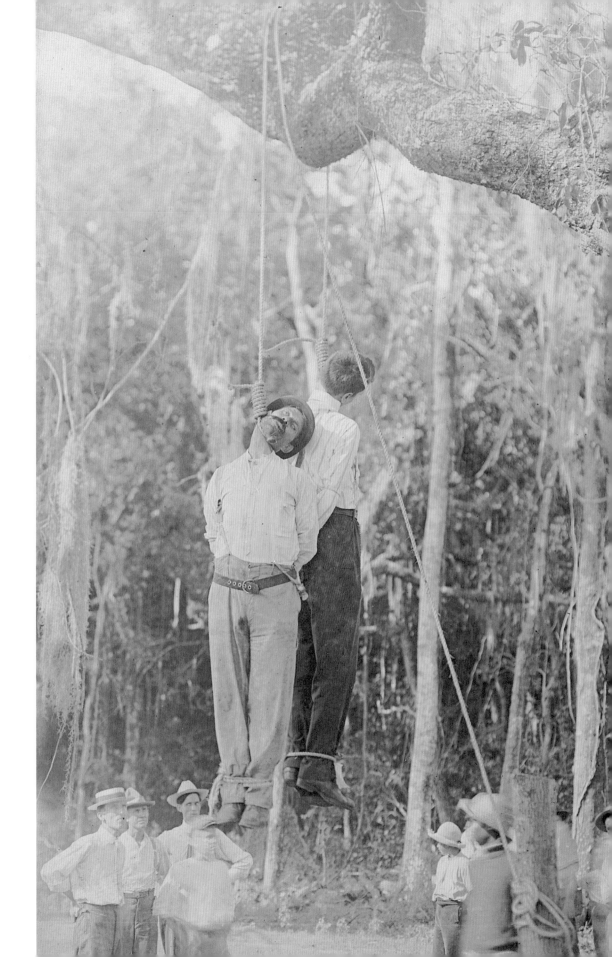

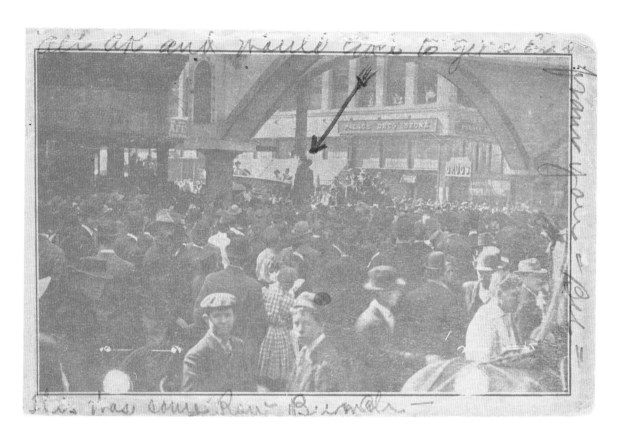

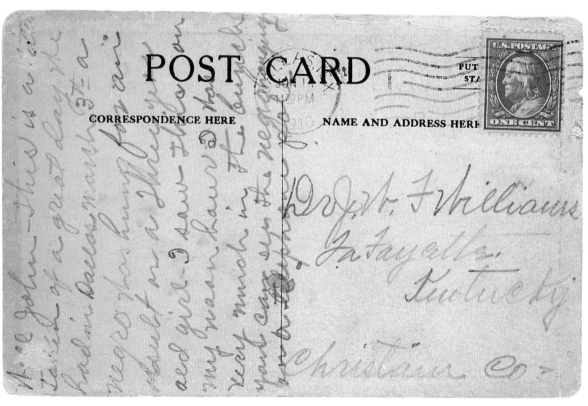

10. and 11. *The lynching of Allen Brooks. March 3, 1910, Dallas, Texas.*
(postcard, front and back)

12. *The lynching of Nease Gillespie, John Gillespie and Jack Dillingham.*
August 6, 1906, Sailsbury, North Carolina.

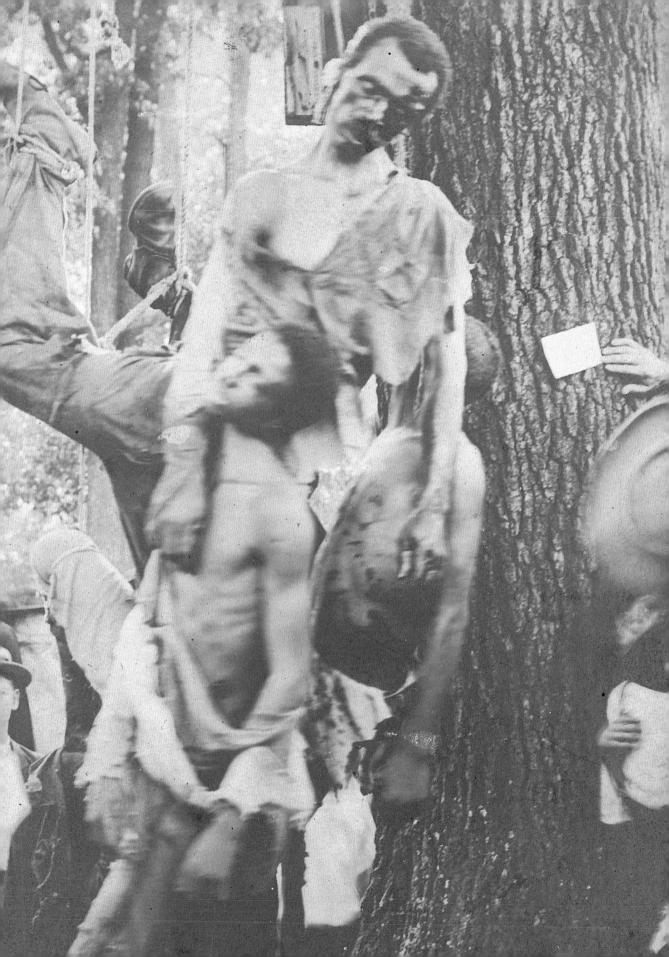

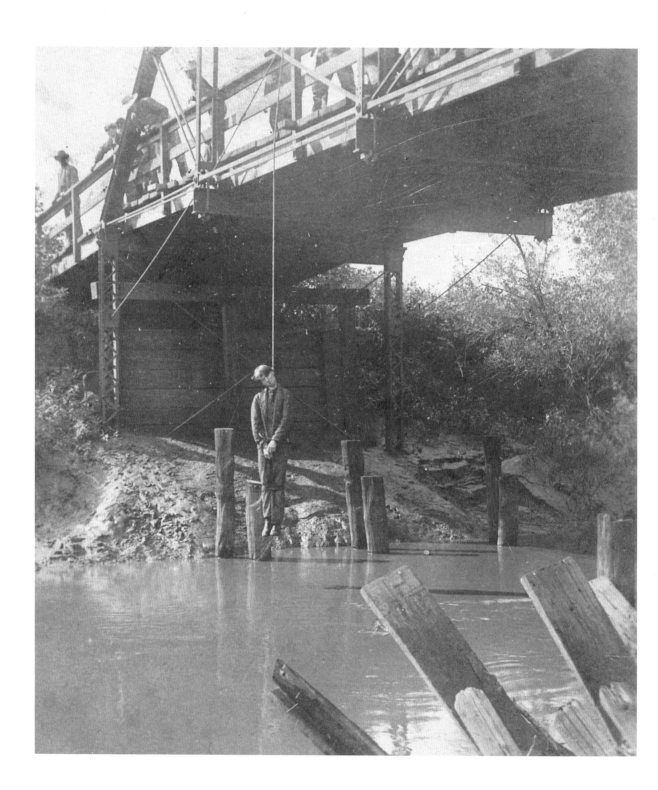

13. *Lynching. Circa 1910, location unknown.*

14. *Lynching. Circa 1908, location unknown.*

15. Following pages, *Posse and unidentified victim. Circa 1900, location unknown.*

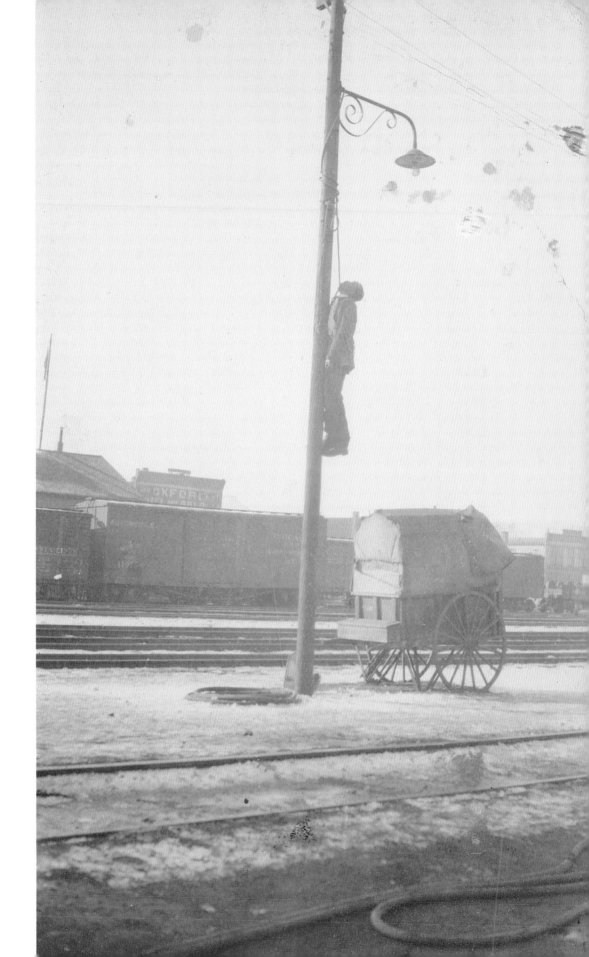

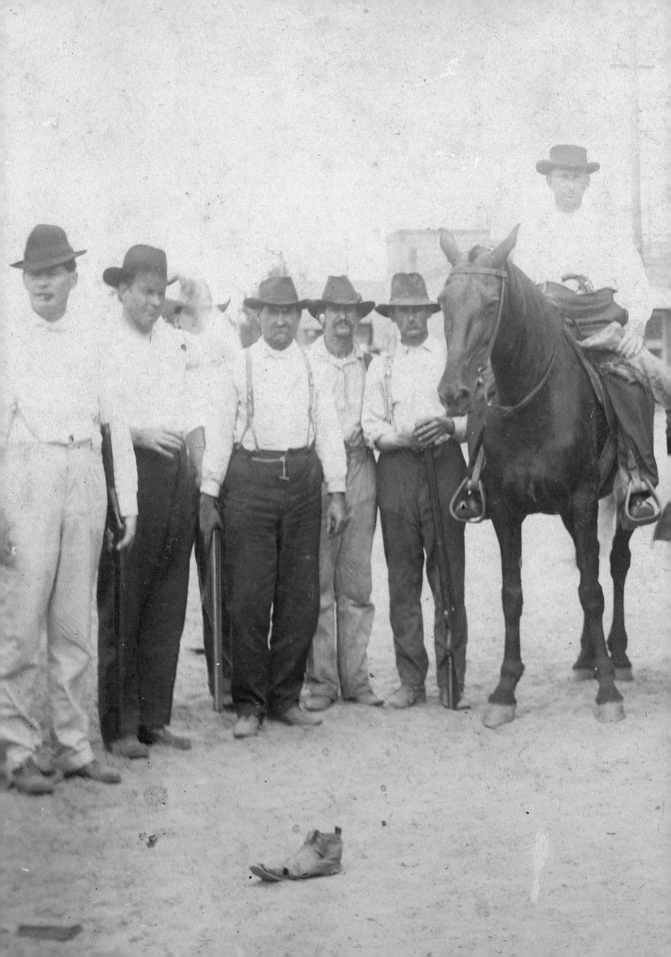

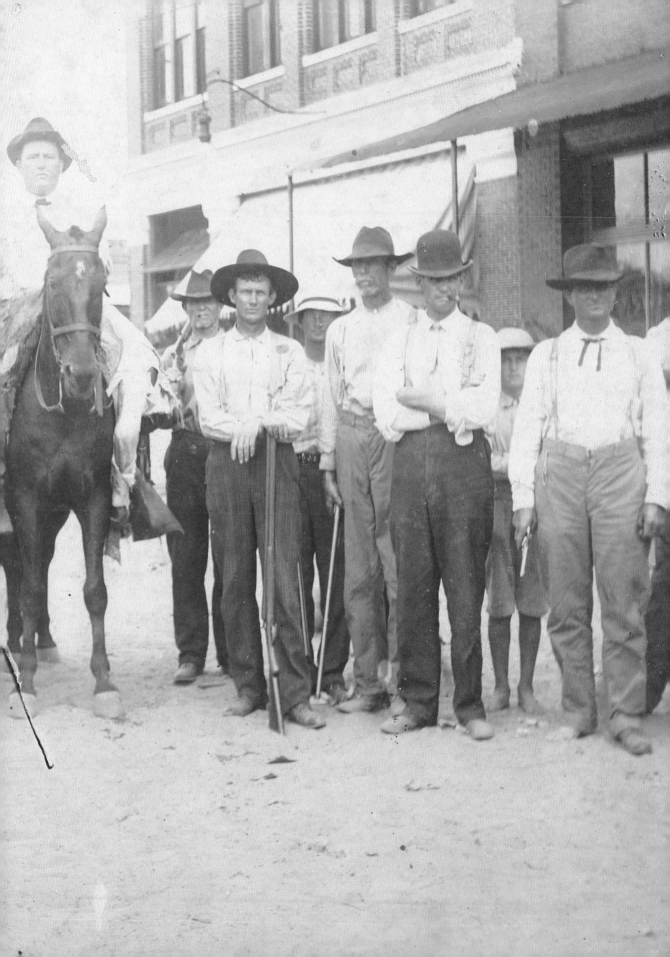

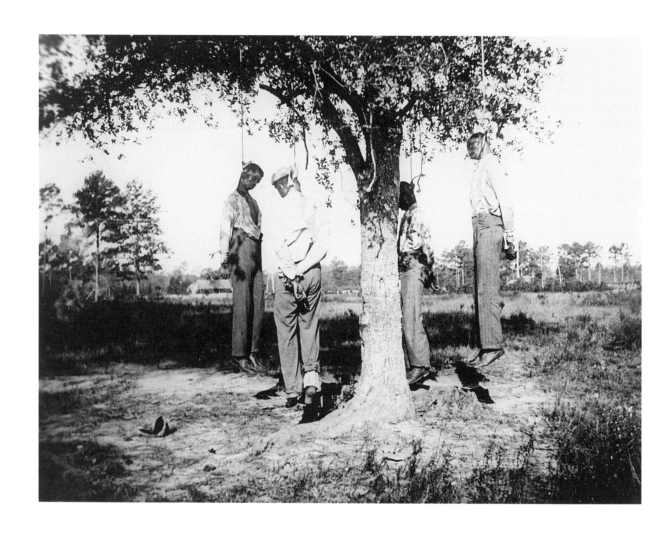

16. *The lynching of four unidentified African Americans. Circa 1900, location unknown.*

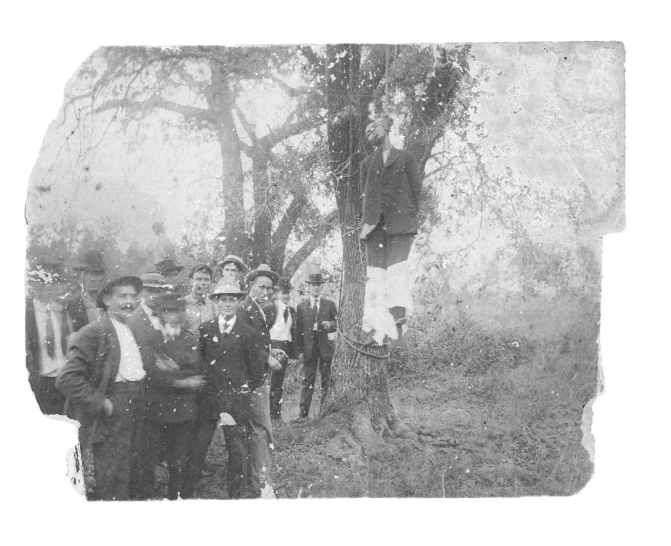

17. *The lynching of Dick Robinson and a man named Thompson.*
October 6, 1906, Pritchard Station, Alabama.

18. Following pages, *The burning of John Lee. August 13, 1911, Durant, Oklahoma.*

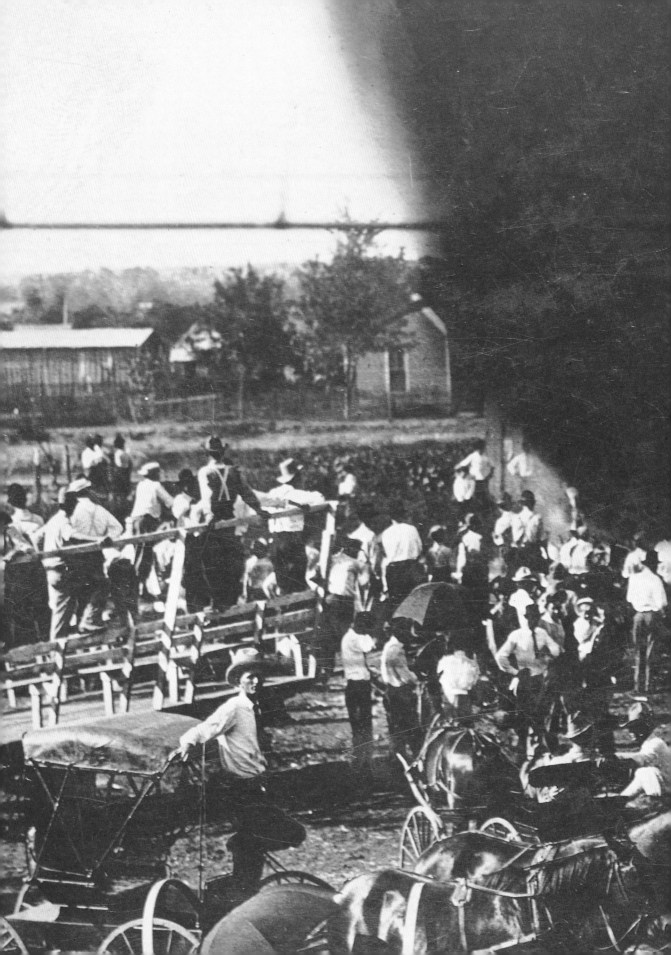

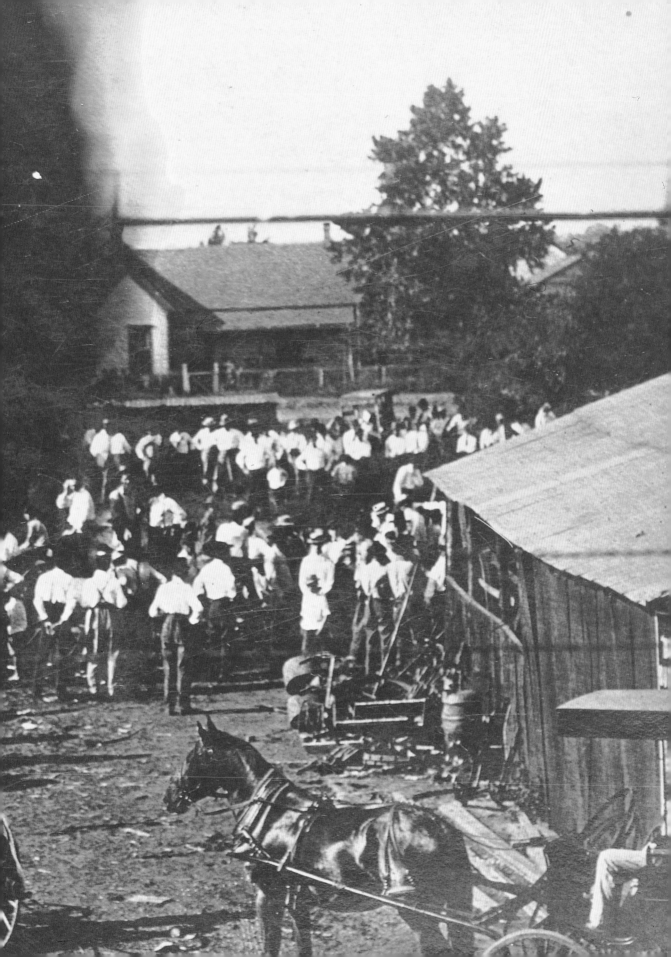

19. *The lynching of David Jackson, December 14, 1961, McDuffie County, Georgia.*

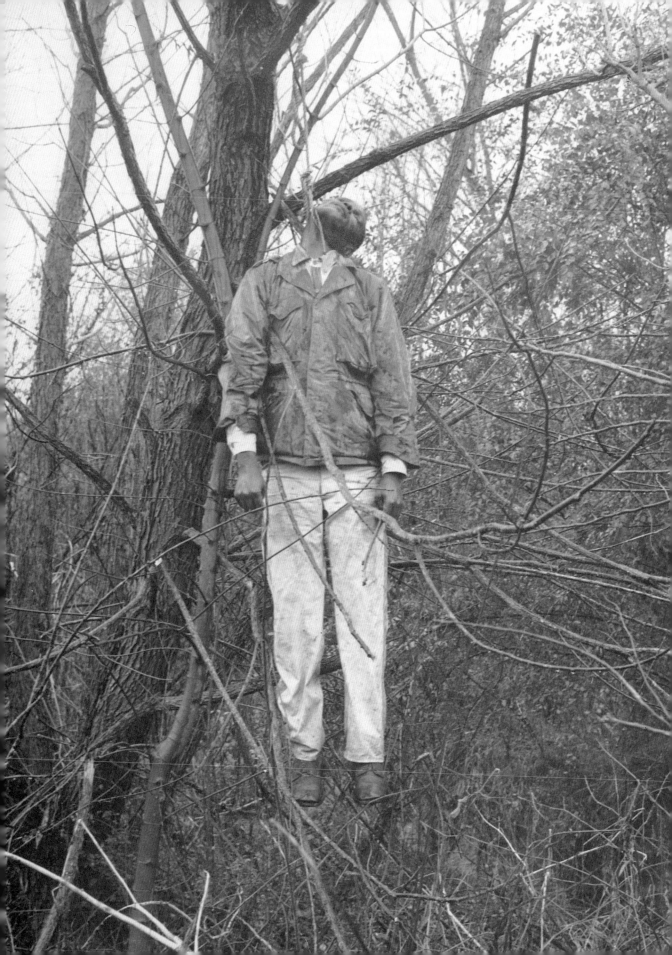

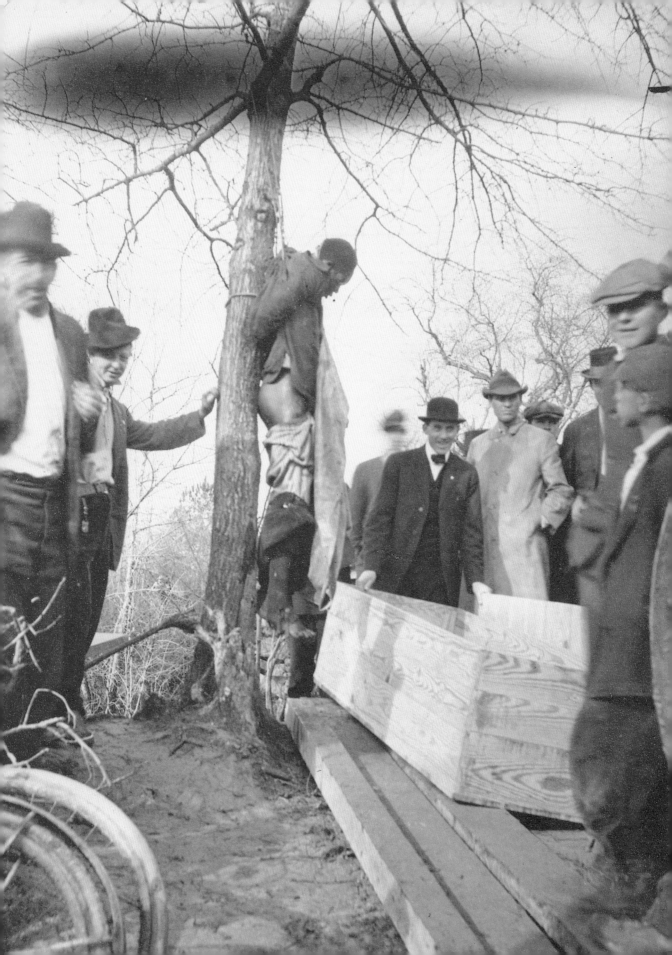

20. *The lynching of John Richards. January 12, 1916, Goldsboro, North Carolina.*

21. Following pages, *Lynching postcard. Date and location unknown.*

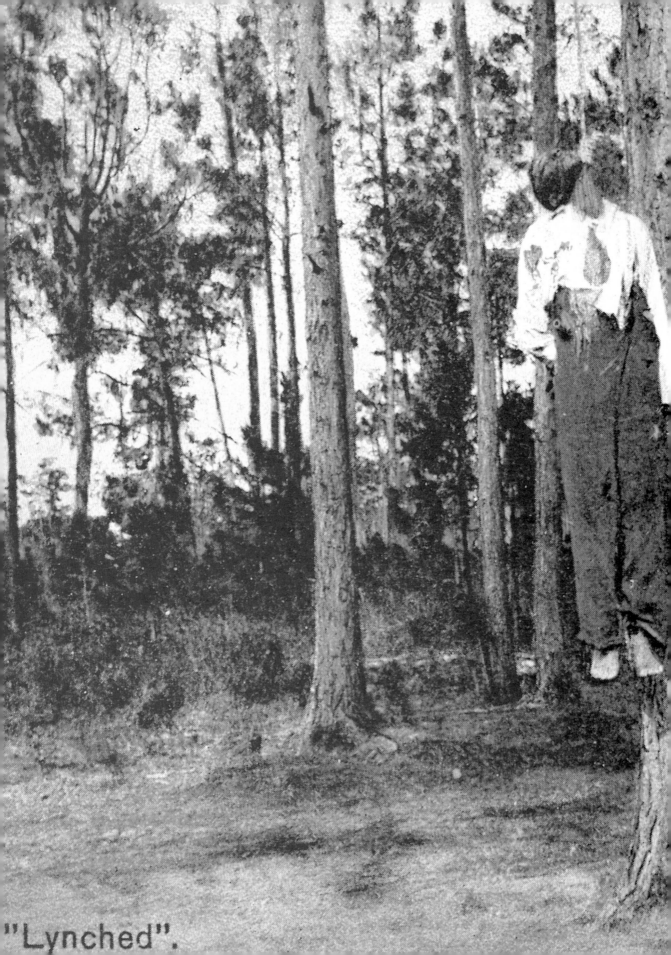

"Lynched".

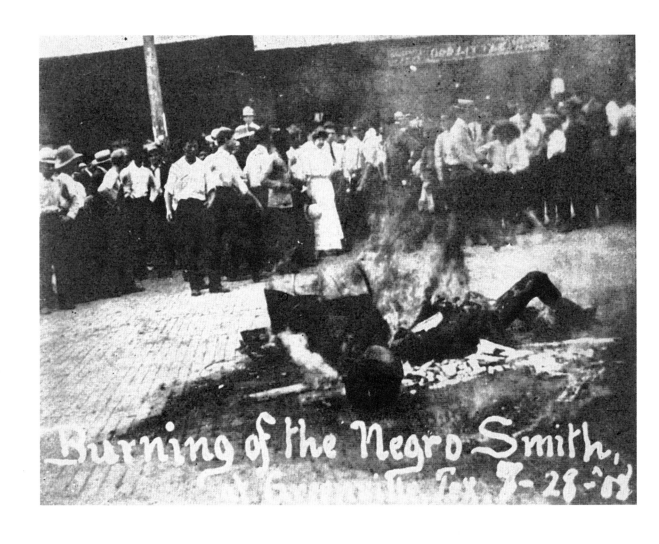

Burning of the Negro Smith, at Greenville, Tx. 7-28-'08

22. *The burning of Ted Smith. July 28, 1908, Greenville, Texas.*

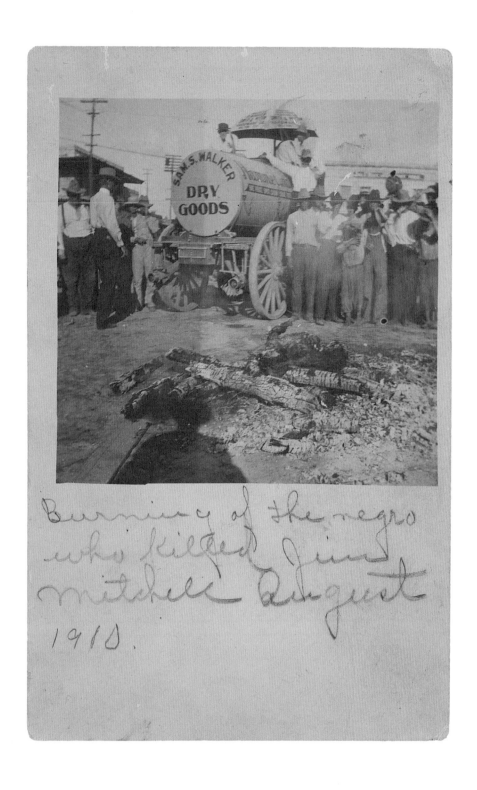

Burning of the negro who killed Jim Mitchell. August 1910.

23. *"Burning of the negro who killed Jim Mitchell." August, 1910, Texas.*

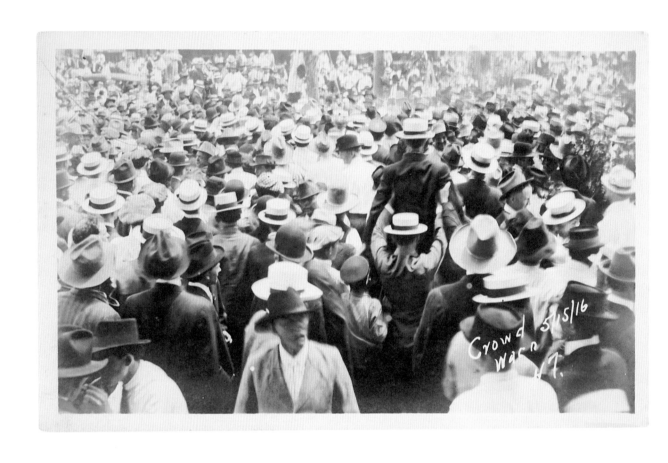

Crowd 5/15/16
Waco
WT.

24. *Spectators at the lynching of Jesse Washington. May 16, 1916, Waco, Texas.*

25. and 26. Right, *Burnt corpse of William Stanley. August, 1915, Temple, Texas.*

(postcard, front and back)

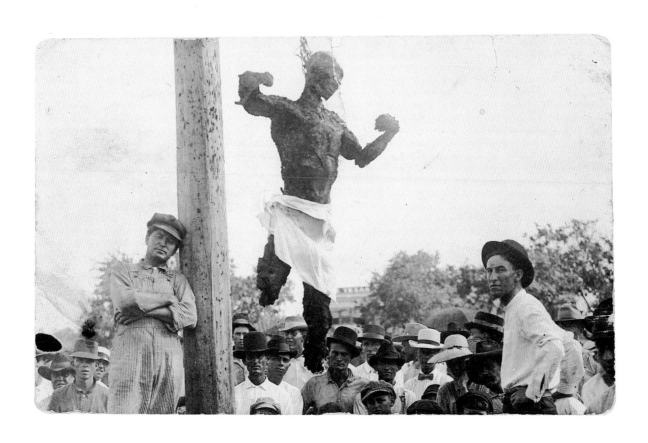

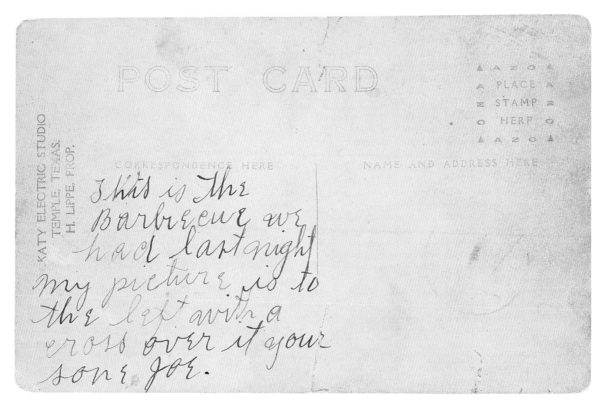

POST CARD

A A Z O A
A PLACE A
Z STAMP Z
O HERE O
A A Z O A

CORRESPONDENCE HERE

NAME AND ADDRESS HERE

This is The
Barbecue we
had last night
my picture is to
the left with a
cross over it your
son Joe.

27. *Lynching. Circa 1900, location unknown.*

LYNCHING

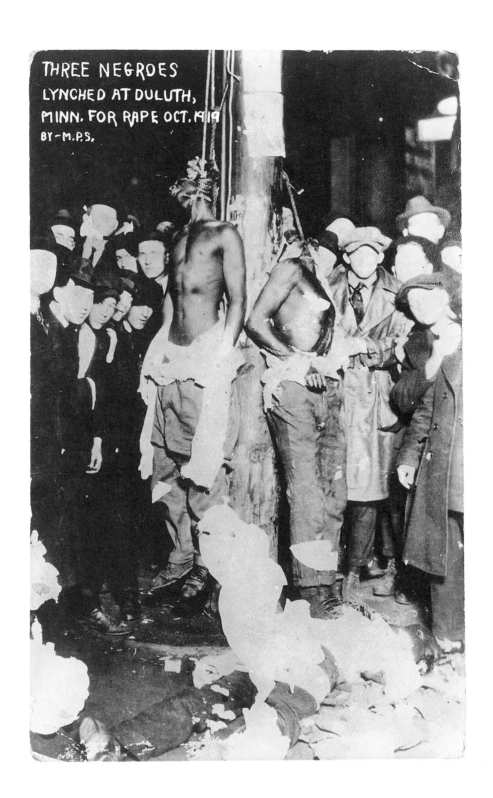

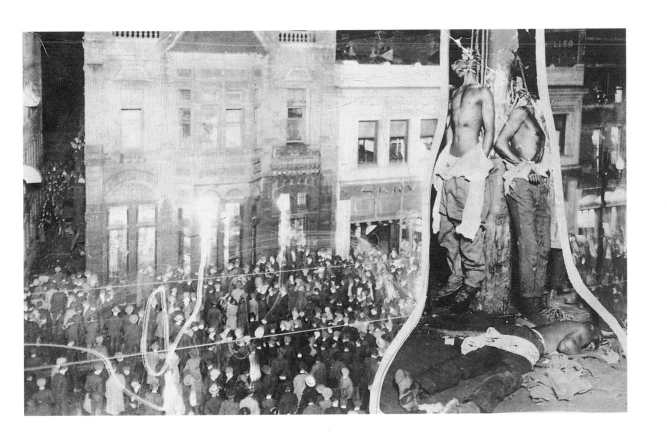

28. 29. 30. Left, above and following pages.
The lynching of Elias Clayton, Elmer Jackson, and Isaac McGhie.
June 15, 1920, Duluth, Minnesota.

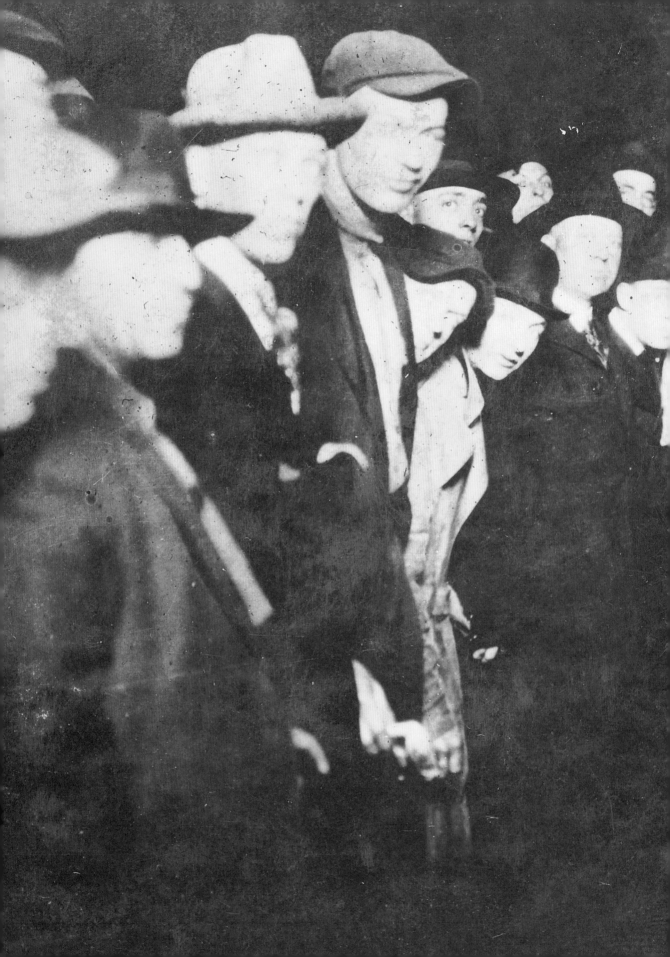

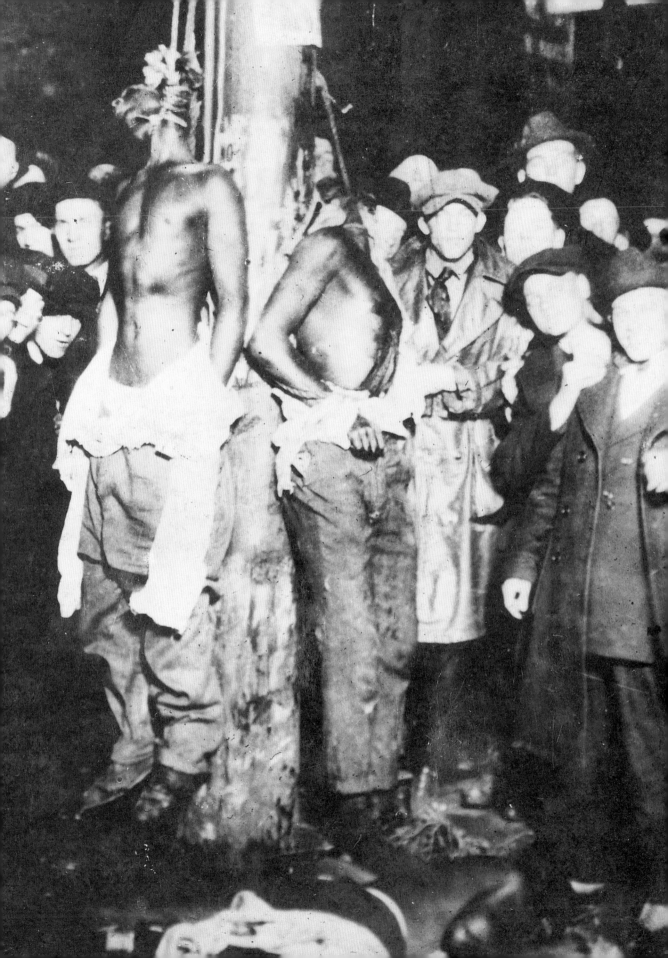

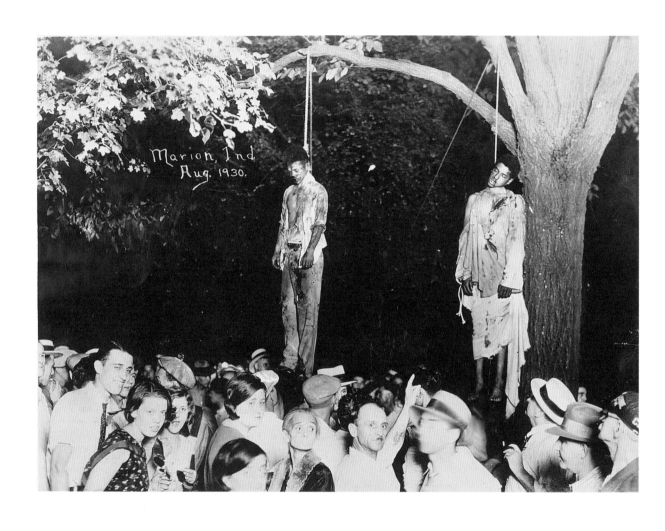

31. *The lynching of Thomas Shipp and Abram Smith.*
August 7, 1930, Marion, Indiana.

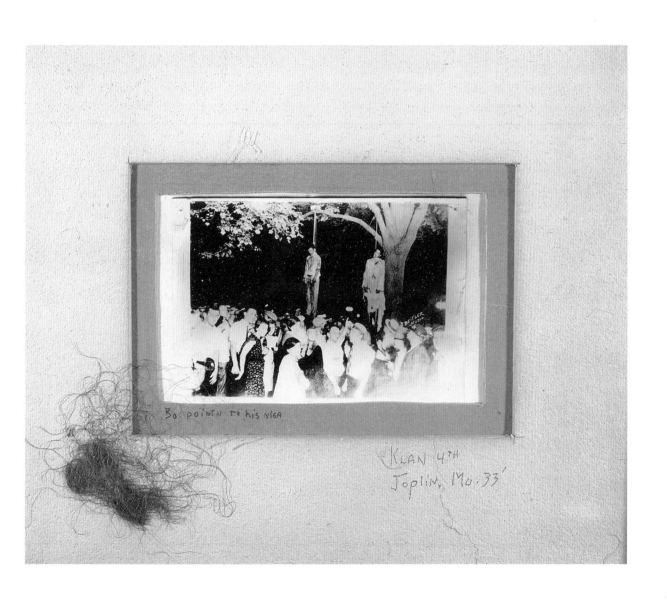

32. *The lynching of Thomas Shipp and Abram Smith.*
August 7, 1930, Marion, Indiana. (framed photograph with victim's hair)

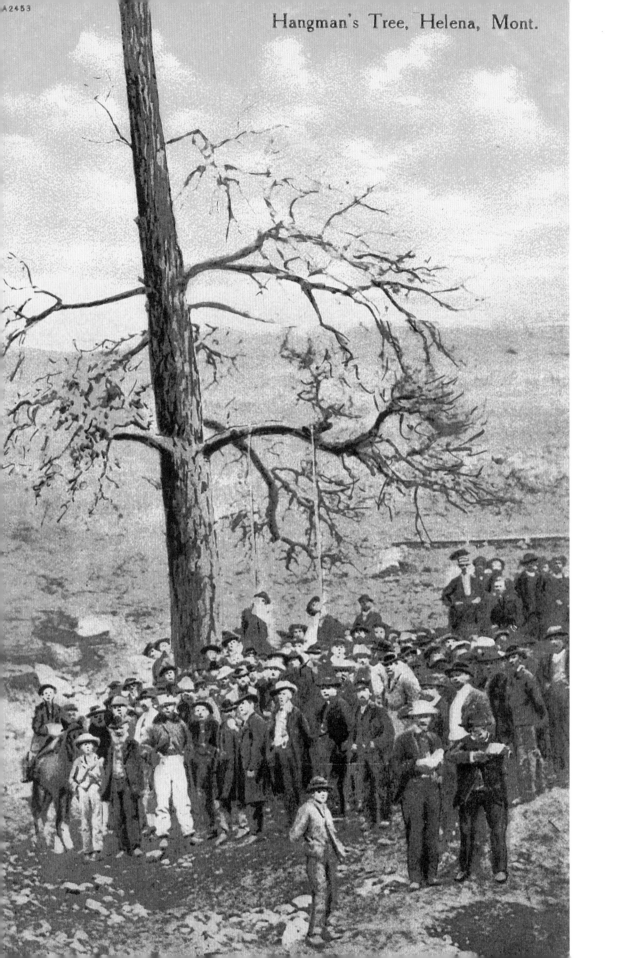

A2453

Hangman's Tree, Helena, Mont.

33. *The lynching of J. L. Compton and Joseph Wilson.*
April 30, 1870, Helena, Montana.

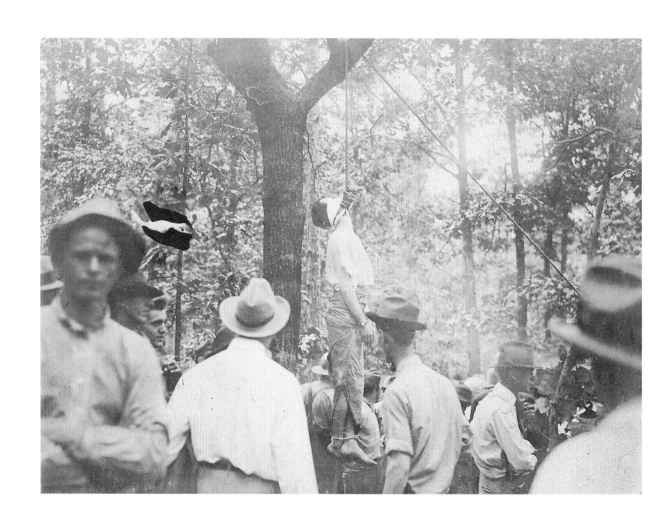

34. and 35. *The lynching of Leo Frank. August 17, 1915, Marietta, Georgia.*

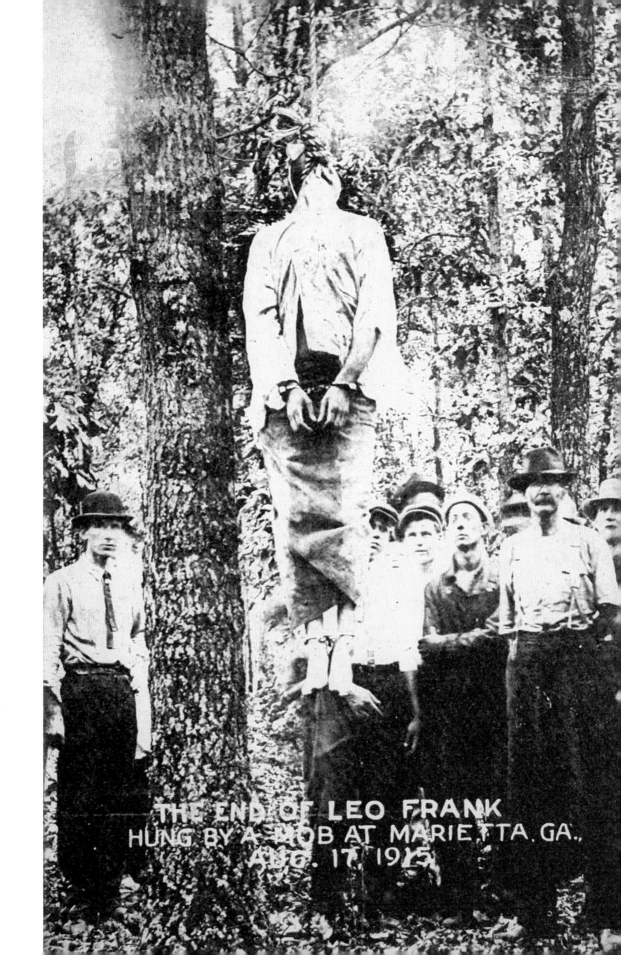

THE END OF LEO FRANK
HUNG BY A MOB AT MARIETTA, GA.,
AUG. 17, 1915

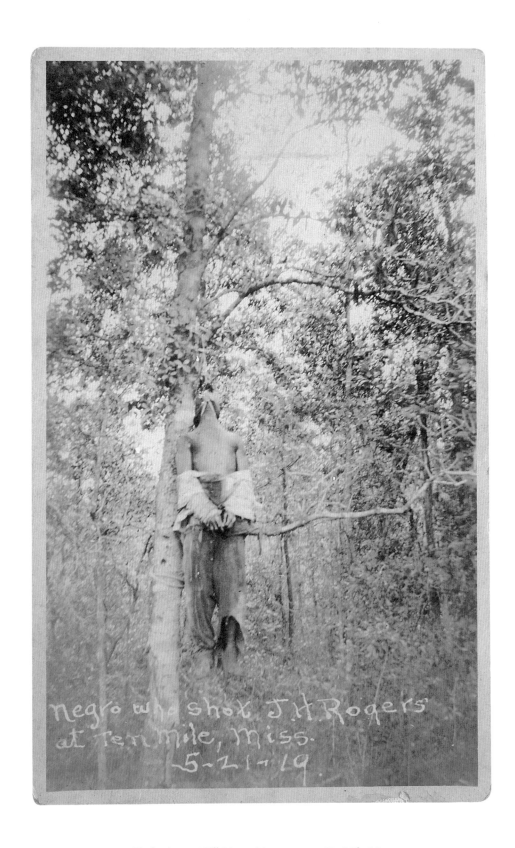

negro who shot J. H. Rogers
at Ten Mile, Miss.
5-21-19

36. *The lynching of Will Moore. May 20, 1919, Ten Mile, Mississippi.*

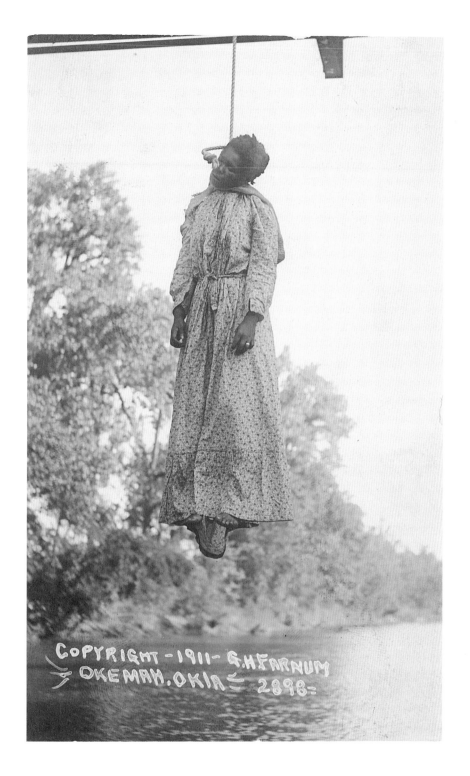

37. *The lynching of Laura Nelson. May 25, 1911, Okemah, Oklahoma.*

38. Following pages, *The lynching of Laura Nelson and her son.*
May 25, 1911, Okemah, Oklahoma.

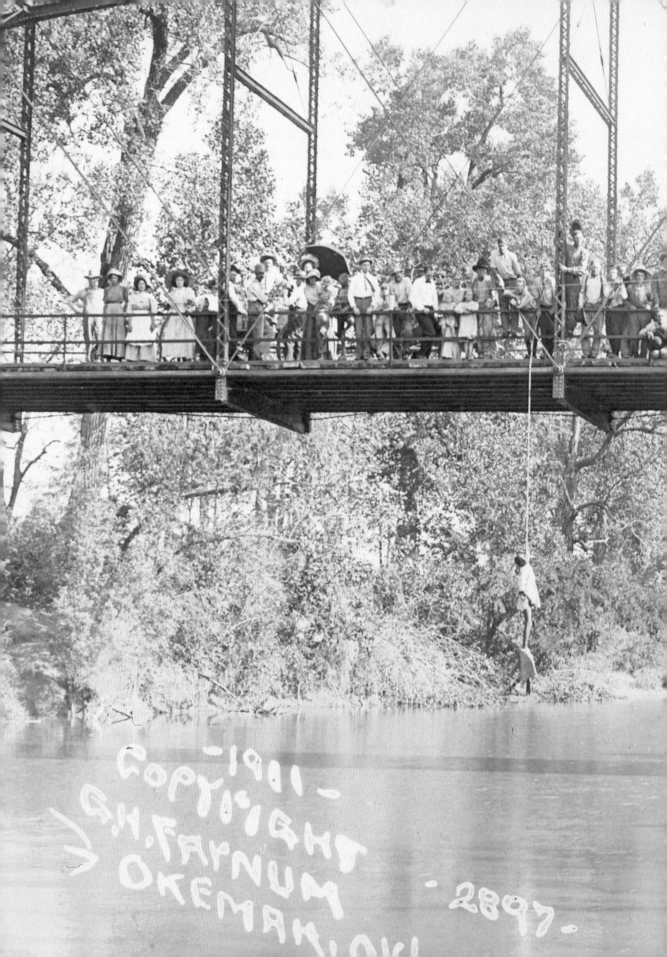

-1901-
COPYRIGHT
G.H.FARNUM
OKEMAH.OK
-2897-

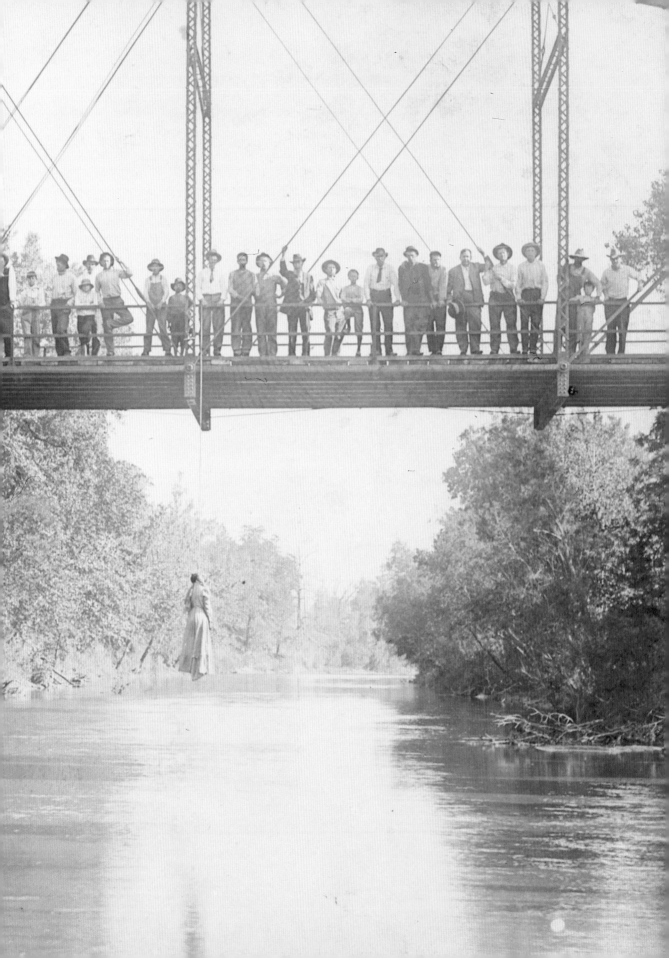

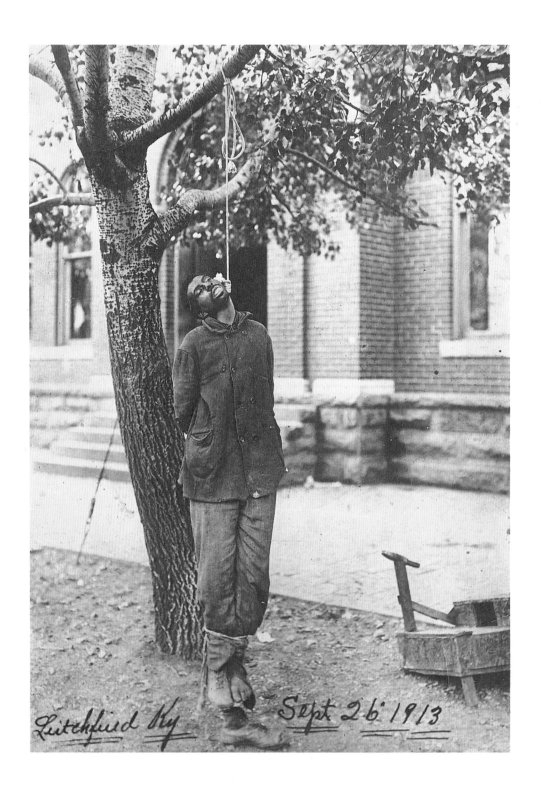

Leitchfield Ky Sept 26. 1913

39. *The lynching of Joseph Richardson. September 26, 1913, Leitchfield, Kentucky.*

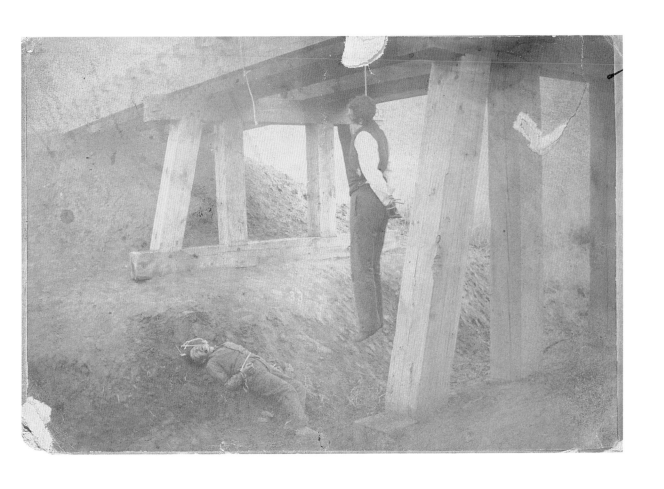

40. *The lynching of Fred Ingraham and James Green. April 3, 1883, Hastings, Nebraska.*

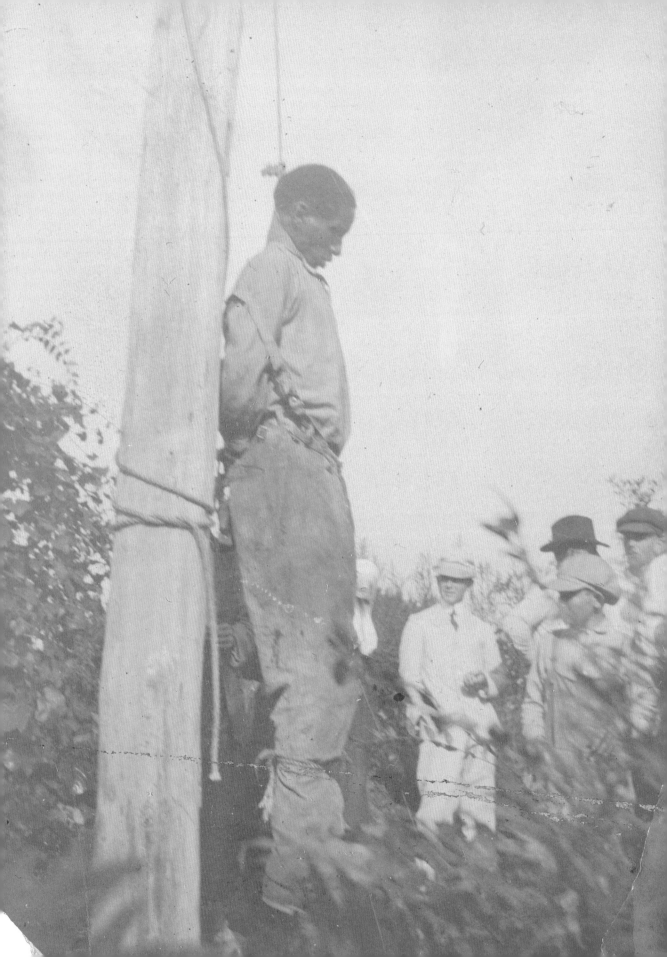

41. *Lynching. September 3, 1915, Alabama.*

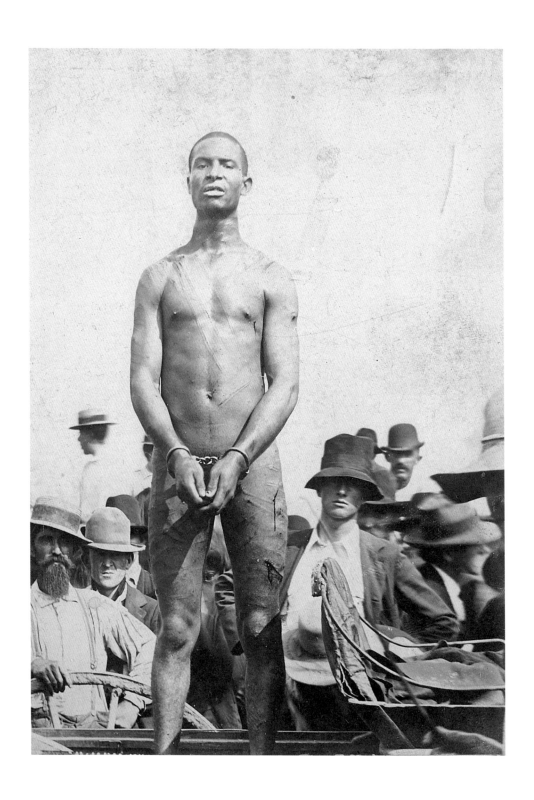

42. *The lynching of Frank Embree. July 22, 1899, Fayette, Missouri.*

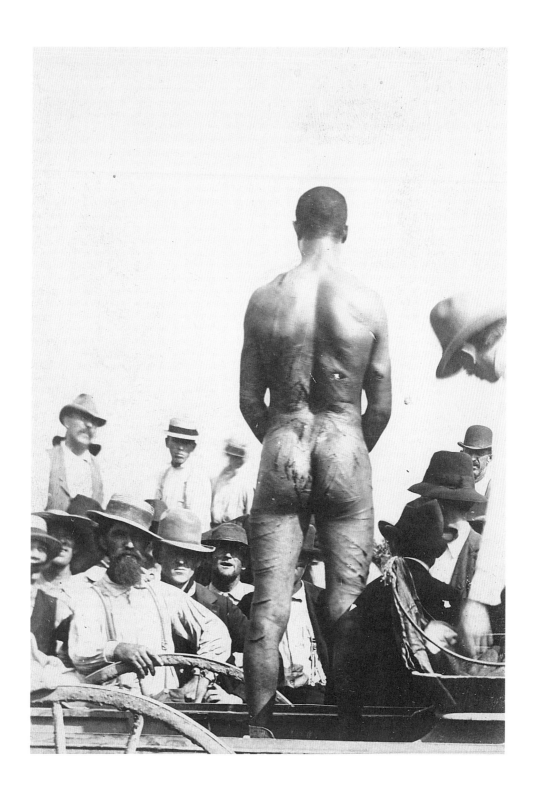

43. *The lynching of Frank Embree. July 22, 1899, Fayette, Missouri.*

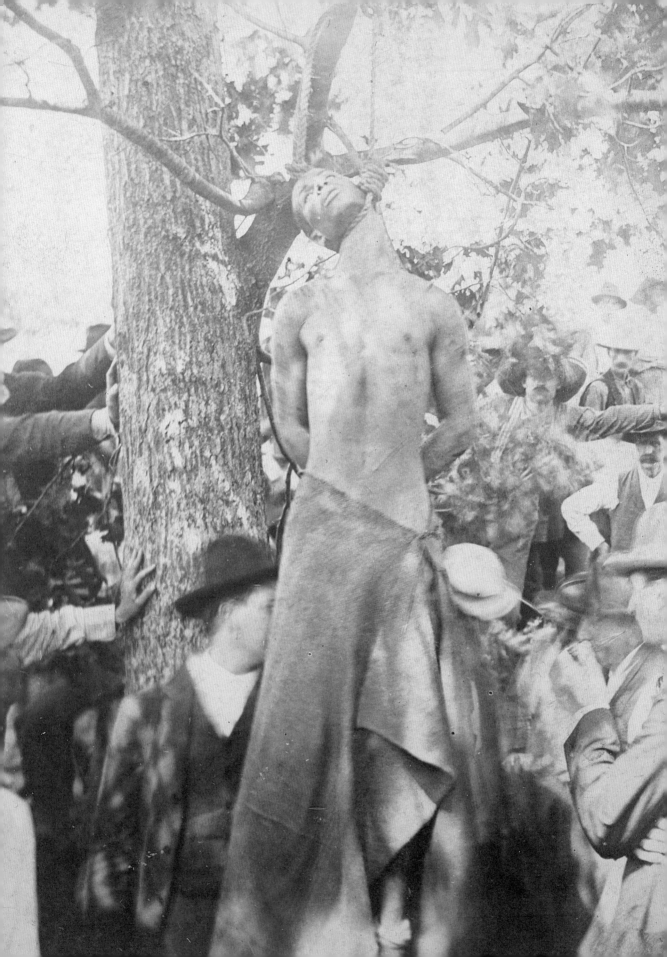

44. *The lynching of Frank Embree. July 22, 1899, Fayette, Missouri.*

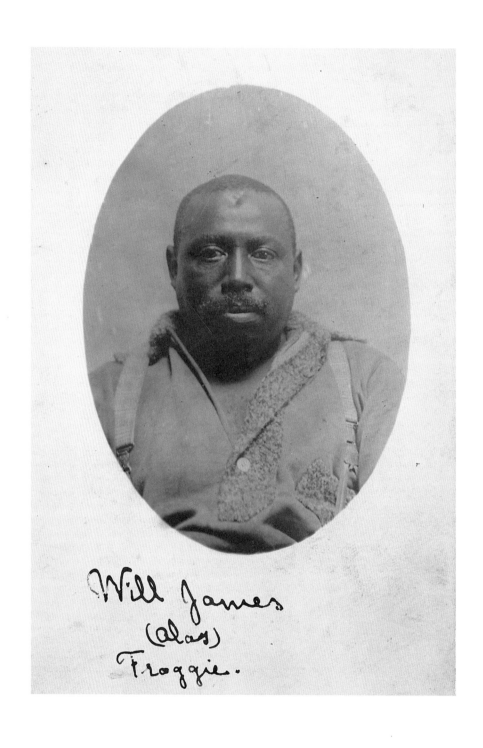

Will James

(alas)

Froggie.

45. Will James. Circa 1907, Cairo, Illinois.

46. Right, *"Half Burned Head of James."* November 11, 1909, Cairo, Illinois.

The text visible in the photograph reads:

LeBlock

Half Burned Head of James

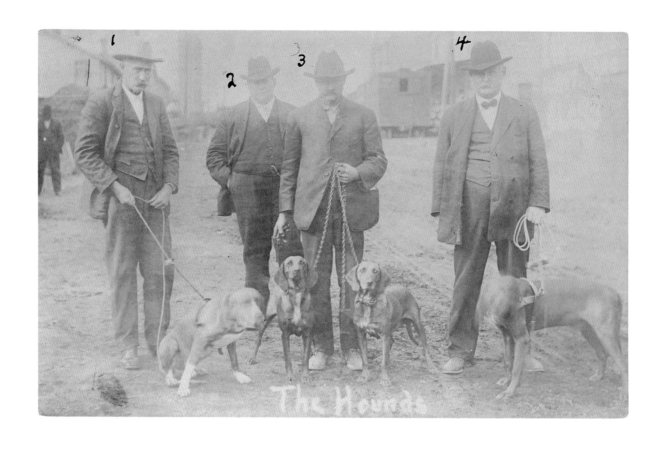

The Hounds

47. 48. 49. *The lynching of Will James. November 11, 1909, Cairo, Illinois.*
Above, *Law enforcement agents and bloodhounds.*
Right top, *View of Commercial Avenue.*
Bottom, *The lynching.*

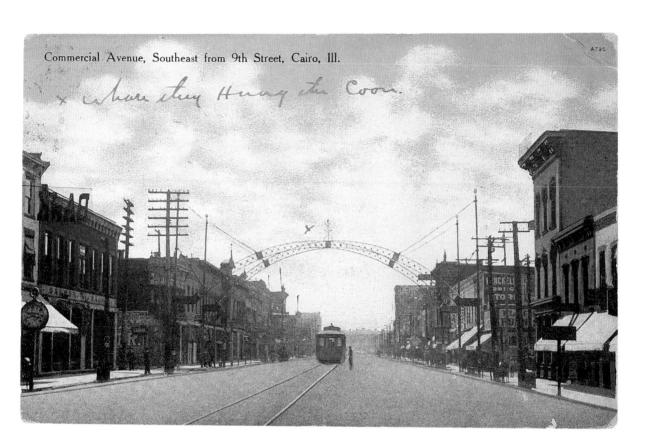

Commercial Avenue, Southeast from 9th Street, Cairo, Ill.

x where they Hung the Coon.

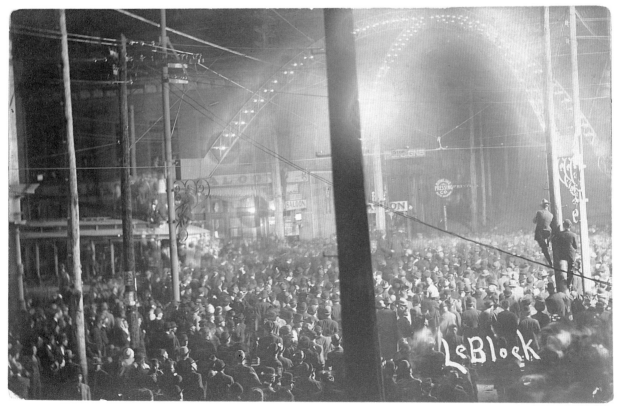

LeBlock

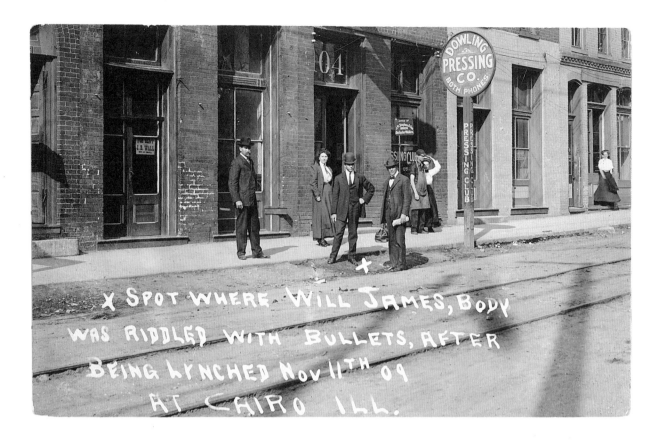

X SPOT WHERE WILL JAMES, BODY
WAS RIDDLED WITH BULLETS, AFTER
BEING LYNCHED NOV 11TH 09
AT CAIRO ILL.

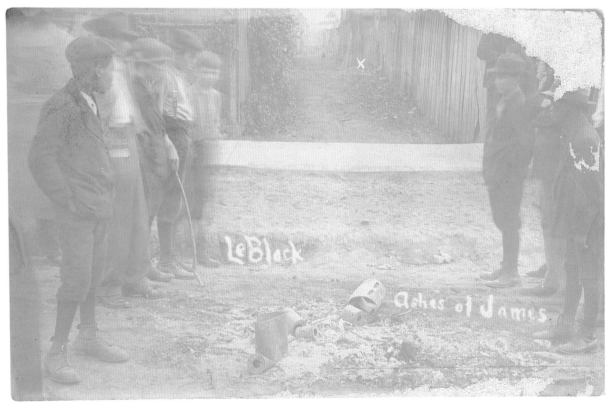

LeBlack

Ashes of James

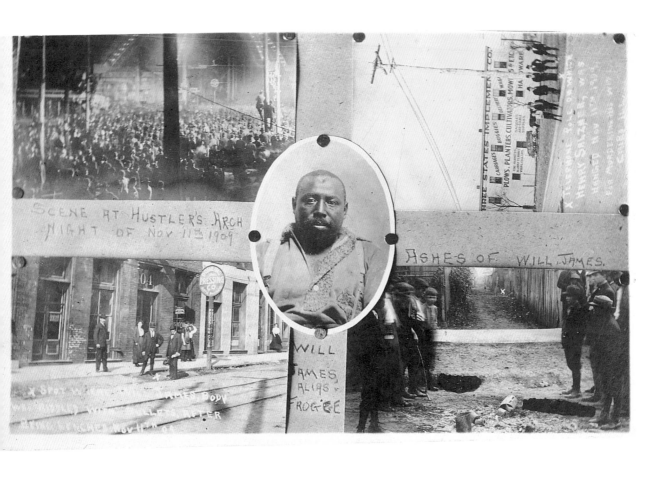

Text visible within composite photo:

SCENE AT HUSTLER'S ARCH
NIGHT OF NOV 11th 1909

ASHES OF WILL JAMES.

WILL JAMES ALIAS FROGGIE

50. 51. 52. *The lynching of Will James. November 11, 1909, Cairo, Illinois.*

Left top, *View of Commercial Avenue.*

Bottom, *The ashes of Will James.*

Above, *Composite photo, Portrait of Will James and scenes of his lynching.*

53. *The lynching of Garfield Burley and Curtis Brown.*
October 8, 1902, Newbern, Tennessee.

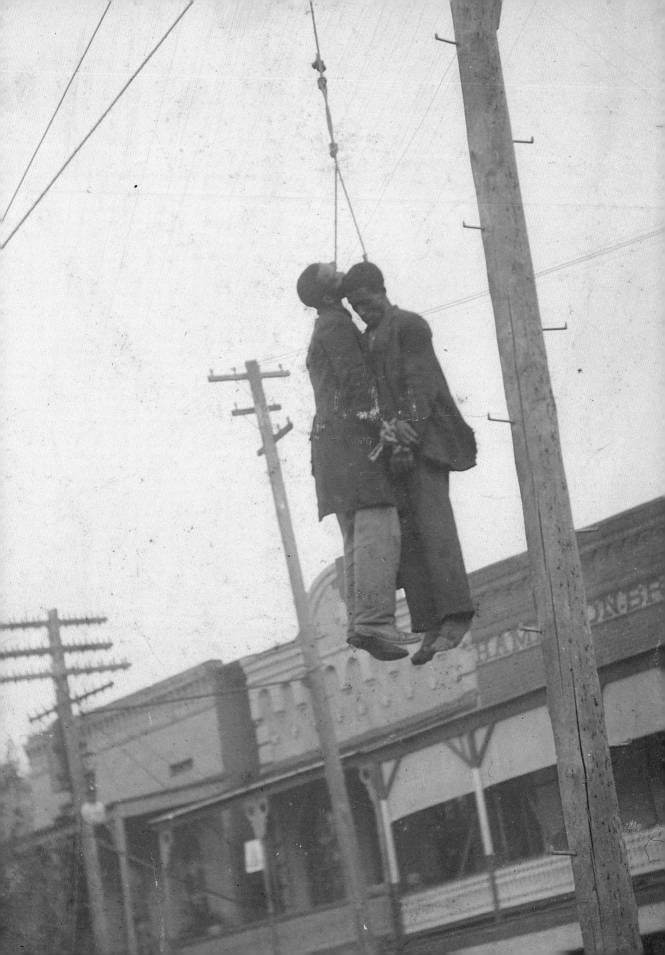

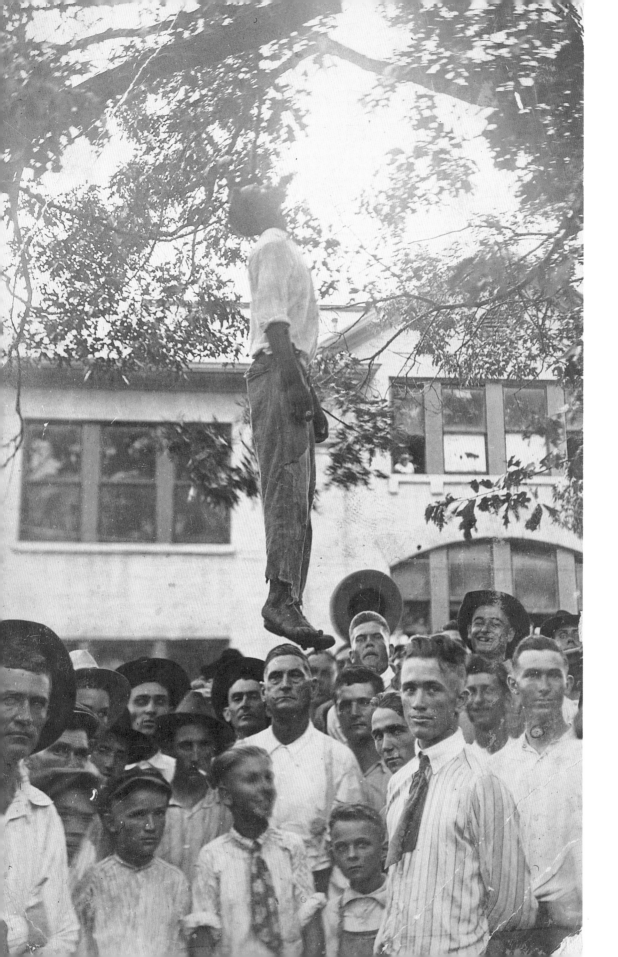

This was made in the court yard
in Center Texas

His a 16 Year Old Black Boy

He Killed Earl's Grandma
She was Florence's Mother.
Give this to Bud
 Frome
 aunt Myrtle

 XoXo

 DJH

54. and 55. *The lynching of Lige Daniels. August 3, 1920, Center, Texas.*
(postcard, front and back)

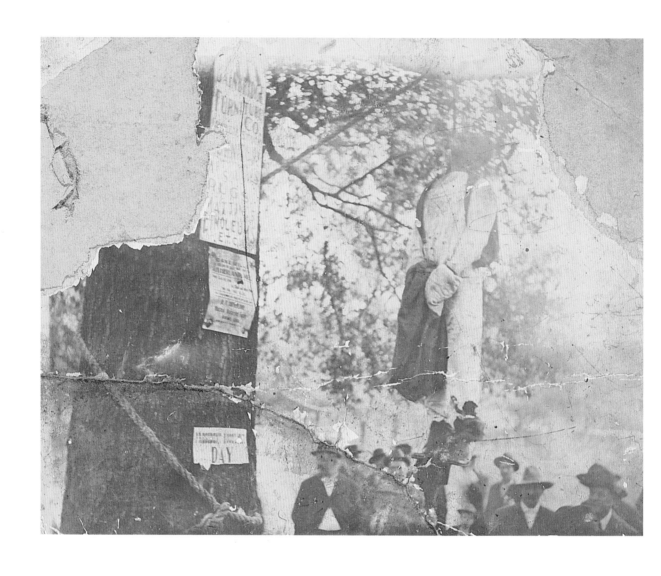

56. *The lynching of Augustus Goodman. November 4, 1905, Bainbridge, Georgia.*

57. Right, *The lynching of Rubin Stacy. July 19, 1935, Fort Lauderdale, Florida.*

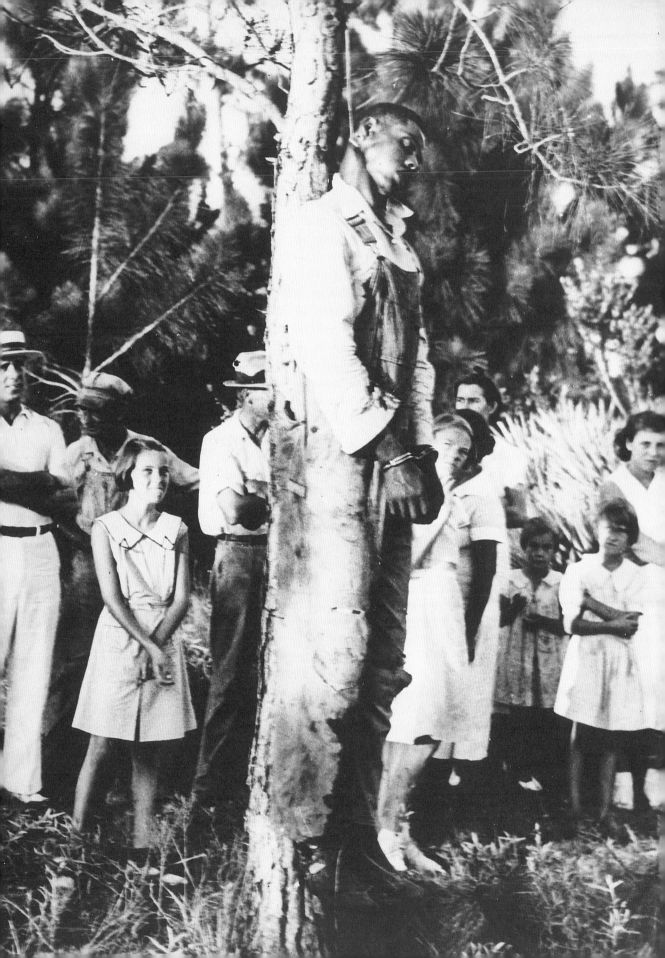

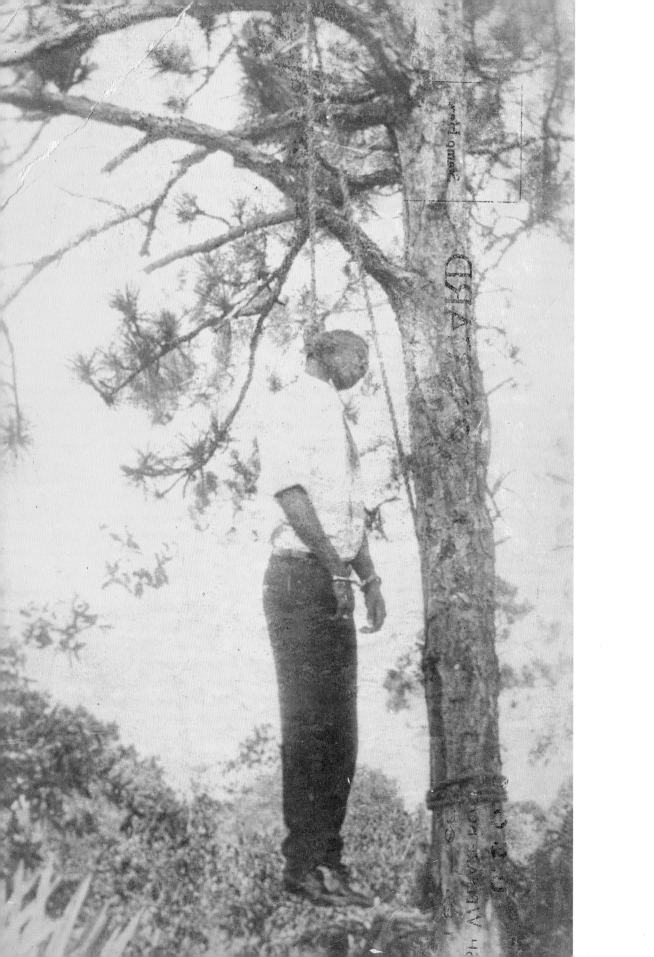

58. *The lynching of James Clark. July 11, 1926, Eau Gallie, Florida.*

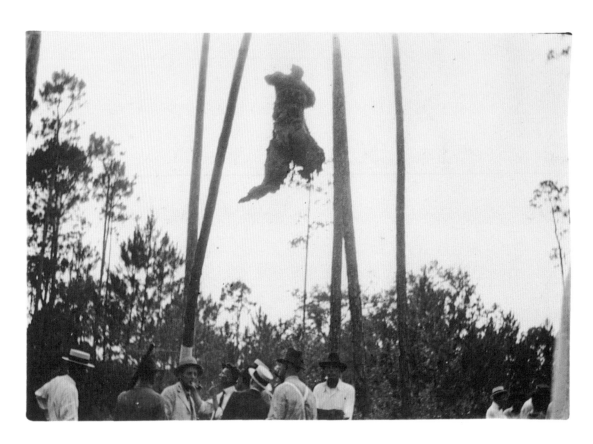

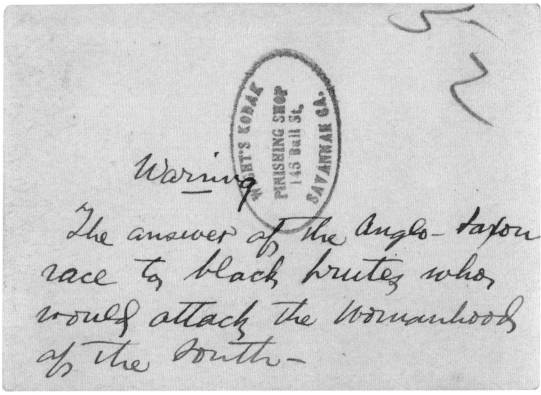

WRIGHT'S KODAK
FINISHING SHOP
145 Bull St.
SAVANNAH GA.

Warning

The answer of the Anglo-Saxon
race to black brutes who
would attack the Womanhood
of the South—

 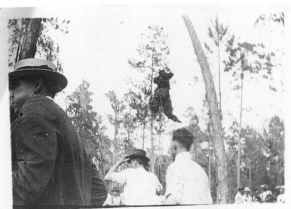

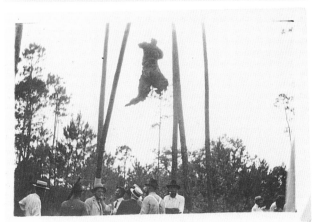 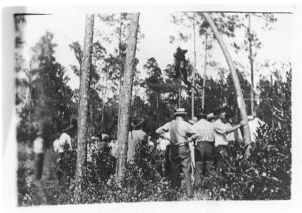

59. and 60. Left, *The charred torso of an African American male. 1902, Georgia.*
(*photograph, front and back*)

61. *Four photographs of the lynching of an unidentified African American male. 1902, Georgia.*

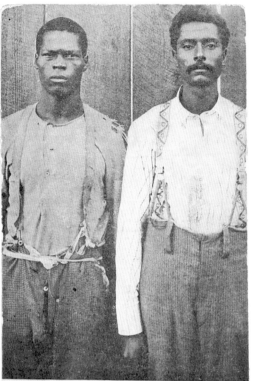

Paul Reed and Will Cato, who Murdered and Burned entire Hodges family of five, July 28, 1904, near Statesboro, Georgia
Copyright 1904 by T. M. Bennett.

Little Kittie Hodges, who offered Cato and Reed five cents, all she had, for her life and was refused.
Copyrighted 1904 by T. M. Bennett.

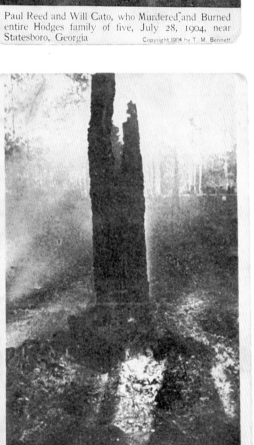

Thirty inmates after Cato and Reed were burned. Aug. 16th, 1904.

Talmage and Harmon, the Hodges infants who were burned alive in their home near Statesboro, Ga., July 28, 1904, by Cato and Reed.
Copyrighted 1904 by M. Bennett

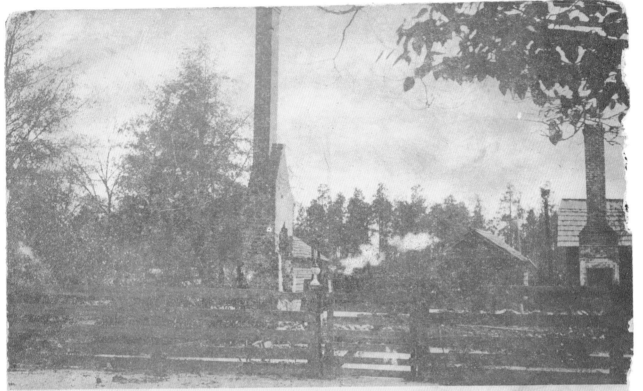

Hodges Home, near Statesboro, Georgia, day after whole family of five were murdered and burned by Reed and Cato. *Copyrighted 1904 by T. M. Bennett*

62. – 65. Left, *Four postcards from the Cato and Reed lynching. August 16, 1904, Statesboro, Georgia.*

66. *Post card of the burnt out home of Hodges family near Statesboro. 1904, Statesboro, Georgia.*

67. *The lynching of Ernest Harrison, Sam Reed, and Frank Howard.*
September 11, 1911, Wickliffe, Kentucky.

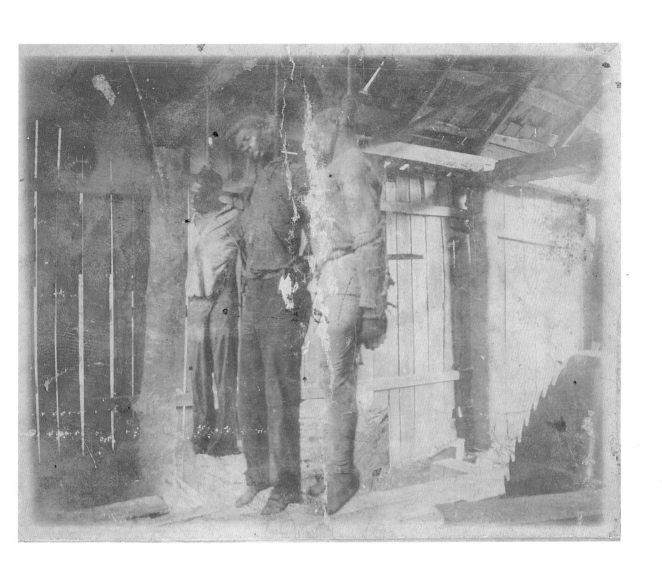

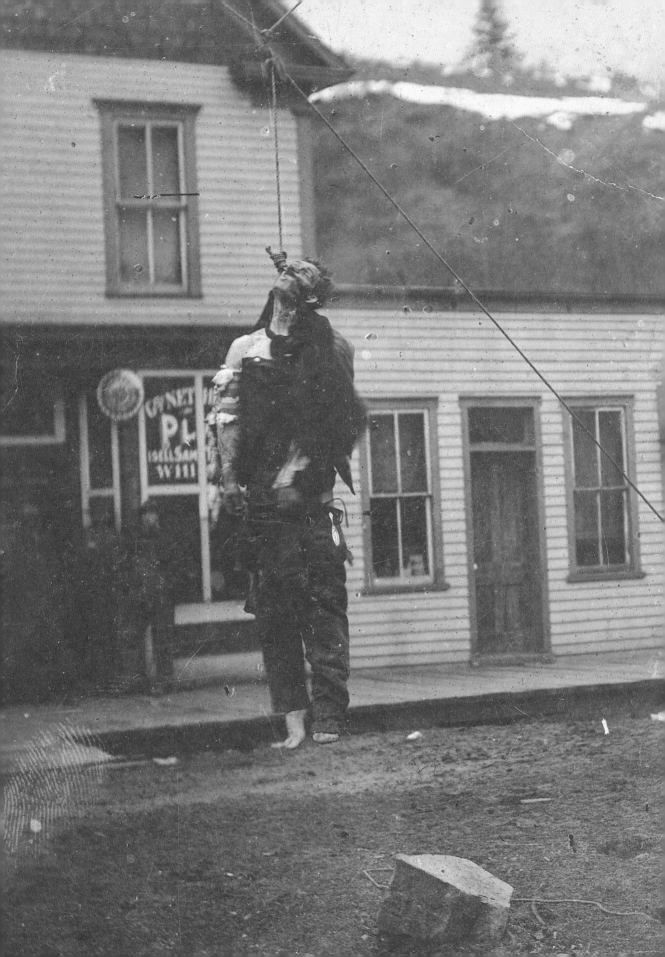

68. *The Lynching of Joe Brown. March, 1909, Whitmer, West Virginia.*

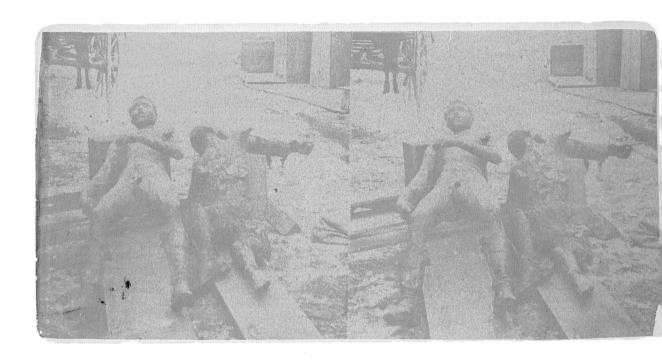

69. and 70. *The burned corpses of Ami "Whit" Ketchum and Luther H. Mitchell.*

December 10, 1878, Calloway, Nebraska. (Stereograph, front and back)

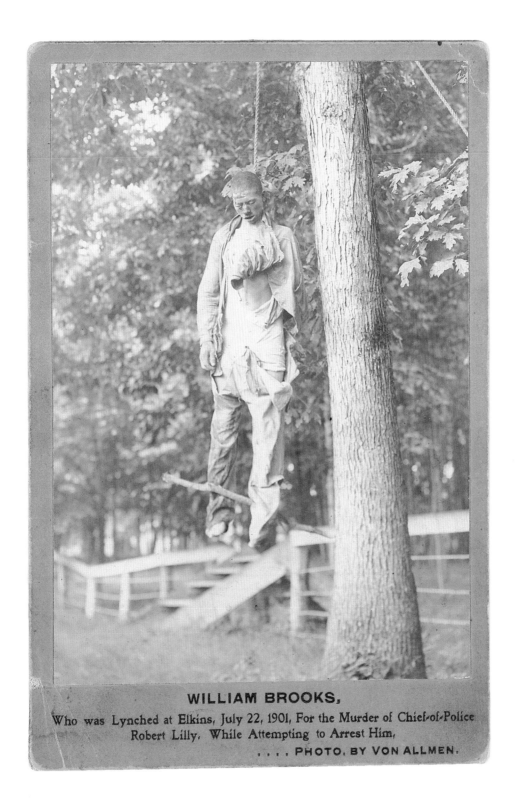

WILLIAM BROOKS,

Who was Lynched at Elkins, July 22, 1901, For the Murder of Chief-of-Police
Robert Lilly, While Attempting to Arrest Him,

. . . . **PHOTO. BY VON ALLMEN.**

71. *The lynching of William Brooks. July 22, 1901, Elkins, West Virginia.*

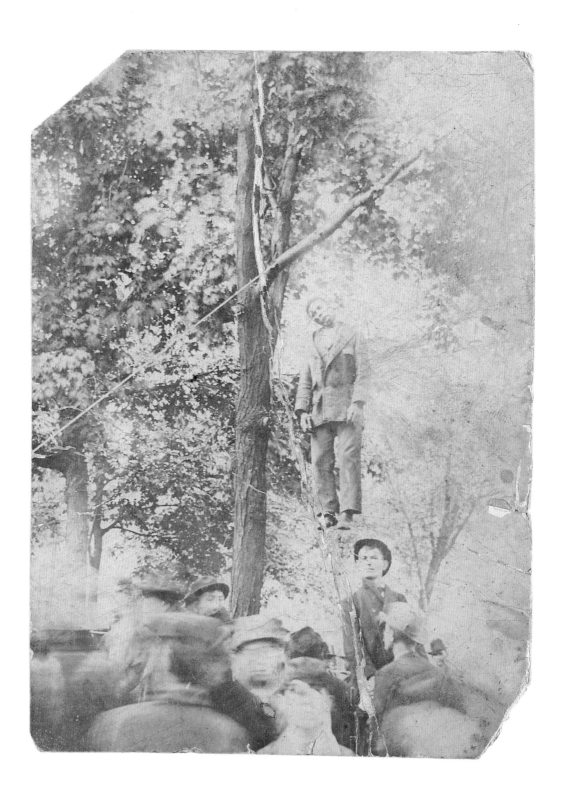

72. *The lynching of Charles Mitchell. June 4, 1897, Urbana, Ohio.*

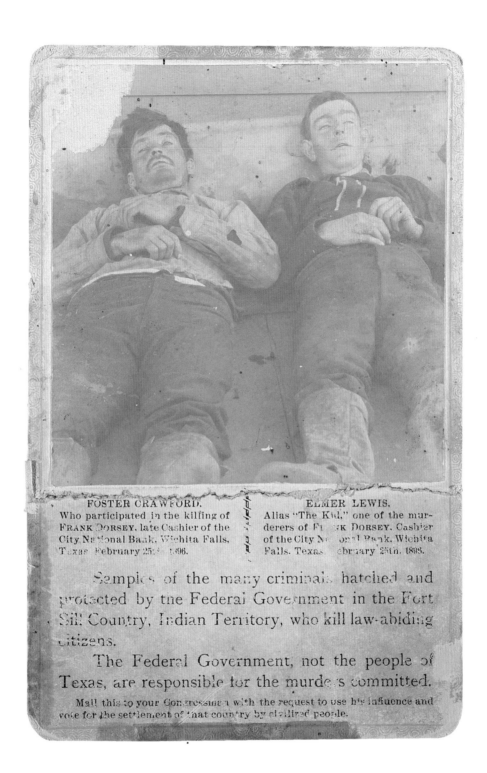

FOSTER CRAWFORD.
Who participated in the killing of
FRANK DORSEY, late Cashier of the
City National Bank, Wichita Falls,
Texas February 25th 1896.

ELMER LEWIS.
Alias "The Kid," one of the mur-
derers of Frank Dorsey, Cashier
of the City National Bank, Wichita
Falls, Texas, February 25th, 1895.

Samples of the many criminals hatched and
protected by the Federal Government in the Fort
Sill Country, Indian Territory, who kill law-abiding
citizens.

The Federal Government, not the people of
Texas, are responsible for the murders committed.

Mail this to your Congressman with the request to use his influence and
vote for the settlement of that country by civilized people.

73. *The corpses of Foster Crawford and Elmer Lewis. February 25, 1893, Wichita Falls, Texas.*

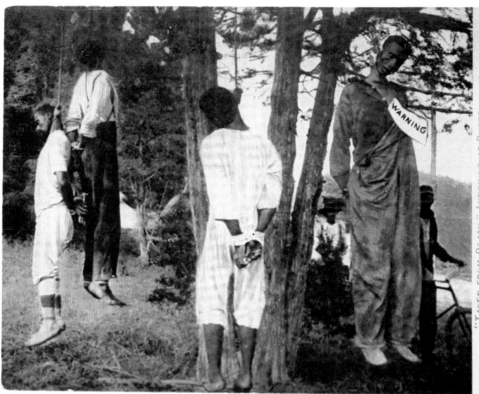

"TAKEN FROM DEATH." LYNCHING AT RUSSELLVILLE,
LOGAN COUNTY, KENTUCKY, JULY 31, 1908.

HANGED ON THE OLD PROCTOR LYNCHING TREE. THIS IS A MULTIPLE CEDAR TREE
AND THESE FOUR MAKE A TOTAL OF NINE MEN LYNCHED ON THIS TREE, SOME
WERE WHITE MEN. THIS TREE IS AN OLD LAND MARK AND WAS AN OLD CEDAR
TREE, EVEN IN THE YOUNGEST DAYS OF THE OLDEST SETTLERS.
RUSSELLVILLE IS ONE OF THE PIONEER TOWNS OF KENTUCKY AND WAS SETTLED
IN A CANE BRAKE. THIS IS AN EXACT PHOTOGRAPH TAKEN AT DAWN AUG. 1, 08.

COPYRIGHTED 1908, BY JACK MORTON, SALESMAN, STAHLMAN BUILDING,
NASHVILLE, TENN, U. S. A.

WARNING

I bought this in Hopkinsville 1st.
each. They are not on sale openly.
I forgot to send it until just now you
across it. I read an account of the
night riders affairs where it says these
men were hung without any apparent
cause or reason whatever.
A law was passed forbidding these
to be sent thru the mail or to be
sold anymore.

25 00

PLACE POSTAGE
HERE
DOMESTIC
IS. POS-
SESSIONS } 1c
CANADIAN
MEXICAN
FOREIGN 2c

Post Card

This Space for Address only.

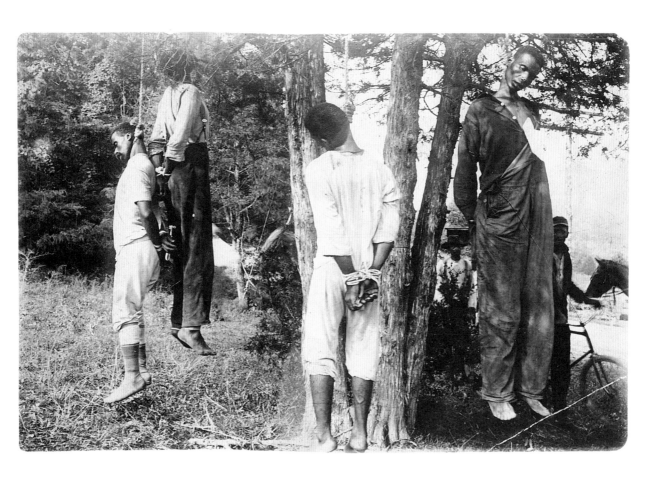

74. and 75. Left, *The lynching of Virgil Jones, Robert Jones, Thomas Jones, and Joseph Riley.*
(postcard, front and back)

76. *The lynching of Virgil Jones, Robert Jones, Thomas Jones, and Joseph Riley.*
July 31, 1908, Russellville, Kentucky.

77. *Lynching. Circa 1900, St. Louis, Missouri.*

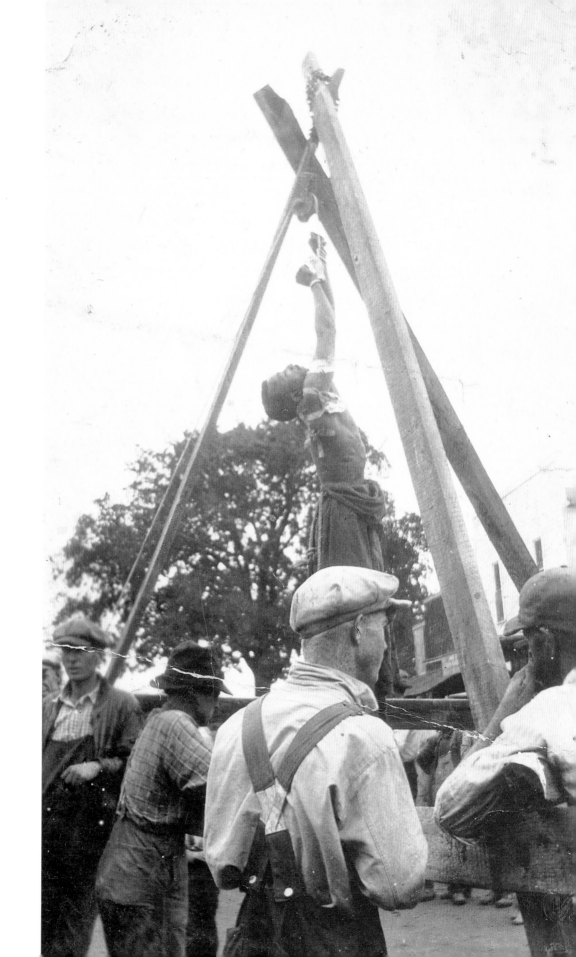

78. Lynching, Pre-1915, southern United States.

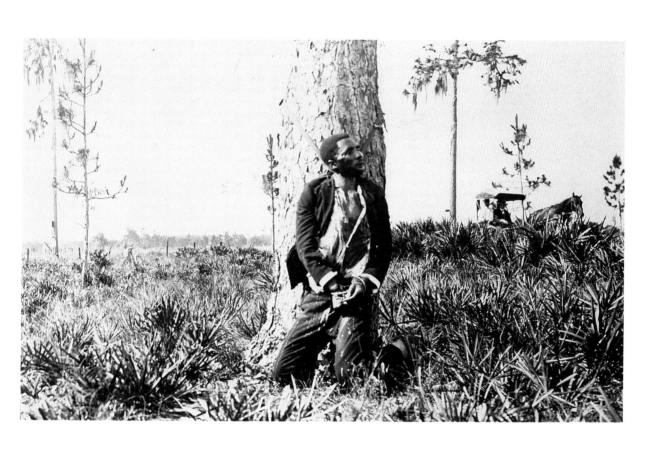

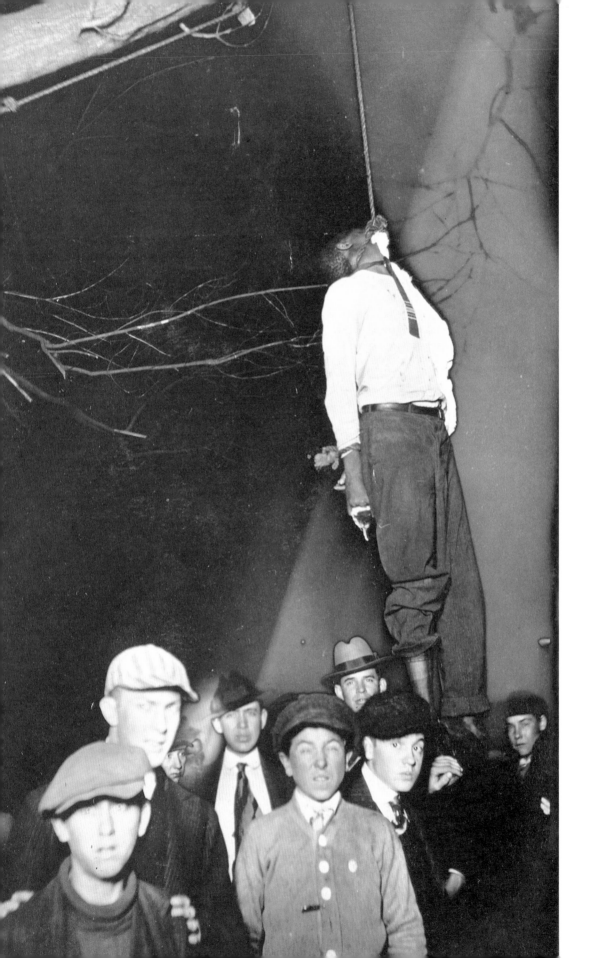

79. *Lynching. Circa 1920, location unknown.*

80. *The lynching of John Holmes. November 26, 1933, San Jose, California.*

81. – 84. Following pages, *Four souvenir images of the lynching of Jack Holmes and Thomas Thurmond.*

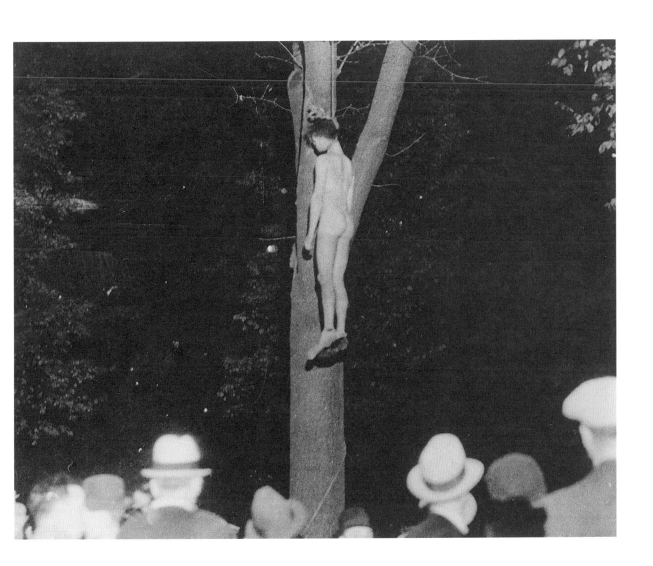

OFFICIAL PHOTOGRAPHS
of
LYNCHING OF SAN JOSE
KIDNAPERS

STAMP
HERE

"While the law should have been permitted to take|its course, the people by their action have given notice to the entire world that in California kidnaping will not be tolerated."

GOV. JAMES ROLPH

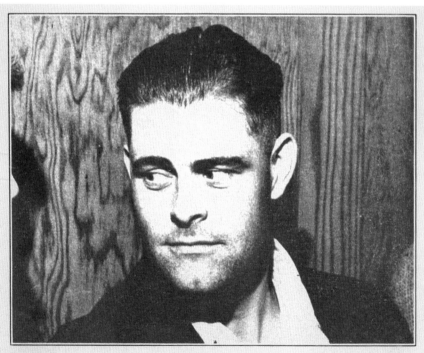

Jail photograph of Jack Holmes, one of the slayers of young Brooke L. Hart, 22, Santa Clara University graduate and son of wealthy San Jose family. Holmes' photo taken just before lynching by 15,000 vigilantes.

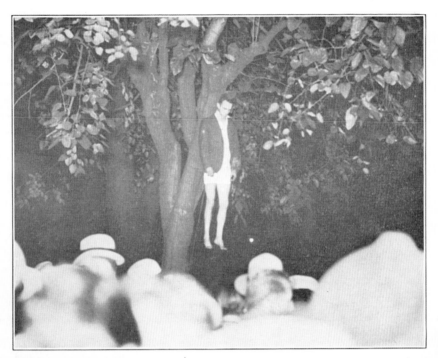

Thomas Thurmond, co-conspirator with Holmes in murder of Young Hart strung to tree in St. James Park across from San Jose jail.

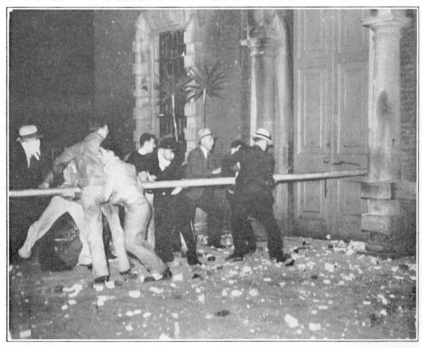

Huge battering ram being used by Holmes-Thurmond lynchers on San Jose jail door.

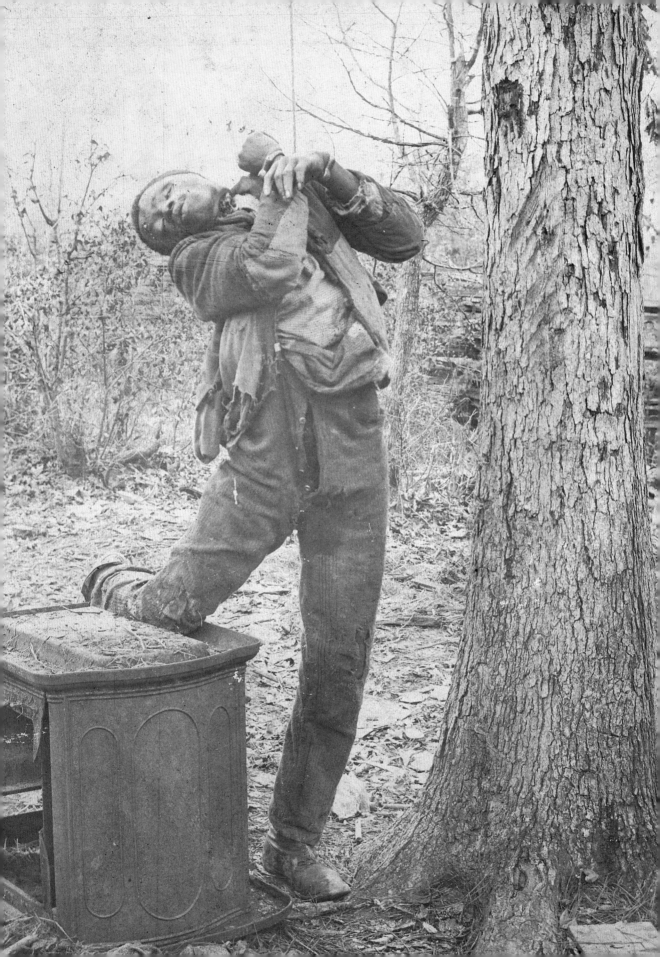

85. *The lynching of Lee Hall. February 7, 1903, Wrightsville, Georgia.*

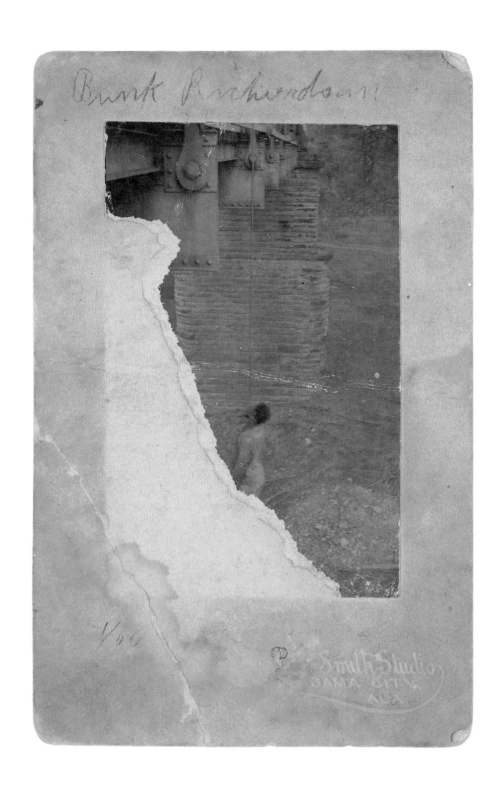

86. *The lynching of Bunk Richardson. February 11, 1906, Gadsden, Alabama.*

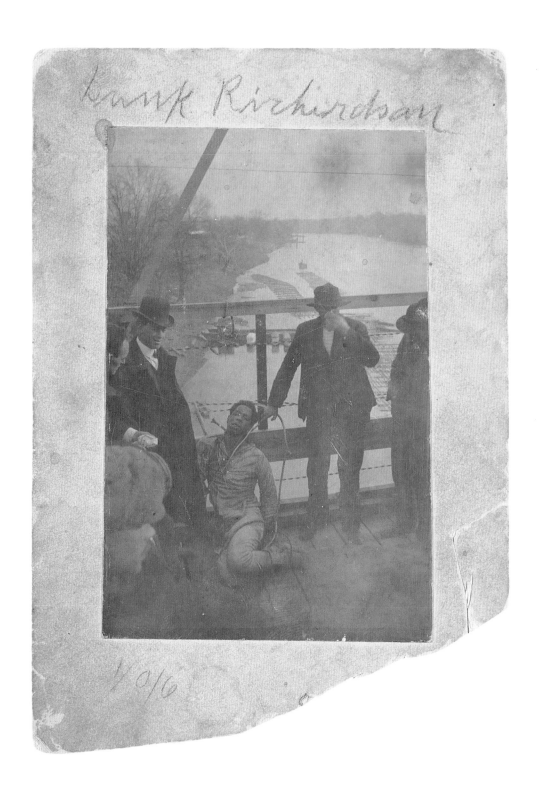

87. *The corpse of Bunk Richardson. February 11, 1906, Gadsden, Alabama.*

88. *The lynching of W. C. or R. C. Williams. October 15, 1938, Ruston, Louisiana.*

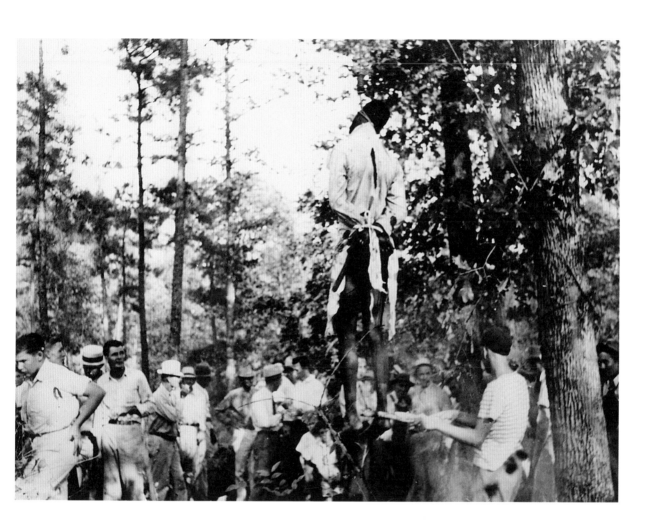

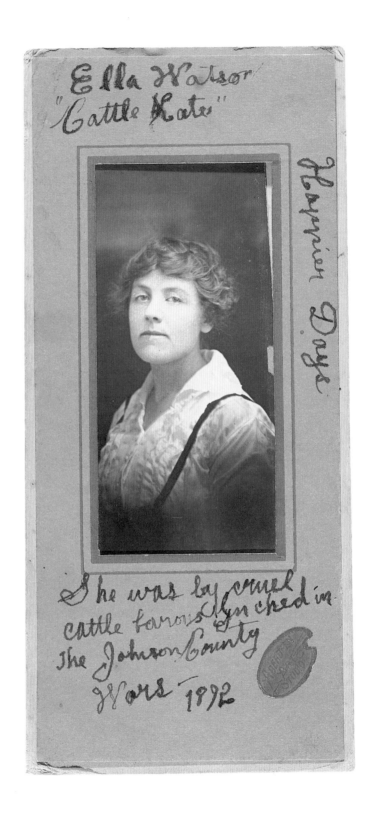

89. *Portrait of Ella Watson, "Cattle Kate." Circa 1890, Johnson County, Wyoming.*

Some boys in Deadwood asked again:
"You knew her once, didn't you, Ben?"

"Well, yes." I said. Thats all I said.
Then rode on down toward Lead.

The wind blew through these Black Hills flowers.
One Spring day. The sun shone on our heads.

I'll pack my Colts and board a train
For old Wyoming once again.

To even up the score for Kate.
No man can change his fate.

Snow blows through those Black Hills towers.
But did I say: "The sun shone on our heads"?

90. *Poem accompanying Ella Watson portrait.*

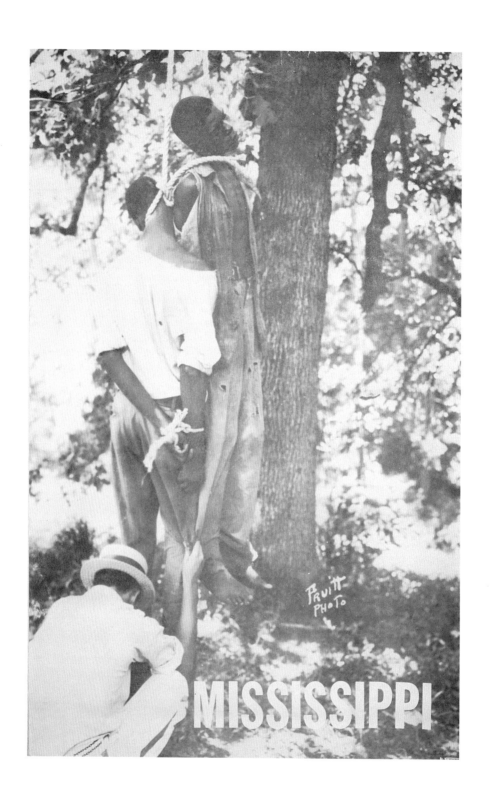

91. *Anti-lynching poster.*

Published by Student Nonviolent Coordinating Committee. Circa 1965.

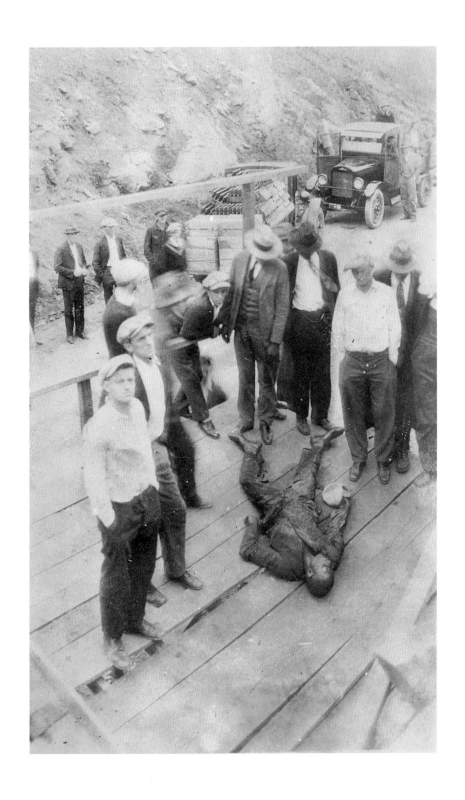

92. *The corpse of Leonard Woods. November 29, 1927, Pound Gap, Kentucky.*

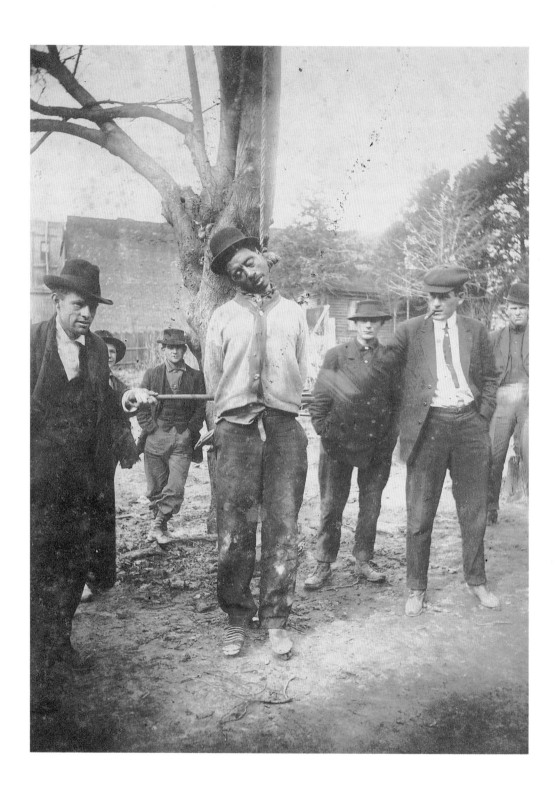

93. Lynching. Circa 1890, Arkansas.

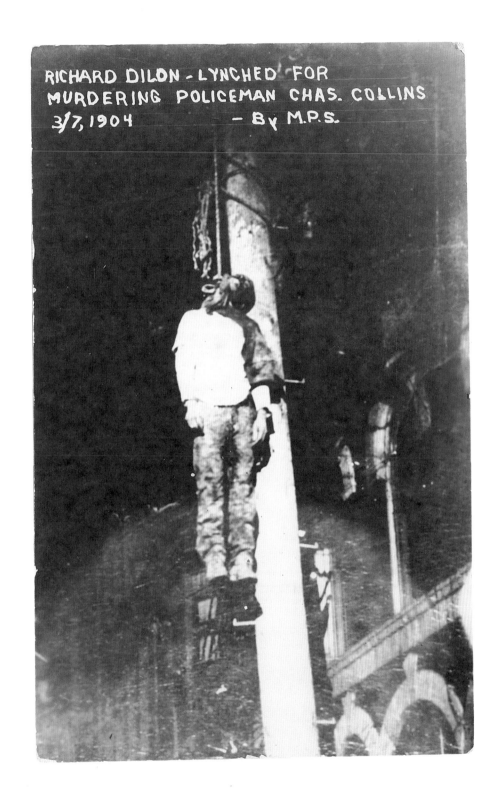

94. *The lynching of Richard Dillon. March 7, 1904, Minnesota.*

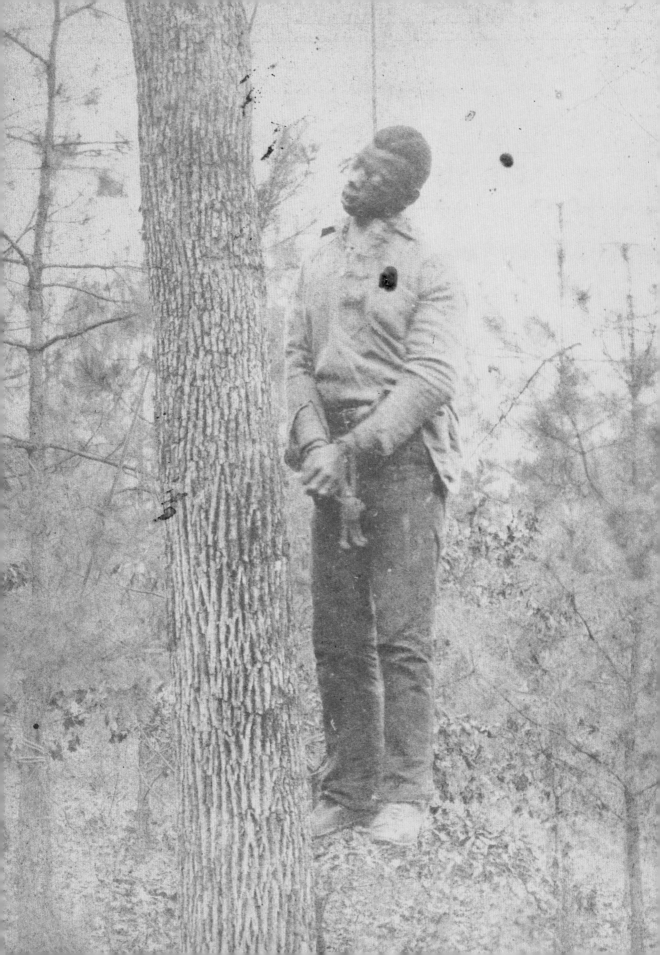

GEORGE MEADOWS,
MURDERER AND RAPIST.
LYNCHED ON THE SCENE OF HIS LAST CRIME.

————

Meadows committed an assault on a lady of Pratt Mines, Ala., January 15, 1889, and brutally murdered her little son before her eyes.

At the coroner's inquest he was convicted of rape on a little negro girl, also of Pratt Mines. Strong evidence was found that he had committed the same crime several times in this vicinity before.

J. HORGAN, JR.,
PHOTO.

P. O. BOX 789.

COPYRIGHT APPLIED FOR

BIRMINGHAM, ALA.

95. and 96. *The lynching of George Meadows. January 15, 1889, Pratt Mines, Alabama.*
(card-mounted print, front and back)

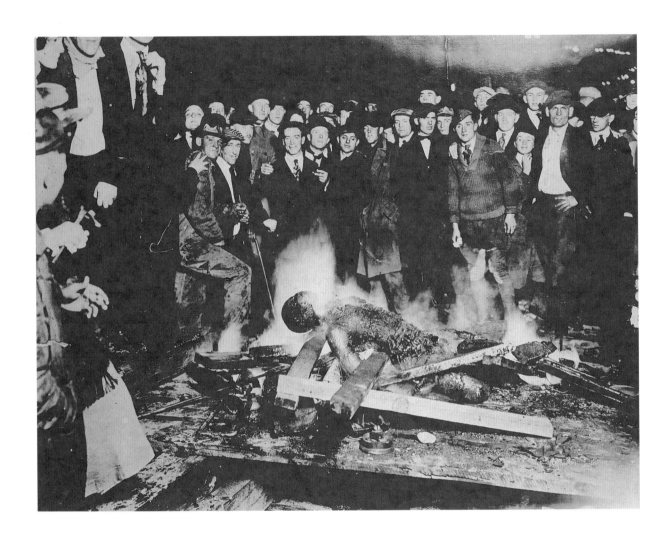

97. *The burning corpse of William Brown. September 28, 1919, Omaha, Nebraska.*

98. *Lynching. Circa 1910, location unknown.*

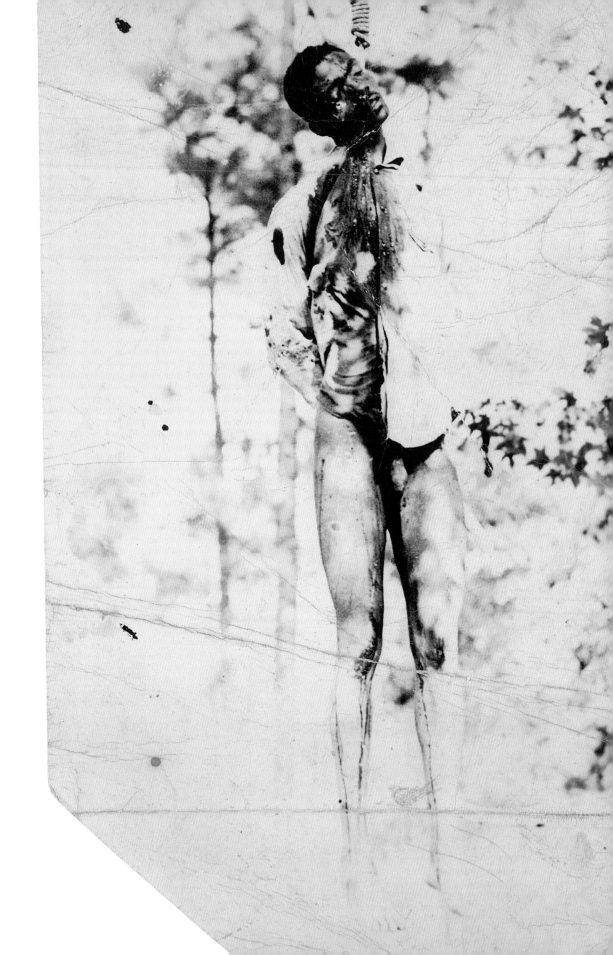

NOTES ON
THE PLATES
James Allen

Spectators at the lynching of Jesse Washington. May 16, 1916, Waco, Texas. Gelatin silver print. Real photo postcard. 5½ x 3½"

HALF-TITLE PAGE

The bludgeoned body of an African American male, propped in a rocking chair, blood-splattered clothes, white and dark paint applied to face, circular disks glued to cheeks, cotton glued to face and head, shadow of man using rod to prop up the victim's head. Circa 1900, location unknown. Gelatin silver print. Real photo postcard. 5⅜ x 2⅞"

This is perhaps the most extreme photographic example extant capturing the costuming of a victim of extra-legal violence. What white racists were unable to accomplish through intimidation, repressive laws, and social codes—namely, to mold the African American male into the myth of the emasculated "good ole darkey"—they here accomplished by violence and costuming.

FRONTISPIECE

The lynching of Jim Redmond, Gus Roberson, and Bob Addison, and one onlooker. May 17, 1892. Habersham County, Georgia. Gelatin silver print. 4¾ x 6¾".

1. *The lynching of Clyde Johnson. August 3, 1935, Yreka, California. Gelatin silver print. Real photo*

postcard. 3½ x 5⅜" Etched in the negative, "Killer of Jack Daw, Aug 3, 1935, Vengence in Siskiyou County."

At the funeral of F. R. Daw, chief of police of Dunsmuir, Oregon, a number of mourners planned the lynching of his alleged murderer, Clyde Johnson. Early on the morning of August 3, 1935, a masked mob, estimated as large as fifty, forcibly removed Johnson from his jail cell and dragged him three miles south of town, where they hung him from a pine tree.

Local and state officials expressed mixed reaction to news of the lynching. District Attorney James Davis declared that he would open an investigation and "do everything the law requires to apprehend members of the mob." On the other hand, the California attorney general, referring to the recently delayed execution of an accused murderer, stated that the "uncontrollable unrest" was a natural result of the "apathy of the Supreme Court of the United States."

2. Unidentified lynching. Gallows, courthouse-jail, and windmill in background. Nine onlookers, two young boys. Circa 1905, location unknown. Gelatin silver print. Real photo postcard. 3½ x 5½" The architectural details of the courthouse suggest a Texas origin. Found in Texas.

3. Unidentified lynching. Circa 1905, Trenton, Georgia. Gelatin silver print. Real photo postcard. 3½ x 5½" A pencil inscription on the reverse reads, "Dade County Trenton, Georgia." Purchased in Georgia.

4. The lynching of Bennie Simmons, soaked in coal oil before being set on fire. June 13, 1913, Anadarko, Oklahoma. Gelatin silver print. Real photo postcard. 3½ x 5½" Etched into negative: "Edies Photo Anadarko Oklo." Purchased in Oklahoma.

Bennie Simmons, or Dennis Simmons, accused of the murder of sixteen-year-old Susie Church, was taken from prison guards in Anadarko, Oklahoma. His killers led him to a nearby bridge and hanged him from the limb of a cottonwood tree by the stream. "The Negro prayed and shrieked in agony as the flames reached his flesh," reported a local newspaper, "but his cries were drowned out by yells and jeers of the mob." As Simmons began to lose consciousness, the mob fired at the body, cutting it to pieces. The Enfaula Democrat remarked, "The mobsters made no attempt to conceal their identity . . . but there were no prosecutions."

5. The lynching of John D. and Charles Ruggles. July 24, 1892, Redding, California. Gelatin silver print. Real photo postcard. 3½ x 5½" Etched in the negative, "Copyright applied for by J. G. Franklin,

Photographer," and *"Hanging of Ruggle Bros Redding, Cal. 1892."*

John D. and Charles Ruggles were alleged to have robbed the Redding stagecoach, killing the express messenger and wounding the driver and a passenger. Before the conclusion of their trial, a mob of forty armed and masked men removed the prisoners from their cell and led them several blocks to the company's woodshed. Utilizing the nearby stack of wood, the mob suspended a crossbeam between two pines and hanged the two brothers. This image was taken shortly before the coroner cut the two bodies down.

6. *The lynching of two unidentified African American males, three white onlookers. Circa 1910, location unknown. Gelatin silver print. Real photo postcard mounted on card stock. 5½ x 3½"*

7. *The lynching of George and Ed Silsbee. January 20, 1900, Fort Scott, Kansas. A large group of spectators holding kerosene lamps, downed fence in foreground. Gelatin silver print. Cabinet card. 10 x 7" Etched in negative,"George and Ed* SILSBEE HANGED *by a* MOB *of* CITIZENS IN FRONT OF JAIL. *Jan. 20, 1900. Fort Scott, Kan. Flash Light by Dabbs."*

Studio label on reverse: J.V. DABBS PHOTOGRAPHER GROUND FLOOR STUDIO, Frames and Mouldings, 407 Market Street. FORT SCOTT, KANSAS.

The two Missourians, known by some as Meeks and Smith, were accused of the murder of Leopold Edlinger, a young farmhand, and the attempted murder of Tom Allen, the deputy sheriff. In the dead of night the lynch mob broke the Silsbees out of jail, placed ropes around their necks, and escorted the shackled men to nearby trees. Men, women, and children crowded the area, perching on fences, climbing adjacent trees, and scaling buildings for a better view. The mob cheered as the leaders executed the two accused. As word of the lynching spread throughout the community, residents flocked to the courthouse to view the dangling corpses before they were cut down at 11:30 a.m. The coroner ruled that their necks had not been broken and that the two died of strangulation.

8. *The lynching of two Italian immigrants, Castenego Ficcarotta and Angelo Albano. One with note affixed to feet, the other with pipe in mouth. September 20, 1910, Florida. Gelatin silver print. 6½ x 4"*

Tensions were high in Tampa after recent violence between striking cigar factory workers and newly hired strikebreakers. The

two Italian immigrants were accused of shooting J. F. Esterling, a bookkeeper. While the "conspicuous" strikers were being taken to jail, a mob separated them from two deputy sheriffs. The lynchers' note read: "*Beware! Others take notice or go the same way. We know seven more. We are watching you. If any more citizens are molested lookout.*" The note was signed, "*Justice.*" "We are watching you" is a phrase of intimidation used throughout the United States by moral regulators and right-wing groups such as the Klan. In this case it was a threat to other strikers.

Mobs costumed corpses in mocking fashion, redressed them with hats and other articles of clothing, and, in this case, placed a pipe in the mouth of one victim. In one incident the killers posed the corpse upright in a chair and glued on cotton sideburns and hair to recreate mockingly the stereotype of the "good ole darky." (Image on half-title page)

9. *The lynching of two Italian immigrants, Castenego Ficcarotta and Angelo Albano. A small handful of onlookers. September 20, 1910, Florida. Gelatin silver print. Real photo postcard. 3½ x 5½" Inked inscription on reverse: "Labor agitators Lynched During the cigar makers Strike, Tampa Fla."*

10. *Silhouetted corpse of African American Allen Brooks hanging from Elk's Arch, surrounded by spectators. March 3, 1910, Dallas, Texas. Tinted lithographed postcard, postmarked June 11, 1910, Dallas, Texas. 5½ x 3½" Printed inscription on border:* "LYNCHING SCENE, DALLAS, MARCH 3, 1910." *Penciled inscription on border: "All OK and would like to get a post from you. Bill, This was some Raw Bunch."*

The Palace Drugstore dominated a prime commercial corner under one of downtown Dallas's most prominent architectural landmarks, the soaring Elk's Arch. Together, they formed a makeshift amphitheater for the events of March 3, 1910.

At midday, Palace employees were drawn to the open second-story windows and pedestrians gathered on the street below. They saw a man scaling the arch and securing a rope. Then the naked, mutilated corpse of an elderly black man was pulled up at the end of the rope. Audible to many were the words of commendation a mob leader had for his fellow lynchers. "*You did the work of men today and your deeds will resound in every state, village, and hamlet where purity and innocence are cherished and bestiality and lechery condemned.*"

The H. J. Buvens family considered Allen Brooks a trusted servant until Flora Daingerfield, another servant, claimed to have

discovered Brooks with their missing three-year-old daughter in the barn. Dr. W. W. Brandau examined the child and found "*evidence of brutal treatment.*" A local newspaper described the alleged crime as "*one of the most heinous since the days of Reconstruction.*"

Immediately after Brooks's arrest, a mob attempted, but failed, to kidnap him from authorities. While his trial was under way, a second mob, of two hundred whites and one "conspicuous Negro," entered the courtroom and successfully overwhelmed a "defending force" of fifty armed deputies and twenty policemen. No shots were fired. The defenseless Brooks was trapped on an upper floor. The mobsters tightened a noose around his neck and threw him down to others some twenty feet below. Dozens attacked, kicking and crushing his face until he was covered in blood. The adherents of hanging overruled those who called for burning, and the procession from courthouse to arch began.

"*Contact with the pavement and obstacles on it wore most of the clothes off the Negro before the arch was reached,*" noted the *Dallas Morning News.* "*At one point his coat was torn off, at another his shoes were dragged from his feet, and finally his trousers yielded to the friction of the passage along the street.*" Remnants of clothing that clung to the corpse were soon stripped away by souvenir hunters.

11. *Reverse side of postcard (plate 10).*

This postcard, addressed to Dr. J. W. F. Williams, LaFayette, Christian County, Kentucky, documents the sentiments of one spectator. "*Well John—This is a token of a great day we had in Dallas, March 3, a negro was hung for an assault on a three year old girl. I saw this on my noon hour. I was very much in the bunch. You can see the negro hanging on a telephone pole.*"

12. *The lynching of three African American males—Nease Gillespie, John Gillespie, and Jack Dillingham. August 6, 1906, Sailsbury, North Carolina. Lithographed photo postcard. 3½ x 5½" Printed on border: "Nease and John Gillespie and Jack Dillingham, murderers of Lyerly family. Lynched August 6th, 1906. Salisbury, N.C."*

A mob numbering in the thousands wrenched three black men from the civil authorities of Salisbury, North Carolina, on the night of August 6, 1906. They accused the men of murdering members of a local family named Lyerly. The *New York Times* reported that the victims were tortured with knives before being hanged. Then their bodies were riddled with bullets.

The authorities in North Carolina, alarmed at the scope of the mob's violence, took unusual steps to punish its leaders. After the governor ordered the National Guard to restore order, local officials arrested more than two dozen suspected leaders. One of the killers, George Hall, was convicted and sentenced to fifteen years at hard labor in the state penitentiary. The *New York Times* predicted that, by taking these measures, North Carolina's Governor Glenn was not improving his political prospects.

13. *Lynching of bound white male, his body hung from a bridge. Circa 1910, location unknown. Gelatin silver print. Real photo postcard. 3½ x 5½"*

This card was purchased at a garage sale in Macon, Missouri. The seller related what he knew of the postcard's history and assured that it was a photograph of a lynching that took place in Missouri.

Researchers confirm the symbolic importance of lynching sites and the conscious selection of these sites by perpetrators of extra-legal violence. The dominance of Christian symbology is reflected in the lynchers' preference for bodies of water, bridges, and landmark trees. Bodies of water are the traditional locations for baptisms; bridges symbolize the most profound rite of passage, the great "crossing over" to death; and trees are the very symbol of life and of Christ's crucifixion. The lynchers sought, in the conscious selection of these sacrificial sites and in their participation in these ritualized murders, their own salvation and passage to a safer place without sin and evil—both of which, in their minds, were physically embodied in the "offending" victim.

14. *Unidentified lynching of an African American male. Circa 1908. Gelatin silver print. Real photo postcard. 3½ x 5½" Pencil inscription on reverse: "Oxford Georgia."*

Publicizing their work was a priority for the mob that murdered this unidentified African American. A lighted telephone pole near railroad tracks created a well-lit gallery for passing trains. The cart hugging the pole was used to transport incoming and outgoing mail. No accounts of this lynching have been found in local papers or state archives.

15. *The unidentified corpse of an African American male with posse. Circa 1900, location unknown. Card-mounted gelatin printing-out paper. 7 x 5" Purchased from a South Georgia estate. The photo matte is impressed with the logo, "T. C. Reynolds, Photographer."*

The limp, ravaged corpse of a young African American male, with clothes shredded from flight and bullets, is propped as a safari trophy for the posse, who pose in hunting costumes and brandish weapons.

Marauding posses of casually deputized or undeputized men accounted for a significant number of lynch mobs. Often, without taking the trouble to properly identify their victims, they acted with dispatch, killing their prey on sight. Torture was not characteristic.

One Georgia police investigator who witnessed a posse-lynching in 1965 described it this way: *"An African American man had assaulted a police officer and fled. Word, from an informant, indicated he was hiding in a nearby residence. Two branches of the state and one local law enforcement agency surrounded the house. An officer banged on the front door. A black male exited the back door and ran towards an adjacent field. The sheriff shot and the man fell dead. The officers gathered about the corpse and kicked the body over which was still clutching a bottle of moonshine whiskey. The sheriff lamented, 'Wrong Nigger.'"* No investigation of this lynching ensued.

Congressman John Lewis of Georgia documented the hunting-party atmosphere of posses in his book *Walking with the Wind*. He relates that the "citizen posses" (squads of local white men deputized by Sheriff Jim Clark in Selma, Alabama, during the civil rights movement of the 1960s) liked to refer to themselves as "squirrel shooters."

James Weldon Johnson, in the early 1900s, described his encounter with a posse of ten militiamen with orders to capture *"a Negro accompanying a white woman"* in a Jacksonville, Florida, park. Unknown to the soldiers, Johnson's companion was a woman of African American descent with fair skin. The soldiers beat him and tore his clothes with cries of, *"Kill the damned nigger! Kill the black son of a bitch!"* Johnson states that if he had turned his back, lowered his eyes, or taken one step in retreat, he would have been a dead man.

16. *The lynching of four unidentified African Americans. Circa 1900, location unknown. Gelatin silver print. 10 x 8˝*

17. *The lynching of Dick Robinson and a man named Thompson. October 6, 1906, Pritchard Station, Alabama. Card-mounted gelatin silver print. 7 x 5˝*

A botched attempt to lynch Dick Robinson on October 2 resulted in the murder of Officer Roy Hole. The leaders of the mob, determined to prevent further "innocent bloodshed," intercepted a train transporting the accused prisoners to a large contingent

of armed guards in Mobile. Forcibly separating the accused men from a sheriff and his deputy, the mob got off the train at Pritchard Station. Anticipating an attack by local blacks, large oaks close to the station were hastily chosen to hang Robinson and Thompson. Different legal charges were filed against the two victims, but the mob accused both of assaulting white women.

18. Townspeople gathered for the burning of John Lee. August 13, 1911, Durant, Oklahoma. Gelatin silver print. Real photo postcard. 5½ x 3½" Another version of this photo postcard was marketed with the negative etched, "Coon Cooking."

According to the August 14 issue of the *Durant Daily Democrat*, Lee died at 11:15 p.m. at the hands of a posse of 500. An additional 1,500 citizens were estimated to have been involved in the manhunt. Reports indicate that Lee exchanged gunfire with his would-be captors until his ammunition was spent. The posse *"calmly emptied their guns into his body."*

Lee was accused of a range of crimes, the most serious of which was the critical wounding of a white woman, Mrs. Redden Campbell. She identified the corpse as that of her assailant. Mrs. Campbell expired later the same day. The mob took John Lee's body to a vacant lot near the railroad tracks, where they built a pyre of gathered lumber and set the remains on fire. It burned from nine in the morning until late in the afternoon. All that remained were ashes and a *"few charred parcels."*

Whites rioted throughout the town of Durant. The city's remaining blacks were warned "not to let the sun go down on them here." All left by sunset.

Rumors spread that blacks were organizing to return and avenge the death of John Lee. Durant's white citizens armed for the coming "race war." In several days, without additional violence, tensions calmed.

19. The lynching of David Jackson. Found December 14, 1961, McDuffie County, Georgia. Gelatin silver print. 7 x 10"

Early on the morning of December 14, 1961, two young boys bicycling to a favorite fishing hole happened upon this scene: a county prison farm trustee's dead weight hanging by the neck in a thorny bramble of Georgia hardwoods. After they reported it to the local authorities, the Georgia Bureau of Investigation's chief looked briefly at the scene and declared, "Suicide." This photo-

graph was snapped, and the investigation was closed.

20. *John Richards hanging on a tree, jubilant lynchers, a freshly hewn pine coffin. January 12, 1916, Goldsboro, North Carolina. Gelatin silver print. 3½ x 4½" Pencil inscription on reverse: "Goldsboro, North Carolina."*

Early in the cold morning of January 12, 1916, a masked mob of some two hundred dragged John Richards from his jail cell in Wayne County, North Carolina. He was accused of the murder of a local farmer named Anderson Gurley. According to local newspaper accounts, he was taken to the scene of Gurley's murder and hanged. This photo puts that account in doubt. Richards is suspended from a deciduous tree by a rope secured under his arms. His pants are lowered, and a cloth is draped over the front of his body. It is more likely that he was castrated and died from the gunfire that "almost cut his body to pieces."

The Calvaryesque cloud formation hovering over Richards is most likely the product of a light-leak in the camera lens.

21. *Lynching of an unidentified African American male. Date and location unknown. Tinted lithographed postcard. 5½ x 3½" Printed in lower left corner: "Lynched."*

Copies of this card turn up frequently, testifying to their popularity.

22. *The smoldering remains of Ted Smith, onlookers. July 28, 1908, Greenville, Texas. Lithographed postcard. 5½ x 3½" Etched in negative: "Burning of the Negro Smith at Greenville, Tex. 7-28-08." Printed on border: "Copywright 1908. Sold by J. Q. Adams, Greenville, Texas."*

Eighteen-year-old Ted Smith was slowly roasted alive on the streets of Greenville, Texas. The mob tended the fire throughout the day. His killers accused him of assaulting Viola Delancey, a white woman. The case was never adjudicated.

The Greenville chief of police, from whom Smith was taken, stated, "*Special occasions occur where the people take the law into their own hands and pass judgment and punish accordingly.*"

23. *A lynch mob and the smoldering remains of an African American. August 1910, Texas. Gelatin silver print. Real photo postcard. 3½ x 5½" Pencil inscription on front reads: "Burning of the negro who killed Jim Mitchell. August 1910."*

24. *Spectators at the lynching of Jesse Washington, one man raised for a better view. May 16, 1916,*

Waco, Texas. Gelatin silver print. Real photo postcard. 5½ x 3½"

Washington was a mentally retarded seventeen-year-old boy. On May 8, 1916, Lucy Fryer, a white woman, was murdered in Robinson, seven miles from Waco. Washington, a laborer on her farm, confessed to the murder. In a brief trial on May 15, the prosecution had only to present a murder weapon and Washington's confession. The jury deliberated for four minutes, and the guilty verdict was read to shouts of, *"Get that Nigger!"*

The boy was beaten and dragged to the suspension bridge spanning the Brazos River. Thousands roared, *"Burn him!"* Bonfire preparations were already under way in the public square, where Washington was beaten with shovels and bricks. Fifteen thousand men, women, and children packed the square. They climbed up poles and onto the tops of cars, hung from windows, and sat on each other's shoulders. Children were lifted by their parents into the air. Washington was castrated, and his ears were cut off. A tree supported the iron chain that lifted him above the fire of boxes and sticks. Wailing, the boy attempted to climb the skillet-hot chain. For this the men cut off his fingers. The executioners repeatedly lowered the boy into the flames and hoisted him out again. With each repetition, a mighty shout was raised.

25. *Burnt corpse of William Stanley, August, 1915 Temple, Texas. Gelatin silver print. Real photo postcard. 5½ x 3½"*

This image was published in *Crisis Magazine* in the January 1916 issue described as the lynching of William Stanley, Temple, Texas, five months prior to the lynching of Jesse Washington in Waco, Texas. Please see image 24 and the endpapers for the Jesse Washington torture and lynching on May 16, 1916. The Library of Congress has other images of the Washington lynching, in their Print and Photograph Division.

The sender of this card, Joe Meyers, an oiler at the Bellmead car department and a Waco resident, marked his photo with a cross (now an ink smudge to left of victim).

26. *Reverse of postcard (plate 25). This card bears the advertising stamp,* "KATY ELECTRIC STUDIO TEMPLE TEXAS. H. LIPPE PROP." *Inscribed in brown ink:* "This is the Barbecue we had last night my picture is to the left with a cross over it your son Joe."

Repeated references to eating are found in

lynching-related correspondence, such as "*coon cooking,*" "*barbecue,*" and "*main fare.*"

27. *Unidentified lynching, onlookers on horseback. Circa 1900, location unknown. Card-mounted cyanotype. 6⅛ x 3⅛" Pencil inscription on front: "Lynching."*

28. *The lynching of nineteen-year-old Elias Clayton, nineteen-year-old Elmer Jackson, and twenty-year-old Isaac McGhie. June 15, 1920, Duluth, Minnesota. Gelatin silver print. Real photo postcard. 3½ x 5½" Etched (in error) into the nega- tive:* "THREE NEGROES LYNCHED AT DULUTH, MINN. FOR RAPE. OCT, 1919 BY MPS"

Six black circus workers, alleged to have assaulted a young white girl on the circus grounds, were dragged from their cells in a Duluth, Minnesota jail by a mob of five thousand people. Twelve policemen were injured during the attack. In an impromptu trial, orchestrated by the mob leaders, three of the suspects were "found not guilty." The three "found guilty" were hanged. A subse- quent investigation by the civic authorities proved that none of the murdered men could have participated in the assault.

The *New York Times* remarked that the "*lynch- ing of Negroes in Duluth is far from the first that*

occurred in the North. Human nature is much the same in both sections of the country."

29. *The lynching of nineteen-year-old Elias Clayton, nineteen-year-old Elmer Jackson, and twenty-year-old Isaac McGhie. June 15, 1920, Duluth, Minnesota. Gelatin silver print. Com- posite real photo postcard. 5½ x 3½"*

30. *The lynching of nineteen-year-old Elias Clayton, nineteen-year-old Elmer Jackson, and twenty-year- old Isaac McGhie. June 15, 1920, Duluth, Minnesota. Gelatin silver print. Real photo postcard. 5½ x 3½" Ink inscription on reverse: "Three Negroes hanged to a pole, in streets of Duluth, Minn June (15 or 16) 1920 during a race riot."*

31. *The lynching of Thomas Shipp and Abram Smith, a large gathering of lynchers. August 7, 1930, Marion, Indiana. Gelatin silver print. 9½ x 7½" Etched in the negative: "Marion, Ind. Aug. 1930."*

The following account is drawn from James Cameron's book, *A Time of Terror*: Thousands of Indianans carrying picks, bats, ax han- dles, crowbars, torches, and firearms attacked the Grant County Courthouse, determined to "get those goddamn Niggers." A barrage of rocks shattered the jailhouse windows, sending dozens of frantic inmates in search of cover. A sixteen-year-old boy, James

Cameron, one of the three intended victims, paralyzed by fear and incomprehension, recognized familiar faces in the crowd — schoolmates, and customers whose lawns he had mowed and whose shoes he had polished — as they tried to break down the jailhouse door with sledgehammers. Many police officers milled outside with the crowd, joking. Inside, fifty guards with guns waited downstairs.

The door was ripped from the wall, and a mob of fifty men beat Thomas Shipp senseless and dragged him into the street. The waiting crowd "came to life." It seemed to Cameron that "all of those ten to fifteen thousand people were trying to hit him all at once." The dead Shipp was dragged with a rope up to the window bars of the second victim, Abram Smith. For twenty minutes, citizens pushed and shoved for a closer look at the "dead nigger." By the time Abe Smith was hauled out he was equally mutilated. "Those who were not close enough to hit him threw rocks and bricks. Somebody rammed a crowbar through his chest several times in great satisfaction." Smith was dead by the time the mob dragged him "like a horse" to the courthouse square and hung him from a tree. The lynchers posed for photos under the limb that held the bodies of the two dead men.

Then the mob headed back for James Cameron and "mauled him all the way to the courthouse square," shoving and kicking him to the tree, where the lynchers put a hanging rope around his neck.

Cameron credited an unidentified woman's voice with silencing the mob (Cameron, a devout Roman Catholic, believes that it was the voice of the Virgin Mary) and opening a path for his retreat to the county jail and, ultimately, for saving his life. Mr. Cameron has committed his life to retelling the horrors of his experience and "the Black Holocaust" in his capacity as director and founder of the museum with the same name in Milwaukee, Wisconsin.

Under magnification, one can see the girls in this photo clutching ragged swatches of dark cloth. After souvenir hunters divvied up the bloodied pants of Abram Smith, his naked lower body was clothed in a Klansman's robe — not unlike the loincloth in traditional depictions of Christ on the cross.

Lawrence Beitler, a studio photographer, took this photo. For ten days and nights he printed thousands of copies, which sold for fifty cents apiece.

32. *The lynching of Thomas Shipp and Abram Smith, a large gathering of lynchers. August 7,*

176

1930, Marion, Indiana. Gelatin silver print. Copy photo. Frame, 11 x 9", photo, 3⅞ x 2¾" Inscribed in pencil on the inner, gray matte: "Bo pointn to his niga." On the yellowed outer matte: "klan 4th joplin, Mo. 33." Flattened between the glass and double mattes are locks of the victim's hair.

A short man with a Hitler moustache points to the body of Abram Smith. On his inner arm is tattooed the bust of an Indian woman.

Indiana historians and researchers are interviewing the reluctant Marion citizens old enough to remember the lynching of Thomas Shipp and Abram Smith. One of their goals is to identify the individuals in this disturbing photo, not to demonize them, but to better understand the factors that produced such a violent and tyrannical era. No one knows who Bo was.

33. *The lynching of J. L. Compton and Joseph Wilson, vigilantes. April 30, 1870. Helena, Montana. Lithographed postcard. Printed 1920-1930. 3½ x 5½" Printed inscription in upper right hand corner reads, "Hangman's Tree, Helena Montana." Another version of this card states, "More than twenty men were hanged upon this tree during the early days."*

A one-thousand-member vigilance committee accused the two men of shooting and robbing an old man named George Lenhart. Their fate was decided on the courthouse steps by mock trial, because "the law was tedious, expensive, and uncertain." When law officers interrupted the proceedings, they were imprisoned by the mob.

34. *The lynching of Leo Frank. August 17, 1915, Marietta, Georgia. Gelatin silver print. Real photo postcard. 5½ x 3½"*

As celebrated as any court battle in the twentieth century, the trial of the "jew," Leo Frank, for the murder of "little Mary Phagan" pitted Jews against Christians, industrialists against workers, northerners against southerners, and city against country folk. It launched political careers and destroyed others, prompted the formation of the Anti-Defamation League, and set the stage for the resurrection of a more sinister and brutal Ku Klux Klan.

Leo Max Frank was arrested on April 27, 1913, the morning after Confederate Memorial Day. A grotesquely engineered trial led to Frank's conviction and a sentence of death by hanging. After Governor John Slaton's commutation of the death sentence, Frank was transferred, for his own safety, to a prison farm in Milledgeville, Georgia. On the night of August 16, 1915 at 11 p.m., a

gang of twenty-five men, some of Marietta, Georgia's "best citizens," wearing goggles and hats pulled down low, pulled Frank from a hospital bed (he had been hospitalized for a near fatal, seven-inch knife wound to his throat.) They placed him, feeble, undressed, and handcuffed, in one of four waiting cars and departed for Marietta, intending to hang him over the monument of Mary Phagan. Frank, often described as stoic, sufficiently impressed two of the lynchers with his sincerity and innocence that they advocated his return to the prison farm. The mob, minus the few who "mutinied," drove into a grove just outside Marietta, selected a mature oak, swung the rope over a limb, stood Frank on a table, and kicked it out from beneath him.

Postcards of the lynched Leo Frank were sold outside the undertaking establishment where his corpse was taken, at retail stores, and by mail order for years. The owner of the property where the lynching occurred refused repeated offers to buy the tree from which Leo Frank was hung. The dean of the Atlanta Theological Seminary praised the murderers as "*a sifted band of men, sober, intelligent, of established good name and character — good American citizens.*" The mob included two former Superior Court justices, one ex-sheriff, and at least one clergyman.

Leo Frank was posthumously pardoned in 1985.

35. *The lynching of Leo Frank. August 17, 1915, Marietta, Georgia. Gelatin silver print. Lithographed postcard. 3½ x 5½" Superimposed over the image:* "THE END OF LEO FRANK HUNG BY A MOB AT MARIETTA. GA. AUG. 17. 1915."

36. *The lynching of Will Moore. May 20, 1919, Ten Mile, Mississippi. Gelatin silver print. Real photo postcard. 3½ x 5½" Etched in the negative:* "Negro who shot J. H. Rogers at Ten Mile, Mississippi."

J. H. Rogers managed a sawmill at Ten Mile.

37. *The barefoot corpse of Laura Nelson. May 25, 1911, Okemah, Oklahoma. Gelatin silver print. Real photo postcard. 3½ x 5½" Etched in the negative:* "COPYRIGHT—1911—G.H. FARNUM, OKEMAH. OKLA 2898." *Stamp on reverse,* "UNMAILABLE."

Grief and a haunting unreality permeate this photo. The corpse of Laura Nelson retains an indissoluble femininity despite the horror inflicted upon it. Specterlike, she seems to float — thistledown light and implausibly still.

For many African Americans, Oklahoma was a destination of hope, where they could

prosper without the laws in southern states that codified racism and repression. What was to be a promised land proved to be a great disillusionment.

District Judge Caruthers convened a grand jury in June 1911 to investigate the lynching of the Negro woman and her son. In his instructions to the jury, he said, *"The people of the state have said by recently adopted constitutional provision that the race to which the unfortunate victims belonged should in large measure be divorced from participation in our political contests, because of their known racial inferiority and their dependent credulity, which very characteristic made them the mere tool of the designing and cunning. It is well known that I heartily concur in this constitutional provision of the people's will. The more then does the duty devolve upon us of a superior race and of greater intelligence to protect this weaker race from unjustifiable and lawless attacks."*

38. *The lynching of Laura Nelson and her son, several dozen onlookers. May 25, 1911, Okemah, Oklahoma. Gelatin silver print. Real photo postcard. 5½ x 3½" Etched in the negative: "*1911 COPYRIGHT, G. H. FARNUM, OKEMAH. OKLA 2897.*"*

America's newspapers, while decrying the savage brutality of the lynch mobs, in general gave only loosely detailed, ultimately sympathetic reports that absolved the communities and officials of any collusion or guilt.

The following account of the lynching of Laura and L. W. Nelson was drawn from Oklahoma papers: A teenage boy, L. W. Nelson, shot and killed Deputy George Loney, whose posse was searching the Nelson cabin for stolen meat. Laura Nelson, trying to protect her son, claimed to have shot Loney. Her innocence was determined weeks before the lynching. The boy's father pled guilty to stealing cattle *"and was taken to the pen, which probably saved his life."*

Forty men rode into Okemah at night and entered the sheriff's office unimpeded (the door was "usually locked"). The jailer, a man named Payne, lied that the two prisoners had been moved somewhere else, but when a revolver was "pressed into his temple," he led the mob down a hall to the cell where L. W. Nelson was sleeping. Payne unlocked the cell, and they took the frightened boy, "fourteen and yellow and ignorant," and "stifled and gagged" him.

"Next they went up to the female jail (a cage in the courthouse) and took the woman out." She was "very small of stature, very black, about thirty-five years old, and vicious." Mother and son were hauled by wagon six miles west of town to a new steel bridge crossing the Canadian River "in a

negro settlement," where they were "gagged with tow sacks" and hung from the bridge. "The rope was half-inch hemp, and the loops were made in the regular hangman's knot. The woman's arms were swinging at her side, untied, while about twenty feet away swung the boy with his clothes partly torn off and his hands tied with a saddle string. The only marks on either body were those made by the ropes upon the necks. Gently swaying in the wind, the ghastly spectacle was discovered by a Negro boy taking his cow to water. Hundreds of people from Okemah and the western part of the country went to view the scene."

"Sheriff Dunagan thought at first that negro neighbors of Nelson's had come and turned them lose." "No attempt to follow the mob was made." "The work of the lynching party was executed with silent precision that makes it appear as a master piece of planning." "While the general sentiment is adverse to the method, it is generally thought that the Negroes got what would have been due them under process of law."

39. *The lynching of Joseph Richardson, damaged shoe-shine stand. September 26, 1913, Leitchfield Kentucky. Card-mounted gelatin silver print. 5 x 7"*

Joseph Richardson was removed from the county jail in Leitchfield by a mob and lynched on the public square at 1:00 a.m. on September 26, 1913. The mob presumed he had assaulted an eleven-year-old white girl named Ree Goff.

The photographer who took this picture peddled the cards door-to-door. A descendent of the original purchaser expressed the remorse the townspeople felt upon recognizing the victim as the town drunk, who had "merely stumbled into the child, and not even torn her dress."

40. *The lynching of Fred Ingraham and James Green. April 3, 1883, Hastings, Nebraska. Card-mounted gelatin printing-out paper. 6½ x 4¼"*

The Invincible 33 mob, as they referred to themselves, overpowered the guards at the courthouse in Hastings and removed prisoners Fred Ingraham and James Green. A third man, John Babcock, who played a minimal role in the robbery and murder of storekeeper Cassius Millet, was spared on account of his youth and his willing confession.

41. *Lynching of an unidentified African American male, onlookers including young boys. September 3, 1915, Alabama. Gelatin silver print. 2½ x 4" Inked inscription on back, "September 3rd, 1915."*

This photo was removed from an Alabama family's photo album. No lynching on this date has been recorded.

42. *Frank Embree standing on buggy, facing camera, stripped, deep lacerations and wounds, his handcuffed hands placed to cover his genitals. Lynch mob. July 22nd, 1899, near Fayette, Missouri. Card-mounted gelatin printing-out paper. 4¼ x 6"*

The defiant victim of this mob is forced to pose on a buggy for the camera. The handcuffs bite into his inflamed lower arms. He stares directly into the camera lens with undiminished dignity. In the right-hand corner, wearing a soft-brimmed hat, edging into the camera's view, is a grinning man with a whip. A coarse blanket rests on the buggy seat.

The three cabinet cards depicting the torture and hanging of Frank Embree (plates 42, 43, & 44) were at one time laced together with a twisted purple thread, so as to unfold like a map.

43. *Frank Embree standing on buggy, back to the camera, feet shackled, stripped, deep lacerations and wounds. Onlookers, one with a blood-stained shirt. July 22nd, 1899, near Fayette, Missouri. Card-mounted gelatin printing-out paper. 4¼ x 6"*

44. *The Lynching of Frank Embree, victim hanging in a tree, stripped, lower body wrapped in coarse blanket. Lynch mob. July 22nd, 1899, near Fayette, Missouri. Card-mounted gelatin printing-out paper. 4¼ x 6"*

45. *Portrait of Will James. Circa 1907, Cairo, Illinois. Gelatin silver print. Real photo postcard. 3½ x 5½" Ink inscription under oval portrait, "Will James (alias) Froggie." Addressed to "Mrs. Jake Petter, 2057 Broad St., Paducah, Ky."*

Will James likely sat for this portrait at a local postcard photographer's studio, a popular and inexpensive fashion of the time. This is the first image of the James lynching in a series of fifteen real photo postcards. Other images not reproduced here include the home of his alleged victim, Miss Anne Pelley; the home of the seven-year-old daughter of Mr. Boren, who found the murdered Miss Pelley in an alley she was crossing on the way to her grandmother's house; the "course the hounds took"; the trains the mob took over to reach Belknap, Illinois, where James was apprehended, and to return him to Cairo for a public execution. The rope from which James was hung broke before he died. His body was then "riddled with bullets," dragged by rope for a mile to the alleged

scene of the crime, and burned in the presence of ten thousand spectators. According to the *New York Times*, five hundred *"women were in the crowd and some helped to hang the negro and to drag the body."*

46. *"Half Burned Head of James on Pole" in Candee Park. November 11, 1909, Cairo, Illinois. Gelatin silver print. Real photo postcard. 3½ x 5½" Ink inscription on reverse: "This Pole is in Candee Park. Enter section of Washington avenue and Elm st which have Will James (alia) Froggie half Burnt Head." Etched into negative, "Half Burned Head of James" and photographer's name, "LeBlock." Addressed to "Mrs. Jake Petter, 2057 Broad st, Paducah Ky."*

47. *Four law enforcement agents and bloodhounds. November 11, 1909, Cairo, Illinois. Gelatin silver print. Real photo postcard. 5½ x 3½" Etched in negative: "The Hounds." Ink numbers 1–4 on front correspond to captions on reverse. Inked inscription on reverse: "No.1 Sheriff Kolp. Charlston Mo 2 Jailer Lutz. Cairo Ill 3 Dupitt sheriff. Rilley of Williffee Ky. 4 Chief Egan. Of Cairo Ill." Addressed to "Mrs. Jake Petter, 2057 Broad st, Paducah Ky."*

In oral histories and correspondence referring to the use of tracking dogs, the term "nigger dogs" is often used. "Dog boys" gained firsthand experience of lynchings and other forms of extra-legal violence in their capacity as runners, trailing the dogs and communicating their progress to the older men, who lagged behind.

48. *View of Commercial Avenue, Cairo, Illinois, November 11, 1909. Tinted lithographed postcard. 5½ x 3½" Printed on card: "Commercial Avenue, Southeast from 9th Street, Cairo, Ill." Postmarked Nov. 11, Cairo, Illinois.*

Images of America's main streets were a favorite subject at the peak of postcard popularity and the height of lynching frequency. In this example, these phenomena are accurately and historically linked. Without fear of judicial reprisals, United States citizens committed repeated acts of extra-legal violence on their busiest streets.

An anonymous sender indicated the site of the lynching of Will James, or "Froggie," by inking an X and a spiderlike stick figure over Hustler's Arch. At the top left of the card, in brown ink, he placed a corresponding X and the words *"where they Hung the Coon."* Hustler's Arch was a prominent and well-lit landmark in Cairo, where banners were customarily hung for Fourth of July celebrations, fairs, and circus parades.

49. *Lynching scene. Commercial Avenue jammed with spectators below the electrically lit Hustler's*

Arch. November 11, 1909, Cairo, Illinois. Gelatin silver print. Real photo postcard. 5½ x 3½" Etched in negative: "LeBlock." Addressed to "Mrs. Jake Petter, 2057 Broad st, Paducah Ky."

This image was taken moments after the rope broke and Will James' body fell onto the unpaved street. Under magnification a small group of suited men peer down as if into a well.

50. *View of Commercial Avenue, Cairo, a few feet from where Will James was lynched. November 11, 1909, Cairo, Illinois. Gelatin silver print. Real photo postcard. 5½ x 3½" Etched into negative: "X SPOT WHERE WILL JAMES, BODY WAS RIDDLED WITH BULLETS, AFTER BEING LYNCHED NOV 11TH 09 AT CAIRO ILL." Ink inscription on reverse: "This Picture is taken from the NE Cor. Of 8th and Commercial avenue Nov-11-09." Addressed to "Mrs. Jake Petter, 2057 Broad st, Paducah Ky."*

51. *Group of young boys, black and white, standing around ashes of Will James. November 11, 1909, Cairo, Illinois. Gelatin silver print. Real photo postcard. 5½ x 3½" Etched into negative: "X," "LeBlock," and "Ashes of James." Ink inscription on reverse: "where the cross is where Miss Pelley was found this alley is between 25 and 26th running East + West and between syc + Elm run-*

ning N. and S. the ashes of James is on syc between 25 and 26th st." Addressed to "Mrs. Jake Petter, 2057 Broad st, Paducah Ky."

52. *Composite photo, Will James portrait in center and three scenes of his lynching. In top right corner the lynching site of Henry Salzner, lynched the same night as Will James. November 11, 1909, Cairo, Illinois. Gelatin silver print. Real photo postcard. 5½ x 3½" All four images of Will James and his lynching have detailed inscriptions etched into the negative. The top right photo of the site of the Henry Salzner lynching has etched in the negative, "Telephone pole on which, Henry Salzner was hanged Nov 11th 1909, for murdering his wife. Cairo Ill." Addressed to "Mrs. Jake Petter, 2057 Broad st, Paducah Ky."*

After the lynching of Will James, the mob turned its attention to the county jail, broke the white Henry Salzner out of his cell by demolishing its solid-metal door, and lynched him from a telephone pole. They did not mutilate or parade his corpse or set it on fire.

Reverend George H. Babcock of the Church of the Redeemer in Cairo declared that the failure of the civil authorities to maintain *"law and order made the lynchings necessary for the infliction of justice."*

53. *The lynching of Garfield Burley and Curtis Brown. October 8, 1902, Newbern, Tennessee. Card-mounted gelatin silver print. 4 x 5½″ Photographer's imprint on mount, "Photo By Taylor Dyersburg, Tenn."*

An account of the lynching in a Tennessee paper reads: "Newbern, Tenn., Oct, 8 — Garfield Burley and Curtis Brown, negroes, were lynched here tonight by a mob of 500 persons. Burley shot and killed D. Fiatt, a well-known young farmer, near Dyersburg, last Saturday. Fiatt had traded horses with the negro, and later Burley demanded that the trade be declared off. Fiatt refused, and while on his way home was shot down by Burley. A posse located the murderer at Huffman, Ark. While being brought to Dyersburg Burley confessed, implicating Curtis Brown as an accomplice. Both men were lodged in jail at Dyersburg today. A mob appeared and demanded possession of the prisoners. Criminal Court Judge Maiden pleaded that the law be allowed to deal with the case, saying that the negroes would be placed on trial tomorrow. The mob would not listen to this and brought the two men to Newbern. The prisoners were taken to a telephone pole, where they were securely tied face to face and strung up."

54. *The lynching of Lige Daniels. Onlookers, including young boys. August 3, 1920, Center, Texas. Gelatin silver print. Real photo postcard. 3½ x 5½″*

Captain W. A. Bridges of the Seventh Cavalry was wired orders from Austin to protect Lige Daniels from the threat of mob violence. His excuse for failing to follow orders was the inability to "find any members of his company in time for mobilization." One thousand men stormed the Center, Texas, jail, battered down the steel doors, wrecked the cell, chose a courthouse-yard oak, and lynched Lige Daniels.

55. *Reverse of postcard (plate 54). Ink inscription on reverse of this card: "This was made in the court yard, In Center Texas, he is a 16 year old Black boy, He killed Earl's Grandma, She was Florence's mother. Give this to Bud. From Aunt Myrtle."*

56. *The lynching of Augustus Goodman (?), his body hanging from oak tree that served as a community bulletin board, onlookers. November 4, 1905, Bainbridge, Georgia. Card-mounted gelatin silver print. 5 x 4¼″ Pencil inscription on reverse: "Killed Jim Rush."*

The Vanishing Georgia project at the Georgia Archives has a view of this lynching captioned, "*The lynching of Gus Goodman.*

After allegedly murdering Sheriff Stegall, Goodman was dragged through town by a mob and then hanged."

The penciled inscription on the back refers to the murder of Jim Rush or Bush. There are eight listings in Decatur County of African American men lynched during this period. One of these lynchings was of a black man, Tok Seabwright, for assaults on two black girls. A black mob took him from county officials, lynched him, and riddled his body with bullets.

57. *The lynching of Rubin Stacy. Onlookers, including four young girls. July 19, 1935, Fort Lauderdale, Florida. Gelatin silver print. 8 x 10"*

According to the *New York Times*, "The suspect, booked as Rubin Stacy, was hanged to a roadside tree within sight of the home of Mrs. Marion Jones, thirty year old mother of three children, who identified him as her assailant." Six deputies were escorting Stacy to a Dade County jail in Miami for "safekeeping." The six deputies were "overpowered" by approximately one hundred masked men, who ran their car off the road. "As far as we can figure out," Deputy Wright was quoted as saying, "they just picked him up with the rope from the ground — didn't bother to push him from an automobile or anything.

He was filled full of bullets, too. I guess they shot him before and after they hanged him."

"Subsequent investigation revealed that Stacy, a homeless tenant farmer, had gone to the house to ask for food; the woman became frightened and screamed when she saw Stacy's face."

James Weldon Johnson captured the disconcerting tone of this photo when he described the epidemic of whites lynching blacks as a "problem of saving black America's body and white America's soul."

58. *The lynching of James Clark, handcuffed. July 11, 1926, Eau Gallie, Florida. Gelatin silver print. Real photo postcard. 3½ x 5½" Ink inscription on reverse: "July 8, 1926. Rocky Water Camp Fla."*

Local newspapers reported that the chief of police and the sheriff were overtaken by a mob while transporting James Clark to trial in Titusville. It was the third lynching of a black man in that region in two months.

59. *The charred torso of an African American male hung in a coastal Georgia swamp, onlookers. 1902. Gelatin silver print. 2¼ x 1⅞"*

Coastal Georgia's whites maintained a paternalistic attitude toward blacks and had little faith in violence as a resolution to racial conflict. A lower than average dependence on black labor, a tradition of politi-

cal involvement by blacks, a higher than average percentage of black land ownership, and, consequently, greater black independence from whites accounted for a significantly reduced threat of lethal violence toward blacks than in other regions of the Cotton Belt. Despite these facts, thirteen blacks were lynched between 1880 and 1902 in the Georgia low country. This photo most closely matches the written accounts of a man falsely accused of having assaulted a Mrs. Fountain and murdering her son, Dower Fountain, in 1902 at their store.

According to the *Chicago Record Herald*, "*A bright bonfire was seen in the swamp in the direction a posse went Friday night and the members of the posse returned stating that they were satisfied with the night's work. It now develops, however, that their victim may not have been Richard Young, for whom the officers of the law are still searching. The remains of the burned negro were brought before the mother of Richard Young who says that they resemble her son in no particular.*"

These tiny documents were purchased by a flea market trader in a trunk stored in the attic of a prominent Savannah family during the dispersal of an estate.

Lynching, as example, usually proved an efficient means of intimidation and oppression. Richard Wright spoke to the heart of black anguish: "*I needed but to hear of them to feel their full effects in the deepest layers of my consciousness. Indeed, the white brutality that I had not seen was a more effective control of my behavior than that which I knew.*"

60. *Reverse of photograph (plate 59) depicting warning note on pine tree. Ink inscription: "Warning, The answer of the Anglo-Saxon race to black brutes who would attack the womanhood of the South."*

Grace Elizabeth Hale documents the ambiguity of sexual power and the evolution of sexual roles between white men, white women, and black males in her book *Making Whiteness*. She discusses Jean Toomer's 1923 poem "Portrait in Georgia," which transforms a white woman into a lynched black man:

> Hair — braided chestnut,
> coiled like a lyncher's rope,
> Eyes — fagots,
> Lips — old scars, or the first red blisters,
> Breath — the last sweet scent of cane,
> And her slim body, white as the ash
> of black flesh after flame.

61. *Four photographs of the lynching of an unidentified African American male in a coastal Georgia swamp. 1902. Gelatin silver prints. 2 x 1⅞" each.*

62. *Postcard portraits of Paul Reed and Will Cato. August 16, 1904. Lithographed postcard. 3½ x 5½" Printed on bottom of card: "Paul Reed and Will Cato, who Murdered and Burned entire Hodges family of five, July 28, 1904, near Statesboro, Georgia. Copyright 1904 by T. M. Bennett."*

There seems to be little doubt of the guilt of Paul Reed and Will Cato in the brutal slayings of the Hodges family of Statesboro, Georgia, and the deliberate burning of their home on July 28, 1904. Their brutality was matched by the retaliatory savagery of August 16, 1904.

On the night of July 28, 1904, in a region of Bulloch County, Georgia, known as the Sink Hole, neighbors were alerted that the farmhouse of the Hodges family was on fire. Those who answered the alarm found blood on the gatepost, the tracks of four people in the lane that ran by the house (one of them barefoot), and, further on, an odd shoe cast aside, a bloody knife, and in what was left of the house, five burning, indistinguishable corpses—Henry Hodges, his wife Claudia, nine-year-old Kittie Corrine, two-year-old Harmon, and Talmadge, six months. By morning, "the entire population of Statesboro was at the scene, and hundreds from all portions of surrounding counties." The following day, July 30, all were buried in a single coffin at the Friendship Baptist Church.

One man recognized the odd shoe as one of a pair he had recently bought for a black tenant, Paul Reed. The Reed cabin was searched, and the mate to the shoe was found. Paul Reed and his wife Harriet were arrested, and soon thereafter Will Cato. The story Harriet Reed told under pressure condemned her husband and his friend.

Tales circulated that Henry Hodges had buried his life savings, three hundred silver coins, in an iron kettle behind the chicken coop. The night before the murders, Hodges surprised Cato and Reed on his place. A quickly concocted story convinced Hodges of their innocence. The next night they returned at 8:00 p.m. to steal the silver treasure. After a struggle, Henry and Claudia Hodges were killed, and the two murderers fled.

Within the hour they doubled back with matches, dragged the bodies into the farmhouse, and discovered "Little Kittie" hiding behind a trunk. She pleaded for her life, offering a nickel in return. They bashed in her head. Harmon and Talmadge were left to burn alive in the blaze, which was ignited with lamp oil.

Paul Reed's unfounded claim of a black terrorist organization called the Before Day

Club made a bad situation worse. According to Reed, the terrorists met nightly to plan robberies and executions of well-to-do whites. News of the fictitious organization, printed as truth, spread beyond the borders of Bulloch County. Imaginary clubs were discovered in other Georgia counties, as well as in Alabama and Virginia. Eighteen other Bulloch County blacks, supposed ringleaders and accomplices, were arrested. In Pavo, Georgia, three supposed Before Day Clubs meeting houses were burned. Soon residents of other counties were offering to help in the lynching and quelling of Bulloch blacks. Later the press was forced to recant their irresponsible reports of the Before Day Clubs.

Mass meetings of whites were held. An All Day Club was formed to rid Bulloch of the troublesome, and to counter the imagined threat of organized blacks. Before and after the trial of Reed and Cato, a wave of violence against blacks went unchecked. Blacks were whipped for vile language, for riding a bike on the sidewalk, for filing complaints against the floggers, and on *"general principle."* Sebastian McBride, three days after giving birth, was whipped, without explanation, in her home. Her husband protested, was dragged into the woods, whipped, and shot. He crawled home and identified

the attackers to sympathetic neighboring whites. Three of the five attackers were arrested but never indicted. McBride died from his wounds.

In Register, Georgia, Albert Roberts (an "unoffending negro") and his seventeen-year-old son were hit by bullets fired into their cabin by a marauding band of whites. Roberts died from his wounds.

A temporary calm took hold when Cato and Reed were spirited to Savannah by Sheriff Kendrick, who said, *"I hated to protect the negroes . . . but I did my duty. I dread to face my friends back in Statesboro."*

On August 2, a coroner's jury examined the evidence and charged Paul Reed and Will Cato with the murder of the Hodges family. The *Atlanta Constitution* reported that the interest in the case was so great that businesses and farms were neglected. Regional newspapers called the six members of the coroner's jury *"the best citizens of the county."* Advertisements ran in the *Statesboro News* offering photos of the murdered family for twenty-five cents apiece.

A special session of Superior Court was convened at 10:00 a.m. on August 15, the earliest date permitted by law. By daybreak that morning the people were arriving in Statesboro by buggies, wagons, and all

manner of vehicles. The trains advertised half-price round-trip fares and added extra coaches to accommodate the crowds. "Rev. Harmon Hodges . . . a brother of the murdered man opened the court with prayer . . . and afterwards begged his listeners not to do anything rash." Will Cato was convicted before court was recessed that evening. Paul Reed's trial followed in like manner the following morning, ending well before noon.

While the attorneys and judge were congratulating themselves on the expeditious nature of their work and the speed of the convictions, lynchers were attempting to get to the prisoners with an outside ladder to the second floor. The militia was ordered to unload their rifles and hold back the mob with rifle butts and bayonets alone. The Savannah Guards, members of the Oglethorpe Light Infantry, were stationed outside, while the local militia was posted at critical points, most importantly the stairways leading to the prisoners. With the increasing nastiness of the mob, officials pleaded for the rule of law. To Reverend Hodges's plea the mob responded, "*We don't want religion we want blood.*" Members of the militia were captured and disarmed. A deputy sheriff seized the captain of the militia and threw him down the stairs to

the mob. Sheriff Kendrick led the charge. He unlocked the cell door and pointed out Cato and Reed. Ropes were placed around their necks, and they were hurried into waiting wagons. The remaining militiamen stood idly by as the mob and their captives made their way to the lynching site.

Women waited with jugs of kerosene at their front gates along the route of the procession. The crowd of two thousand grew impatient and tired in the Georgia heat, and an alternative to the Hodges farm was chosen as the lynching site. According to several accounts, the mother of Henry Hodges was asked to name the method of execution. "*Burn them,*" she said.

Reed and Cato were given time to pray and confess. Reed named other members of the fictitious club. Cato's pitiful mumblings were incoherent.

The two men were chained to a pine stump, and wood was stacked to the height of their legs. Each man was soaked with ten gallons of oil. Cato begged to be shot. Reed beseeched, "*God have mercy!*" When the photographer asked for room to work, the crowd politely gave way.

As Cato flung his head about wildly in a futile attempt to avoid the flames, members of the crowd threw pine knots at him.

When the bodies were still and evidently dead, the crowd dispersed. The fire was maintained until the corpses were reduced to ashes. Souvenir hunters unlinked the chains and chipped away at the stump. Two boys excavated the ashes in search of bones. They wrapped the fragments in handkerchiefs and offered them to Judge Daly, who refused them.

"PHOTOS OF THE STATESBORO HORRORS FOR SALE" Under this headline, which appeared two weeks after the lynching, photos were offered for sale of the family, the murderers, and the lynching. They were the work of T. M. Bennett, as are the postcards reproduced here.

63. *Postcard portrait of Kittie Hodges. 1904, Statesboro, Georgia. Lithographed postcard. 3½ x 5½" Printed on bottom border: "Little Kittie Hodges, who offered Cato and Reed five cents, all she had, for her life and was refused. Copyrighted 1904 by T. M. Bennett."*

64. *Postcard portrait of Talmage and Harmon Hodges. 1904, Statesboro, Georgia. Lithographed postcard. 3½ x 5½" Printed on bottom border: "Talmage and Harmon, the Hodges infants who were burned alive in their home near Statesboro, Ga., July 28, 1904, by Cato and Reed. Copyrighted 1904 by T. M. Bennett."*

65. *Charred tree used as stake for burning of Paul Reed and Will Cato. August 16, 1904, Statesboro, Georgia. Lithographed postcard. 3½ x 5½" Printed on bottom border: "Thirty minutes after Cato and Reed were burned, Aug 16th, 1904."*

66. *Burnt out home of Hodges family near Statesboro, Georgia. 1904, Statesboro, Georgia. Lithographed postcard. 5½ x 3½" Printed on bottom border: "Hodges Home, near Statesboro, Georgia, day after whole family of five were murdered and burned by Reed and Cato. Copyrighted 1904 by T. M. Bennett."*

67. *The corpses of Ernest Harrison, Sam Reed, and Frank Howard hanging from a rafter in a sawmill, jagged circular blade in lower right hand corner. September 11, 1911, Wickliffe, Kentucky. Card-mounted albumen print. 6 x 4" Pencil inscriptions on reverse: "One of two things which made Wickliff famous, John Sherman Wickliffe Ky., Make. C. M. Troy."*

"Lynched by a Mob of Negroes — Three Colored Murderers Are Executed by Their Own People

Special to the *Record Herald*. Wickliffe, Ky. Sept. 12. – Late last night a mob of Negroes invaded the jail here, took out three negro murderers and hanged them to a cross beam in McAuley's mill at the river's edge. The

three Negroes, Ernest Harrison, Sam Reed and Frank Howard, confessed to the murder of Washington Thomas, an aged, respectable colored man. Thomas was employed in a tobacco factory, and Saturday night the three men waylaid him along the railroad track, killed him and robbed his clothes of his salary. They were speedily captured and placed in jail. During the night the colored people of Wickliffe held secret meetings and decided to lynch the murderers. Everything was quietly done. The bodies of the lynched men were left hanging until noon today, and there will be no effort by the authorities to apprehend the executioners."

68. *The lynching of Joe Brown, his corpse badly beaten in shredded clothes hanging from rope stretched over unpaved street, onlookers in background. March, 1909, Whitmer, West Virginia. Gelatin silver print. 3½ x 5½" Ink inscription on reverse: "V City Mont."*

The vast majority of lynching victims in the United States belonged to minority groups such as African Americans, Hispanic Americans, Native Americans, Chinese immigrants, and Italian immigrants. The state most likely to lynch whites was Montana.

69. *Stereograph of the burnt and partially skinned corpses of Ami "Whit" Ketchum and Luther H. Mitchell. December 10, 1878, Calloway, Custer County, Nebraska. Albumen prints. 7 x 3⅜"*

"Cattle Thieves Burned to Death.

Special Dispatch to the *New York Times*. Omaha, Neb., Dec. 1.—Information has been received here today to the effect that two men named Ketchum and Mitchell, in Custer county, suspected of stealing stock, resisted the attempts of four herders to arrest them last Tuesday, and a desperate fight ensued, in which one of the herders was killed. Ketchum and Mitchell were arrested subsequently by the Sheriff of Custer County. That night 25 masked men, well armed, overpowered the Sheriff and his posse, who were taking the prisoners to the county seat for trial, tied the prisoners to a tree and burned them to death."

"Burned to Death by Cattle Men

Special Dispatch to the *New York Times*. Omaha, Neb., Dec. 19.—Later reports from Custer County show that the burning to death of two men recently, reported in previous dispatches, was the result of the determination of the cattle men to keep homesteaders out of that county. Custer, the most extreme north-west county in the State, is almost exclusively given up to cattle-ranges. The two men burned to death had taken homesteads and resolved to stay, despite the

fearful threats made against them. Gov. Garber has offered $200 reward, the highest amount allowed by State law, for the arrest of the men implicated in the terrible crime. He will also recommend to the Legislature, which will sit in January, to offer a reward of $10,000 for the arrest and conviction of the guilty men."

Cattle barons accumulated great wealth by grazing their cattle in the West's open ranges. Homesteaders threatened their fortunes by fencing in areas that would otherwise have been available to them.

A reward of $700 was posted for the capture of Ketchum and Mitchell by Isom Prentice "Print" Olive, a cattle baron. When the men were delivered to the sheriff, Olive and his men took the prisoners. Collusion between the authorities and the cattle baron is likely.

Torture, such as skinning and burning, was virtually never practiced on Anglo Americans. Mitchell's body was taken to his former home at Central City, Nebraska, and buried in the Central City Cemetery. Ami "Whit" Ketchum's brother claimed his body and buried him in Kearney, Nebraska. A pink marble headstone is inscribed, "*Pioneer Ami Ketchum, 1855-1878, A Victim of the Homesteaders and Cattlemen Conflict of Custer County, Nebraska.*"

I. P. "Print" Olive was eventually captured and convicted of the murders. Legal maneuvering to free him was successful but cost him his fortune. He was killed by Joseph Sparrow at Trail City, Colorado, on April 25, 1892. He is buried in Dodge City, Kansas, next to his wife.

70. *Reverse of stereographic card (plate 69).*

71. *Badly beaten corpse of William Brooks, his clothes ripped and torn, a branch fastened to his left leg. July 22, 1901, Elkins, West Virginia. Card-mounted gelatin silver print. 4¼ x 5¾"* Printed on mount: "William Brooks, Who was lynched at Elkins, July 22, 1901, For the Murder of Chief-of-Police Robert Lily. While Attempting to Arrest Him. PHOTO BY VON ALLMEN."

"Lynched in the Public Park, West Virginia Negro Pays Penalty for Shooting Chief of Police.

Special to the *Record Herald.* Elkins, W. Va., July 22.—William Brooks, colored, was lynched in City Park here this afternoon by a maddened mob of 500 half an hour after he had shot and fatally wounded Robert Lilly, chief of police. Brooks was creating a disturbance in the lower end of town and

when Chief Lilly tried to arrest him the negro fled into a house. The officer followed and clinched with him. While they were rolling on the floor the officer's revolver dropped from his pocket and Brooks seized it and shot Lilly through the abdomen. Brooks then jumped from a window and was instantly pursued by the crowd which had been attracted by the fight. He was captured after a chase of half a mile and carried to the park, where his body was soon swinging from a tree."

The branch fastened to William Brooks's left leg was a primitive restraining device used to hobble a prisoner.

72. *The lynching of Charles Mitchell, his body hanging from a tree in a courthouse yard. June 4, 1897, Urbana, Ohio. Card-mounted gelatin printing-out paper. 2¼ x 3¼"*

A widow, Ellen Gaumer, was a white Ohioan of social standing. Her husband had been a state senator and publisher of the *Zanesville Signal.* When she escalated her accusation against Charles Mitchell from robbery to rape, racial animosities doomed the twenty-three-year-old black hotel porter.

Gaumer identified Mitchell as the man who had assaulted her in her home. Two days later, the prisoner waived the reading of the indictment, pled guilty, and was sentenced to the severest punishment provided under Ohio law, twenty years in the state penitentiary.

The militia was unable to board the prisoner on a train to Columbus because the depot was under siege by a growing mob. It was apparent to the sheriff that "*it would be grim work to protect the wretch who was cowering in his jail cell.*"

When the mob tried to break in the rear door of the jailhouse, the sheriff ordered the militia to fire. Two men were killed instantly, two more died later, and another was paralyzed for life. The mob retreated with their dead to the front yard.

The exhausted militiamen abandoned the vigil at 7 a.m., expecting the Springfield Company of the Ohio National Guard to arrive from the station. However, the mayor of Urbana intercepted the reinforcements and sent them back to the depot. The lynchers saw their chance and broke for the jail. They encountered no resistance, and the sheriff handed them the keys to Charles Mitchell's cell. Mitchell "received blows and kicks," and the noose was applied.

In the public square, a rope was hitched over a limb. Mitchell was jerked up and down until the executioners were confident his neck was broken. The corpse was placed in a coffin under the lynching tree for public exhibition, where it stayed until late in the day. Relic hunters stripped it, "even taking his stockings and shoes." No relatives came to claim the remains.

73. *The corpses of Foster Crawford and Elmer Lewis. February 25, 1893, Wichita Falls, Texas. Card-mounted gelatin printing-out paper. 4 x 6½"*

FOSTER CRAWFORD. *Who participated in the killing of* FRANK DORSEY, *late Cashier of the City National Bank, Wichita Texas. February 25th 1896.*

ELMER LEWIS. *Alias "The Kid." One of the murderers of* FRANK DORSEY. *Cashier of the City National Bank, Wichita Falls, Texas. February 25th. 1896.*

Samples of the many criminals hatched and protected by the Federal Government in the Fort Sill Country, Indian Territory, who kill law abiding Citizens. The Federal Government not the people of Texas, are responsible for the murders committed.

Mail this to your Congressmen with the request to use his influence and vote for the settlement of that country by civilized people.

The placement of the corpses, side by side with heads raised as if on a pillow, demonstrates a peculiarity of western lynching photographs, some of which closely resemble postmortem photographs of the period.

The sensational aspects of extra-legal violence were exploited by religious organizations, race supremacists, civil rights groups, photographers, and journalists to increase organizational growth, excite social activism, maintain racial dominance, solidify racial unity, and in this example to manipulate public opinion and increase political voice.

74. *The lynching of Virgil Jones, Robert Jones, Thomas Jones, and Joseph Riley. Black onlookers. July 31, 1908, Russellville, Logan County, Kentucky. Lithographed postcard. 5½ x 3½" Printed on card:*

"TAKEN FROM DEATH," LYNCHING AT RUSSELVILLE, LOGAN COUNTY, KENTUCKY. JULY 31, 1908.

HANGED ON THE OLD PROCTOR LYNCHING TREE. THIS IS A MULTIPLE CEDAR TREE AND THESE FOUR MAKE A TOTAL OF NINE MEN LYNCHED ON THIS TREE, SOME WERE WHITE MEN. THIS TREE IS AN OLD LAND MARK AND WAS AN OLD CEDAR TREE, EVEN IN THE YOUNGEST DAYS OF THE OLDEST SETTLERS.

RUSSELLVILLE IS ONE OF THE PIONEER
TOWNS AND WAS SETTLED IN A CANE BRAKE.
THIS IS AN EXACT PHOTOGRAPH TAKEN AT
DAWN AUG 1, 08.

COPYRIGHTED 1908, BY JACK MORTON,
SALESMAN, STAHLMAN, STAHLMAN BUILD-
ING, NASHVILLE, TENN, U. S. A.

A real photographic postcard bearing this
image falsely attributes the location of and
motive for the lynching. The typed inscrip-
tion on the reverse reads, "*Four Niggers hanged
by a mob in the State of Georgia for assaulting a
white woman.*" In fact this lynching occurred
in Kentucky, and the men were known for
their public criticism of the white-run legal
system—this is the most likely reason they
were executed. The false information reflects
a common justification for lynching in the
South—that blacks were inferior and sexu-
ally uncontrollable. Such justification by
southern leaders fostered the misconcep-
tion that blacks were lynched predominant-
ly for sexual assault, but few lynching vic-
tims were actually convicted or even indict-
ed for such crimes.

75. *Reverse of postcard (plate 74). Ink inscrip-
tion on reverse reads: "I bought this in Hopkinsville
15¢ each. They are not on sale openly. I forgot to
send it until just now I ran across it. I read an*

*account of the night riders affairs where it says
these men were hung without any apparent cause
or reason whatever. A law was passed forbidding
these to be sent thru the mail or to be sold any-
more."*

Lynchings reported in the northern and
foreign presses were damaging to southern
political and economic interests. The author
of the above message documented one of
the earliest efforts by local or state govern-
ments to contain the damage done to its
public image by outlawing the sale and dis-
tribution of lynching images. This inscrip-
tion is dated only a few months after the
May 27, 1908, amendment to U. S. Postal
Laws and Regulations forbidding the mail-
ing of "*matter of a character tending to incite
arson, murder or assassination.*"

76. *The lynching of Virgil Jones, Robert Jones,
Thomas Jones, and Joseph Riley, warning note.
Black onlookers. July 31, 1908, Russellville, Logan
County, Kentucky. Gelatin silver print. 5 x 3½"
Pencil inscription on reverse: "another view of
nigeros that was lynched in Russelville K.Y."*

Dating to Reconstruction, historical proof
exists of the willingness of Logan County
whites to murder blacks in an effort to
control labor and profits. Joseph Riley, and
Virgil, Robert, and Thomas Jones were dis-

195

contented sharecroppers in Logan County. Rufus Browder had been a friend and lodge brother of the four sharecroppers. He and James Cunningham, the farmer for whom he worked, had an argument. Browder turned and walked away when Cunningham cursed him and struck him with a whip. Cunningham then drew his pistol and shot Browder in the chest. Browder, in self-defense, returned the fire and killed Cunningham. After having his wounds tended to, Browder was arrested and sent to Louisville for his own protection.

Subsequently, the three Jones men and Riley were conducting a lodge meeting in a private home when police entered and arrested them for disturbing the peace. In fact, they were arrested for having expressed approval of Browder's actions and discontentment with their employers. (Whites feared that black lodges were planning assassinations.) One hundred men entered the jail and demanded the prisoners. The jailer complied, and the four men were lynched. A note pinned to one of the men read, "*Let this be a warning to you niggers to let white people alone or you will go the same way.*"

Another example of this card, owned by James Mathews, notes, "*This picture was taken at sunrise, Aug 1st by a young lady.*"

77. *Stripped African American male stretched on a tripod rack, raised with pulley, upper body bandaged, lower body wrapped with a blanket tied with rope, fingers curled involuntarily. Circa 1900, St. Louis, Missouri. Gelatin silver print. 2⅜ x 4⅜"* Pencil inscription on back: "St Louis Mo. is this man him?"

78. *Corpse of black male slumped to knees, tied to trunk of pine tree by leather strap around neck. Bicycle with coat neatly folded leans against fence post. Covered hack with two well-dressed white men in background. Pre-1915, southern United States. Gelatin silver print. Real photo postcard. 5½ x 3½"*

The victim was shot through the eyes, ears, mouth, and torso. He was shot in the groin, at very close range, as he attempted to protect his genitals with his bound hands. Palmetto scrub, lack of mature trees and stumps, and the growth of Spanish moss suggest a coastal region, possibly an abandoned plantation.

79. *Lynching of gagged black male hanging from a tree in autumn. Large crowd of onlookers, mostly boys. Circa 1920, location unknown. Gelatin silver print. 3½ x 5½"*

The victim's right hand is bandaged, and fingers appear to have been amputated. The

refracted light may be a fire or car lights. The boy's dress and the clothes of the two adult men suggest a school.

80. *The lynching of John (Jack) Holmes. November 26, 1933, San Jose, California. Gelatin silver print. 10 x 8"*

This photo appeared in the morning edition of the San Jose newspaper. The city fathers were sufficiently offended by the nude male figure on the front page that they had the entire edition confiscated.

81. *Mailing cover for souvenir images of the lynching of Jack Holmes and Thomas Thurmond. November 26, 1933, San Jose, California. Lithographs. 6¼ x 4¼" Printed on reverse: "OFFICIAL PHOTOGRAPHS OF LYNCHING OF SAN JOSE KIDNAPPERS"*

When the corpse of Brooke Hart, a San Jose youth, was discovered in San Francisco Bay on November 26, 1933, a mob materialized to punish the alleged kidnappers and murderers, Thomas H. Thurmond and John Holmes. The lynchers rammed open the jail door, assaulted the guards, and dragged Holmes and Thurmond to St. James Park, beating them into near unconsciousness. Holmes's clothes were sheared from his body, and Thurmond's pants were drawn down to his ankles. A gathering of some six thousand spectators witnessed the hanging.

Governor James Rolph's double-speak was typical of many lynching-era politicians: *"While the law should have been permitted to take its course, the people by their action have given notice to the entire world that in California kidnapping will not be tolerated."*

82. *"Thomas Thurmond, co-conspirator with Holmes in murder of young Hart strung to tree in St. James Park across from San Jose jail."*

83. *"Huge battering ram being used by Holmes-Thurmond lynchers on San Jose jail door."*

84. *"Jail photograph of Jack Holmes, one of the slayers of young Brooke L. Hart, 22, Santa Clara University graduate and son of wealthy San Jose family. Holmes' photo was taken just before lynching by 15,000 vigilantes."*

85. *The lynching of Lee Hall, his body hung from a tree, bullet hole in head, ears cut off, discarded cookstove and trash. February 7, 1903, Wrightsville, Georgia. Card-mounted gelatin printing-out paper. 3⅞ x 5½" Inscription on reverse in brown ink: "Lee Hall col, Lynched Saturday Feb, 7th 1903 about 11 o'clock P.M."*

Two years before his death at the hands of "persons unknown," Hall had allegedly murdered a black man in Johnson County. Some of the colored friends of the murdered man made up a reward for the arrest of Hall. On February 5, 1903, Sheriff D. A. Crawford of Johnson County went to arrest him, and in the attempt he was seriously wounded. Crawford's brother led the posse that eventually captured Hall, crippled him with bullets through both hips, and turned him over to the coroner for a receipt in lieu of the $400 reward money. Hall was *"in a bad way,"* said the newspaper. *"Everybody expected a lynching as the town was crowded with strange faces, and newcomers arriving from every direction."* At about 9 p.m. the jail was partially demolished, and the wounded man was forced to walk the three-quarters of a mile to the dump.

Lynching was live theatre. The executioners of one African American staged the lynching in a theatre and charged admission. One nickel bought you a seat and a shot at the victim. Journalists and newspaper publishers acted as press agents for these events—hyping, scripting, and advertising. Lynchings also sold newspapers. After the "opening" they reviewed the performance. A journalist in Wrightsville reported the lynching of Lee Hall for the *Sandersville Progress*: *"It seems that the lynchers made a complete failure to remove his handcuffs and the negro is now hanging to the tree handcuffed. The lynchers used a small rope, tying the rope under his arms and throwing the rope over a limb of the tree. They did not even hang him up. He was found this morning with his feet on the ground in an apparently standing position with his head thrown back . . . completely riddled with bullets and his ears severed."*

86. *The lynching of Bunk Richardson, his body suspended over the Coosa River, stripped to long johns. February 11, 1906, Gadsden, Alabama. Card-mounted gelatin silver print. 2½ x 3⅞" Pencil inscription on border: "Bunk Richardson 1/06."*

Bunk or Bunkie Richardson was lynched over the heavily trafficked Coosa River. He was accused of rape and murder.

87. *The corpse of Bunk Richardson, propped up for photographer on plank walk of bridge spanning the Coosa River, severely beaten, stripped to long johns. Onlookers hold handkerchiefs to cover nose and mouths. February 11, 1906, Gadsden, Alabama. Card-mounted gelatin silver print. 2½ x 3⅞"*

88. *The lynching of W. C. or R. C. Williams, his body hanging from oak tree, lower body covered with kitchen apron, blood streaming down legs suggests*

castration, onlookers include white men and young children. October 15, 1938, Ruston, Louisiana. Gelatin silver print. Press photo. 9⅜ x 6¼" International News stamp and copyright requirements on reverse. Taped on news sheet:

LYNCH LAW — RUSTON, LA

THE SHOT RIDDLED BODY OF NEGRO W.C. WILLIAMS HANGS FROM A TOWERING OAK TREE LESS THAN 150 YARDS FROM WHERE THE MURDER AND ASSAULT FOR WHICH HE WAS KILLED WERE COMMITTED. A MOB OF 300 PERSONS ADMINISTERED LYNCH LAW AFTER WILLIAMS ADMITTED THAT HE HAD CLUBBED MILL WORKER ROBERT N. BLAIR TO DEATH AND CRIMINALLY ASSAULTED HIS GIRL COMPANION. THE MOB TOOK WILLIAMS FROM THE POSSE WHICH HAD CAPTURED HIM AFTER A THREE DAY HUNT, STRUNG HIM UP TO THIS TREE, THEN RIDDLED HIS BODY WITH BULLETS.

89. *Portrait of Ella Watson, "Cattle Kate." Circa 1890, Johnson County, Wyoming. Toned gelatin silver print. 1¼ x 4" Ink inscriptions on gilt-edged matte: "Ella Watson. 'Cattle Kate.' Happier Days. She was by cruel cattle barons lynched in the Johnson County Wars—1892."*

Studio sticker in shape of painter's palette: "Aberdeen Art Studio." On back of mount:

"FROM THE WESTERN COLLECTION OF CAPTAIN FRENCH."

90. *Poem accompanying Ella Watson portrait:*

> Some boys in Deadwood asked again:
> "You knew her once, didn't you, Ben?"
> "Well, Yes" I said. That's all I said
> Then rode on down toward Lead.
> The wind blew through these Black Hills flowers.
> One Spring day. The sun shone on our heads.
> I'll pack my Colts and board a train
> For old Wyoming once again.
> To even up the score for Kate.
> No man can change his fate.
> Snow blows through the Black Hills towers
> But did I say: "The sun shone on our heads?"

Lynching ballads became popular folk songs. Some were written in advance and handed out at the lynching. Some ballads imparted moral lessons; others simply gloried in the event.

91. *Lynching of two unidentified African American males, white man squatting, hides face as he stills corpses. Signed in negative: "Pruitt Photo." Original photograph circa 1910. Lithographed poster circa 1965. 10¼ x 16¼"*

This poster was salvaged by a vice president of the Students for a Democratic Society at

an abandoned Freedom House in Mississippi. Freedom Houses were established by the Student Nonviolent Coordinating Committee to provide havens for African Americans working to regain their right to vote. Some Freedom Houses were set up as storefronts with hidden meeting rooms in back to teach citizenship classes to blacks and help them maneuver through the Byzantine maze of Mississippi voting regulations.

92. *Corpse of Leonard Woods prostrate on speakers platform, white mob. November 29, 1927, Pound Gap, Kentucky. Gelatin silver print. 3⅜ x 5¾″*

Leonard Woods, a miner, was reported to have shot and killed Herschel H. Deaton, a foreman at an Elkhorn Company mine, for refusing him a ride in his car. A mob of five hundred attacked the Whitesburg jail forty-eight hours after the death of Deaton. Neither Sheriff Reynolds nor the jailor, Mrs. Fess Whitaker, was able to discourage the mob. With hacksaws and crowbars they tore off a corner of the roof and entered the jail. Their original intention was to lynch Woods and the two black women who were accompanying him. Woods "begged off for them," stating that they had nothing to do with the shooting, and the mob leaders decided to leave the

women. Practically all the other prisoners in the jail escaped.

Leonard Woods was taken to the state line at Pound Gap and tied to a speaking platform that had been erected ten days earlier to celebrate the opening of a new road through the mountains. He was shot through with more than a hundred bullets from pistols and high-powered rifles, and then his clothing was set on fire.

93. *Lynching of an unidentified African American male, his body hanging from a tree with swollen face and busted lip, hat replaced. White onlookers. Circa 1890, Arkansas. Card-mounted gelatin printing-out paper. 5 x 7″*

This photograph was purchased with others identified as scenes from Arkansas by an Arkansas collector.

The smug faces and bold postures of the onlookers as well as the replacement of the victim's hat typifies the mocking attitude, nonchalance, and superiority assumed by lynch mobs.

94. *The lynching of Richard Dillon. March 7, 1904, Minnesota. Gelatin silver print. Real photo postcard. 3⅜ x 5⅜″ Etched in negative:* "WILLIAMS RICHARD DILON LYNCHED FOR MURDER-

ING POLICEMAN CHAS. COLLINS 3/7/1904
—BY M. P. S."

The initials M. P. S., the photographer or his studio, can be found on other Minnesota real photo postcards.

95. *The lynching of George Meadows, his body hanging from a hardwood tree. January 15, 1889, Pratt Mines, Alabama. Card-mounted gelatin printing-out paper. 4¼ x 6½"*

96. *Reverse of card (plate 95).*

97. *The burning and mutilated corpse of William Brown, male and female onlookers. September 28, 1919, Omaha, Nebraska. Card-mounted gelatin silver print. 6¼ x 8"*

James Weldon Johnson named the summer of 1919 the "Red Summer" for the rash of deadly riots which erupted in more than twenty-five American cities between April and October of that year. Racial tensions were at an extreme in Omaha that summer; the influx of African Americans from the South and a perceived epidemic of crime created an atmosphere of mistrust and fear that led to the lynching of William Brown.

Brown had been accused of molesting a white girl. When police arrested him on September 28, a mob quickly formed which ignored orders from authorities that they disperse. When Mayor Edward P. Smith appeared to plead for calm, he was kidnapped by the mob, hung to a trolley pole, and nearly killed before police were able to cut him down.

The rampaging mob set the courthouse prison on fire and seized Brown. He was hung from a lamppost, mutilated, and his body riddled with bullets, then burned. Four other people were killed and fifty wounded before troops were able to restore order.

This photograph was acquired from a Lincoln, Nebraska, man whose grandfather purchased it for two dollars as a souvenir while visiting Omaha in 1919.

98. *The lynching of unidentified African American male, naked lower body, bloodied, bullet holes. Circa 1910, location unknown. Gelatin silver print. 2¼ x 4½"*

Blood streams down the corpse of this African American. His shirt is torn, his knees are scraped, and his face and body are pockmarked with bullet holes.

AFTERWORD
James Allen

I am a picker. It is my living and my avocation. I search out items that some people don't want or need and then sell them to others who do. Children are natural pickers. I was. I played at it when I collected bees in jars that were dusting blossoms in the orange groves surrounding my family's home, or when I was wandering along swampy lakesides and hidden banana groves and found caches of stolen liquor or mossy old canoes.

My father would bring home bulging canvas sacks stenciled with bank names, bags of copper pennies or weighty half dollars, and we kids would sit around the mounds of coins as if around a campfire and shout bingo sounds when we found an S penny or silver fifty-cent piece. At fourteen, I used those coins to run away, searching for the lush drifting continent that existed only in my mind, where the people spoke in cryptic tongues and feasted on honey and slingshot gem-feathered birds, sleeping at ease under open skies. I never found that place, but the police found me and shipped me back home. Picking, I guess, is a kind of extension of that search.

Once, in a deep waxy green grove, near to our house, I followed a path to the mildewed shack of an unshaven, alcoholic her-

mit. He made fantastic drip paintings on a portable turntable that splattered pure liquid color outwards like sunrays. Years later a taxicab pulled up to the curb in front of our house and rolled the old man out on to the street like a duffle bag of dirty laundry. He lay still, as good as dead. This was my first grappling with the concurrence of beauty and pain, art and the hidden.

Mothers don't counsel their sons to be pickers. No adult aspires to be called a picker. In the South it is a pejorative term. He is thought to be a salvage man, lowly and ignorant, living hand to mouth, maybe a thief that doubles back at night and steals what couldn't be bought outright. I have tried hard to bring some dignity to the work, traveling countless roads in my home state, acquiring things that I thought were telling — handmade furniture and slave-made pots and pieced quilt tops and carved walking sticks. Many people who sell me things are burdened with their possessions or ready for the old folks home or pining for the grave. Some are reluctant sellers, some eager. Some are as kind and gentle and welcoming as any notion of home. Others are mean and bitter, and half crazy from life and isolation. In America everything is for sale, even a national shame. Until I came upon a postcard of a lynching,

postcards seemed trivial to me, the way secondhand, misshapen Rubber-maid products might seem now. Ironically, the pursuit of these images has brought to me a great sense of purpose and personal satisfaction.

Studying these photographs has engendered in me a caution of whites, of the majority, of the young, of religion, of the accepted. Perhaps a certain circumspection concerning these things was already in me, but surely not as actively as after the first sight of a brittle postcard of Leo Frank dead in an oak tree. It wasn't the corpse that bewildered me as much as the canine-thin faces of the pack, lingering in the woods, circling after the kill. Hundreds of flea markets later, a trader pulled me aside and in conspiratorial tones offered to sell me a real photo postcard. It was Laura Nelson hanging from a bridge, caught so pitiful and tattered and beyond retrieving — like a paper kite snagged on a utility wire. That image of Laura layered a pall of grief over all my fears.

I believe the photographer was more than a perceptive spectator at lynchings. Too often they compulsively composed silvery tableaux (natures mortes) positioning and lighting corpses as if they were game birds shot on the wing. Indeed, the photographic art played as significant a role in the ritual as torture or souvenir grabbing — creating

a sort of two-dimensional biblical swine, a receptacle for a collective sinful self. Lust propelled the commercial reproduction and distribution of the images, facilitating the endless replay of anguish. Even dead, the victims were without sanctuary.

These photographs provoke a strong sense of denial in me, and a desire to freeze my emotions. In time, I realized that my fear of the other is fear of myself. Then these portraits, torn from other family albums, become the portraits of my own family and of myself. And the faces of the living and the faces of the dead recur in me and in my daily life. I've seen John Richards alone on a remote county road, rocking along in hobbyhorse strides, head low, eyes to the ground, spotting coins or rocks or roots. And I've encountered Laura Nelson in a small, sturdy woman who answered my knock on a back-porch door. In her deep-set eyes I watched a silent crowd parade across a shiny steel bridge, looking down. And on Christmas Lane, just blocks from our home, I've observed another Leo, a small-framed boy with his shirttail out and skullcap off center, as he made his way to Sabbath prayers. With each encounter, I can't help thinking of these photos, and the march of time, and of the cold steel trigger in the human heart.

SELECTED BIBLIOGRAPHY

Bond, Horace Mann, and Julia W. Bond. *The Star Creek Papers, Washington Parish and the Lynching of Jerome Wilson.* University of Georgia Press, Athens and London. 1997.

Brundage, W. Fitzhugh. *Lynching in the New South, Georgia and Virginia, 1880-1930.* University of Illinois Press, Chicago. 1993.

— *Under Sentence of Death: Lynching in the South.* University of North Carolina Press, Chapel Hill. 1997.

Cameron, James. *A Time of Terror: A Survivor's Story.* Black Classic Press. 1994.

Carrigan, William Dean. *Heritage of Violence: Memory and Race Relations in Twentieth Century Waco, Texas.* Emory University. 1998.

Commission on Interracial Co-operation. *Southern White Women on Lynching and Mob Violence.* Atlanta, Georgia. 1920.

Dinnerstein, Leonard. *The Leo Frank Case.* University of Georgia Press, Athens. 1987.

Fedo, Michael W. *They Was Just Niggers.* Brasch and Brasch, Ontario, California. 1979.

Garrett, Franklin M. *Atlanta and Environs.* Lewis Historical Publishing, New York. 1954.

Ginzburg, Ralph. *100 Years of Lynchings.* Lancer Books, New York. 1962.

Haldeman-Julius, Marcet. *The Story of a Lynching.* Haldeman-Julius Publications, Girard, Kansas. 1927.

Hale, Grace Elizabeth. *Making Whiteness.* First Vintage Books Edition, New York. 1999.

Ingalls, Robert P. *Urban Vigilantes in the New South, Tampa, 1882-1936.* University of Tennessee Press, Knoxville. 1988.

Johnson, James Weldon. *Along This Way.* Viking Press, New York. 1933.

Kansas State Historical Society. *Kansas Historical Quarterly,* 2, no. 2 (May 1933).

Litwack, Leon F. *Trouble in Mind.* Alfred A. Knopf, New York. 1998.

Lawrence, Ken. *Gregor Forgeries Still Surfacing.* "American Philatelist," July 1996.

Mace, O. Henry. *Collector's Guide to Early Photographs.* Wallace Homstead Book Company, Pennsylvania. 1990.

Mills, Kay. *This Little Light of Mine: The Life of Fannie Lou Hamer.* Penguin Books, New York. 1994.

Morgan, Jonnie R. *The History of Wichita Falls.* Oklahoma City, Oklahoma. 1931.

National Association for the Advancement of Colored People. *Life, Liberty and the Pursuit of Happiness.* New York. 1916.

— *The Lynchings of May, 1918 in Brooks and Lowndes Counties Georgia.* New York. 1918.

— *Can the States Stop Lynching?* New York. 1937.

Patterson, Orlando. *Rituals of Blood.* Civitas Counterpoint, Washington, D.C. 1998.

Payne, Charles M. *I've Got the Light of Freedom.* University of California Press, Berkeley and Los Angeles. 1995.

Shapiro, Herbert. *White Violence and Black Response: From Reconstruction to Montgomery.* University of Mass. Press, Amherst. 1988.

Southern Commission on the Study of Lynching. *Lynchings and What They Mean.* Atlanta, Georgia. 1932.

Tolnay, Stewart E., and E. M. Beck. *A Festival of Violence, An Analysis of Southern Lynchings, 1882-1930.* University of Illinois Press, Urbana and Chicago. 1995.

Toomer, Jean. *Cane.* Liveright, New York. 1975.

Ward, Robert. *Real Photo Postcards.* Antique Paper Guild, Bellevue, Washington. 1994.

Wells-Barnett, Ida B. *Southern Horrors: A Red Record.* Arno Press, New York. 1969.

White, Walter. *Civil Rights: Fifty Years of Fighting.* Pittsburgh Courier. 1915.

— *Rope & Faggot: A Biography of Judge Lynch.* Alfred A. Knopf, New York. 1929.

Wright, George C. *Racial Violence in Kentucky, 1865-1940.* Louisiana State University Press, Baton Rouge. 1990.

ACKNOWLEDGEMENTS

This book is for John.

John Spencer Littlefield, whose insight and thought has shaped every page of this book, and my life.

Fred R. Conrad, "New York Times" photographer, who saw a few scraps of paper and loose thread and wove a book.

Mark Bussell, photographer and visionary.

Randall K. Burkett, African American Studies bibliographer, Emory University. The first to recognize the importance of a lynching photo archive, a fountain of knowledge, enthusiasm and support.

William Carrigan, Ph.D., reams of research and new ways of thinking.

Special Collections Department, Robert W. Woodruff Library. Housing and care of Allen/Littlefield Collection of Rare African-Americana.

Frank Hunter, Photography, Atlanta, Georgia.

E. M. Beck, Professor of Sociology and Head of the Department of Sociology, University of Georgia. Shared his lifetime of research with unguarded generosity.

George S. Whiteley IV, photographic conservator and expert.

Tom Long, Twin Palms Publishers. Whose patience and perseverance were invaluable.

Jack Woody, Twin Palms Publishers. Risk taker.

THE WRITERS

Hilton Als is a staff writer for *The New Yorker.* His first book, *The Women,* was chosen by the *New York Times Book Review* as a notable book of the year.

Congressman John Lewis was elected to Congress from Georgia's Fifth Congressional District in November, 1986. For more than three decades, he has been in the vanguard of progressive social movements and the human rights struggles in the United States. In 1963, he was one of the planners and a keynote speaker at the historic "March on Washington." From 1963 to 1966, Lewis was Chairman of the Student Nonviolent Coordinating Committee (SNCC), which he helped form. With writer Michael D'Orso, he authored *Walking with the Wind: A Memoir of the Movement* (June, 1998).

Leon F. Litwack is the author of *Trouble in Mind: Black Southerners in the Age of Jim Crow* (1998) and *Been in the Storm So Long: The Aftermath of Slavery* (1979), which won the Pulitzer Prize in History and the Parkman Prize. He is the recipient of a Guggenheim Fellowship and is the Alexander F. and May T. Morrison Professor of American History at the University of California. In 1987 he was elected to the American Academy of Arts and Sciences. He is coeditor of the forthcoming *Harvard Guide to African American History.*

COLOPHON WITHOUT SANCTUARY is limited
to 5,000 seventh edition casebound copies.
The photographs reproduced in this volume
are part of the Allen/Littlefield Collection,
and are on deposit in the Special
Collections Department, Robert W.
Woodruff Library, Emory University. They
are open to researchers by appointment.
GWTW is copyright Hilton Als, 2000.
Hellhounds is copyright Leon F. Litwack,
2000. The contents of this book are copy-
right Twin Palms Publishers, 2000.

Book design is by Arlyn Nathan and Jack
Woody. The typeface is Centaur originally
designed by Bruce Rogers based on the
roman type cut by Nicolas Jenson in the
mid fifteenth century.

Special thanks to Lannan Foundation for
their support.

Printed in Hong Kong.

TWIN PALMS PUBLISHERS

Post Office 10229

Santa Fe, New Mexico 87504

1-800-797-0680

www.twinpalms.com

ISBN 0-944092-69-1

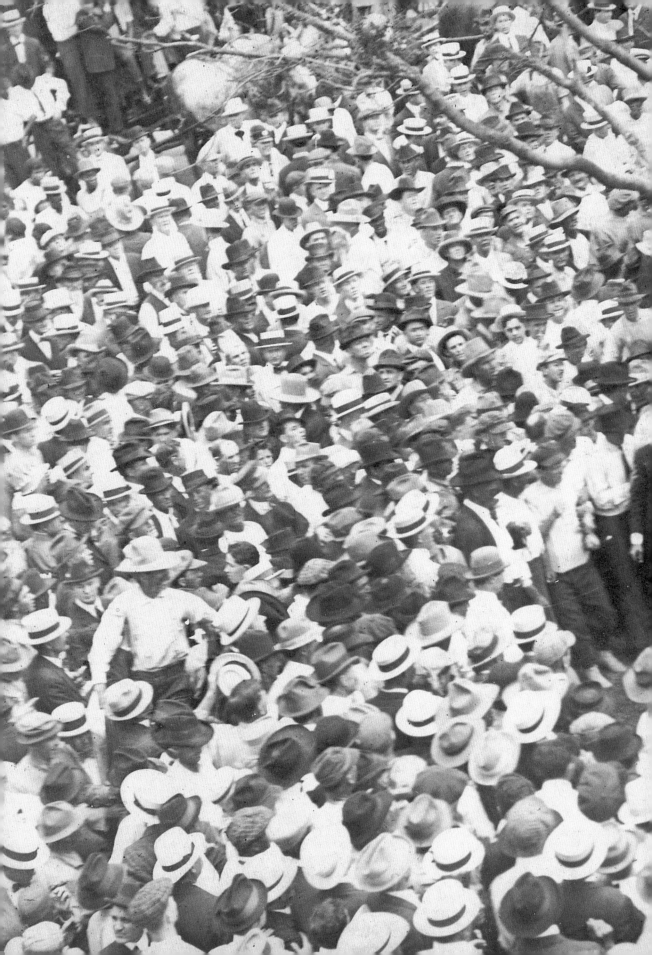